ART OF LIZARD

Fashion Sharpens Your Style.

施 易 亨 | 藝 術 · 時 尚

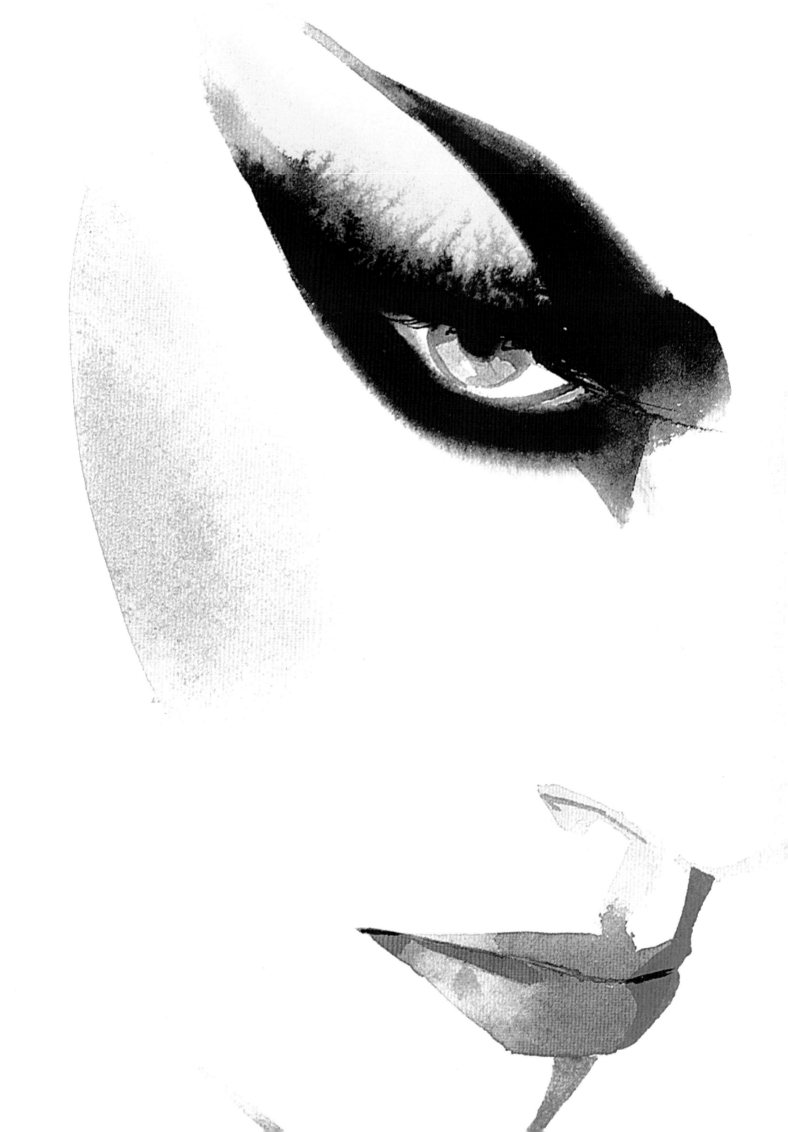

FOREWORD

Written by costume designer HSU CHIU I
撰文 / 服裝設計師 徐秋宜

With the global pursuit of fashion trends and the help of Cultural and Creative Industry in Taiwan, more and more art and fashion combinations are being motivated. Fashion itself not only has cultural and commercial functions, but also has both artistic and diverse talents. This trend of world fashion trend has nurtured some talented fashion illustrators, like Shi, Yi-Heng Lizard, graduated from Fu-Hsin Trade & Arts School and Taiwan University of Arts, he is full of passion about art, painting and fashion. A freelance fashion illustrator who is fascinating, he is known for his unique minimalist fashion illustration style and fashion illustration teaching.

He specializes in painting media such as watercolors and inks. He is good at combining traditional painting techniques with modern and novel design styles, and combines oriental ink, Zen and Western fashion elements to create a new look with abstract and concrete elements. For him, painting has long been a part of life. Over the years, Lizard has worked hard to build solid skills through non-stop creation; he also started his career as a fashion illustrator five years ago. As a fashion illustrator, he also teaches the theme of fashion illustrations in different fashion schools. Through teaching, he can resurrect the neglected fashion illustration art. These rich experiences have brought him the growing power of becoming a professional fashion illustrator. In addition, he is also involved in different cross-border forms of exhibition or cooperation with other industries. Many of his design works have also been recognized by the domestic and international fashion boutiques and have won many fame.

He clearly understands that painting requires enthusiasm and basic work, especially the importance of training on structure. He said: "Although every course is different in the past five years of teaching, I insist on helping students analyze the structure, in the first hour of the course, because the infrastructure is so important." Despite of paying attention to the discipline of basic skills and training, as he is creating, he doesn't like to be restricted. He likes to play with different media. He can use pencils, charcoal pens, and stylus pens. He likes watercolors, colored pencils, and pens. You may simply add the main line with color block, or sticker, etc. to make the work more vital. He said: "For the works, I only care about conveying emotions." The deeper the understanding, the more mastery of the Charm, the Presence and the Shape, the easier it is to draw.

It is easy to identify the style of his work through its decent composition and style of the spiritual symbol, sometimes simple and leisurely, sometimes contradictory conflict, but there is a quiet, elegant power, capable of grasping the viewer's attention. Those have become a unique feature of the aesthetics of Lizard.

In addition to his exposure to diverse art exhibitions, Lizard also runs his own media in addition to his creative exploration. He often expresses his views and philosophy of life in social media; he also shares fashion ideas, the spark of painting, and his passion to various fashion illustration techniques. Whether it's art, fashion professionals and amateurs, he's known for developing thousands of community followers.

As a fashion illustrator across art and design, he is more accustomed to paying attention to art, creativity and fashion design related news and opinions from time to time, like the 50s elegant curve, the 60s bold avant-garde, and the eternal elegance of the classics is the source of inspiration for Lizard. He believes that the combination of the two can already contain the main essence of 97% of fashion painting!

It is his love of painting and his popularity and uniqueness in the field of fashion illustrations that have made him the advantage of many customers and the cooperation of different boutique fashion designers.

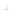
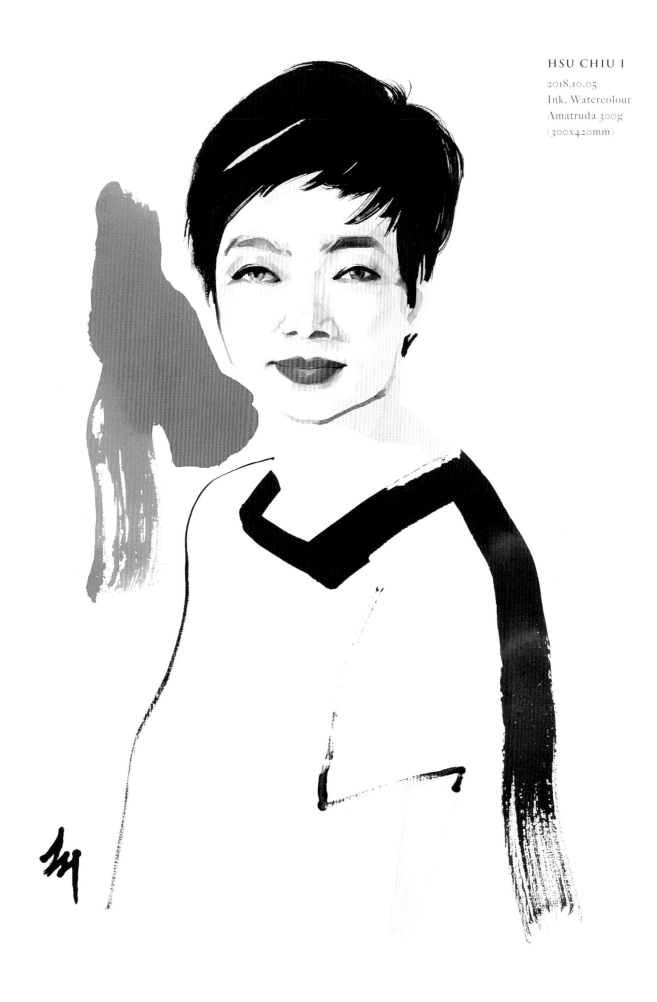

HSU CHIU I

2018.10.05
Ink. Watercolour
Amatruda 300g
(300x420mm)

The uniqueness of his style is the creative ability and artistic expertise of traditional fashion illustrations, which allows him to easily combine tradition with modernity. He said that when painting watercolors, he must use curiosity to overcome fear, and realize that if you understand the various rules of water and color, the rendering can be laid out as you like, and if the looming map reversal is in place, it is simple. The color blocks and lines give a sense of realism.

He believes that fashion illustrators must clearly convey the concept of fashion through artistic means, but the way of drawing can be simple, while observation and thinking should be longer and drawing much faster. Only the fallen composition can make you feel the delicate and ingenious in the color arrangement. This mentality urges him to focus on improving his skills and personal style both now and in the future. For Lizard: Everything you create now is never to let yourself stop changing the way you paint.

在全球追求流行風尚與文創台灣的推波助瀾下，使得愈來愈多藝術與時尚的組合受到更多激勵，時尚本身不但具備文化性、商業性等功能外，也同時兼具了藝術性及多元人才孵化等功能。這一股世界性時尚藝術趨勢，孕孵了一些有才華的時尚插畫家，就像施易亨，自復興美工、台藝大美術設計系畢業，對藝術、繪畫和時裝充滿熱情，是台灣年輕輩正在掘起的一位自由時尚插畫家，他以獨特簡約的時尚插畫風格與時尚插畫教學而聞名。

他專精於水彩和墨水等繪畫媒材，擅長將傳統的繪畫技法融合現代新穎設計風格，並結合東方水墨禪意與西方時尚元素，以抽象與具象交相托襯的手法，作為展新風貌。對他來說，畫畫早已成為生活中的一部分。多年來，施易亨通過不停的創作鍛鍊扎實的技術；五年前也開始了他的時裝插畫師生涯。作為時尚插畫師外，他還在不同的時裝學校教授時裝插畫的主題，透過教學更能復活被忽略的時尚插畫藝術，這些豐富經歷為他帶來成為專業時尚插畫家不斷增長的力量。除此之外，他也參與不同跨界形式展出，或與其他業界合作。很多設計作品也獲得了國內外時尚精品界的認可，並贏得了很多名聲。

他清楚明白，繪畫需要熱情與基礎工，尤其結構訓練是多麼地重要。他說：「儘管過去五年來教學時每一堂課程畫的都不一樣，但我都堅持在課程第一小時都要幫學生解析，因為基礎結構就是如此重要。」，重視基本功與訓練的紀律，然而創作時卻不喜歡受限制，喜歡玩不同的媒材，隨手可用的鉛筆、炭精筆、代針筆，喜歡水彩，彩色鉛筆，鋼筆等。如果可以，也可簡單地再加上主線色塊，或貼紙等⋯，讓作品更俱生命力。他說：「對於作品，我在意的只有傳遞出情感與否。」當理解的愈深入，對神、氣、形的掌握，反而畫得愈簡單。

通過精神性標誌的俐落構圖與風格來識別其作品風格，時而簡約悠閒，時而對比衝突，但都有一種安靜、優雅的力量，非常能抓住觀者的注意力。那些已然成為審美施易亨作品的一種獨特特徵。

他除了接觸多元的藝術展覽活動外，像施易亨這樣的人：浪漫藝術家在創作探索之餘也經營自媒體，他常在社群媒體上表達觀點與生活哲學；對時尚插畫心得，也分享時裝設計和繪畫的火花以及各種時尚插畫技巧的熱情。無論是藝術、時尚專業人士和業餘愛好者，已發展出數千人次的社群追隨者而聞名。

就作為一名藝術與設計跨域的時尚插畫家而言，他更習慣於不時地關注藝術，創意和時裝設計相關的新聞和觀點，像 50s 的優雅曲線、60s 的大膽前衛，以及永恆的優雅經典是施易亨無限靈感來源，他認為光是這兩者的結合就已經可以包含了時尚繪畫 97% 的主要精髓了！

正是他對繪畫的熱愛和在時尚插畫領域的知名度與獨特性，使他受到許多客戶的青睞與不同精品時裝設計師合作的優勢。他風格的獨特之處在於傳統時裝插畫的創作能力和藝術專業知識，讓他能輕易地將傳統與現代合併在一起。他說畫水彩時，要用好奇心來戰勝恐懼，更體會到若懂水、彩的各種法則後，渲染也就可以隨心所欲地佈局了，而若隱若現的圖地反轉如有到位，只需要簡單的色塊與線條就可呈現真實感。

他認為時尚插畫師必須通過藝術手段清晰地傳達時尚概念，但畫畫的方式，可以簡單點，而觀察與思考應想久一些，畫快一點。唯有俐落的構圖才能感受到色彩配置中較為細膩的巧思。這心法促使他在現在與未來，都要更專注在提高自己的技能並培養個人風格，對施易亨來說：創作當下的一切，就是永遠不要讓自己停止改變畫法。

CONTENTS

SHI YI-HENG(LIZARD), Born in Taipei in 1983, he graduated from the Visual Communication Design Faculty of the National Taiwan University of Arts in 2006. In 2013, he founded the Fashion Art Style and in the same year established a fashion illustration classroom in Taipei. The central idea of "human" is the traditional painting technique, Incorporating modern and innovative design style, the self-liberation between the brush strokes captures the most realistic colors, combining the oriental Zen and western fashion elements to present a new generation of fashionable watercolor features.

It is black, from birth; it is white, from pure; or, no color, unlimited possibilities and impossibilities. Between culture and fashion, between art and business, I have always embraced dreams and learning. Between understanding and not understanding, I look for real emotional connections with human beings, and express the real society through the way of art promotion and creation. Watercolor seems to be the medium, which started my exploration of color variations. I stroll along the road of artistic creation through different cultures or media, which can also satisfy my desire for artistic creation. Every artwork is like self-talk, as my avatar re-examines, the emotions between the strokes are expressed with sorrow and joy. Creation is a challenge and a new realization for me.

INTRODUCTION

時　尚　藝　術　創　作　家　施　易　亨

I actually do not like to be positioned as having a certain style, but I feel the closest term would be "fashion illustration", which to me is an explanation of stylizing my artwork. Simply speaking, it belongs to the watercolor painting style of this era, one may boldly use black and chromatics but not to be limited, and it's quite interesting to fuse designing concept in it. I like the subject that's full of emotions, no matter it's facial expression or body language. Portrait is certainly the first pick. Having women as the main element for creation is something of high extensibility due to women always have romantic stories and unforgettable emotions, even one facial expression could be interpreted by hundreds of meaning with different people and under different circumstances.

Fashion is the "accessories" in my creation. It makes the skillful ways of expression with unlimited possibilities. Watercolor is the media which gives me continuous innovation ideas, with countless experimenting processes, it always gives me new discoveries and sense of achievement. As a result, most of my artwork is created by watercolor or ink.

Picasso said, "Style is the greatest enemy of artist". What's funny is that when I first read this quote, I was worried by not finding my own style. After several years of not purposely searching for my style have I found my own style, but this is not defined by myself, rather it came from people surrounded. And because I am used to draw whatever I want to, categorizing my artwork is something of a headache to me, therefore, there is not very clear collection in my album.

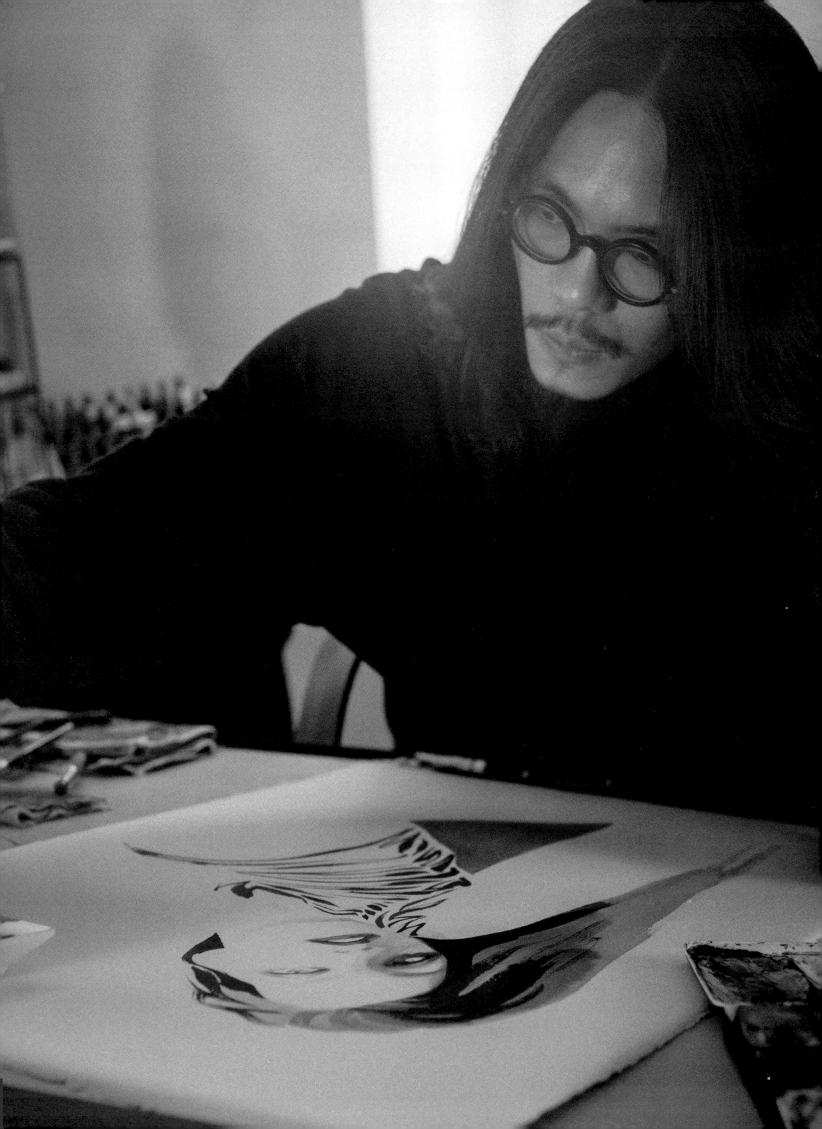

施易亨（LIZARD），1983 年出生於台北，2006 年畢業自國立台灣藝術大學視覺傳達設計學系。2013 年創立時尚藝術畫派，同年於台北成立時尚插畫教室。以「人」為創作的中心思想，將傳統的繪畫技法融合現代新穎設計風格，筆觸間的自我奔放並且捕捉最真實的色彩，結合東方水墨禪意與西方時尚元素展現新一代的時尚水彩風貌。

是黑，來自於誕生；也是白，來自於純粹；或者，無色彩，無限的可能與不可能。在文化與時尚之間，在藝術與商業之間，我一直懷抱著夢想與學習。懵懵懂懂間，尋找一些真實與人之間的串連與情感，藉由藝術推廣與創作的方式來表達真實的社會。水彩彷彿是媒介，啟動了我對顏色變化的摸索，我在藝術創作這條路途上遊走著。利用不同文化或是媒材創作，悠遊其中，也能滿足自己對於藝術創作的渴望。一切都好比與自我心靈對話，如同我的分身重新檢視，筆觸間的情緒悲傷喜悅，創作對我來說是一種挑戰與新的體悟。

其實不大喜歡自己被定位成何種風格，但覺得較為接近的稱謂是「時尚插畫」。「時尚插畫」於我來說像是一種風格化的解釋，簡單來說就是屬於這個世代的水彩畫風，可以大膽的使用黑色、能夠擅用色彩學卻又不被框架，並在之中融入設計概念也是相當有趣的。我喜歡富有情感的主題，不論是表情或肢體語言，人物畫理所當然就是首選。關於以「女人」為創作主要元素這件事，在日常、電影、小說裡，女人總有浪漫的故事與刻骨的情感流露，就算同樣的一號表情在人和情境的差異下也可以有著上百種的不同意涵，對於創作來說是非常有具有延展性的。

時尚是我創作裡的「配件」，它在表現技法的呈現上有著無限發揮的可能性。水彩是能夠讓我有不斷想創新的繪畫媒材，無數次的過程總是能讓我有新的發現與成就感，所以我大部分的作品都是使用水彩或水墨來進行創作的。

畢卡索曾說過：「風格是藝術家最大的敵人。」可笑的是我第一次看到這句畫時就正在為找不到風格而煩惱，不再刻意尋找風格的數年後我找到了自己的風格，並非由自己所定義，而是從週遭的人們口中得知。也因為已經習慣想畫什麼就畫什麼，對於替作品分門別類是令我非常頭痛的事情，所以畫冊中並沒有非常明確的系列分析。

ART OF LIZARD
—Fashion Sharpens Your Style.—

Any person, anything, or any object would have a gesture of artistic expression, and art itself is also a way of expression. There have been countless artistic revolutions in human history. Everyone is an individual with independent thinking, and it is impossible to fully agree on the viewpoint of art. There will be an enlightener behind every artist, and he will let you realize what the language you like, but you have to rely on yourself to find out what you like more, perhaps in the same direction, but the belief is never repeated. Everyone's art should be unique.

I think that the language of painting is the most direct and special artistic transmission, figurative, imagery, abstraction; characters, landscape, geometry are different modes of conveying ideas, characters can express joy; landscape can also reflect sadness. But I especially like the uncontrollable changing forms of temperature and emotion, so in my artistic creation, I chose "people" as my main communication tool, just as rich as the water-based media I often use in painting tools. Full of imagination and creativity.

There are many paintings in my artworks named after the imagery of thoughts, emotions, ideas, etc., but there are also some forms that simply intended to pursue beauty. Although sometimes it may be because of the non-figurative unconsciousness or the chilliness of the winter, I will try my best to find the gesture and expression that reflects my thoughts, and use "portrait" to state my ideals. The pictures are all from my life experience, so some people like it, and some people can't understand it. I have no way to cater to all people, and I don't want to do that. Just stick to my idea and one day they will eventually feel the spirit.

I hope that through my own creation, the public will be aware of the connection between art and life. Although these are my stories, I believe that with resonance, we can inspire the artistic form that is different from each different viewers. The means of transmission would enrich the public's development of life aesthetics. Art comes from life, and life begins with people.

任何的人、事、物都會有其藝術表現的姿態，藝術本身也是一種表現方式。人類史上歷經了無數次的藝術革命。每個人都是獨立思維的個體，對於藝術的觀點也不可能完全達成共識。藝術家開始的背後都會有著一位啟蒙者，而他會讓你體會到自己喜歡的語言是什麼，但得靠自己從這份喜歡之中再去發現更喜歡的，或許方向雷同，但信念絕不會重複，每個人的藝術應該都是獨一無二的存在。

我認為繪畫形式的語言是最直接也最特別的藝術傳遞，具象、意象、抽象；人物、風景、幾何則是傳遞上想法的不同模式，人物可以表現歡樂；風景也可反映悲傷。但我特別喜歡溫度、情感這些無法駕馭的形式變化，所以在我的藝術創造美學世界裡，選擇了「人」作為我的主要傳達工具，也正如繪畫工具中我經常使用的水性媒材那樣富有想像及創造力。

我的作品中有不少以思緒、情感、理念等意象形式來命名的畫題，但也有的只是單純想追求美的形式。儘管有時候可能是因非具象的淺意識感知又或者只是冬日的蕭瑟而有所感觸，我還是會想盡辦法找到那個能反映其意念的姿態、表情，用「人」來陳述我心中理想的畫面，這些不外乎都來自於我的生活體驗，因此會有人喜歡，也會有人無法理解。我沒有辦法去迎合所有的人，也不想要那麼做，只要堅持理念，有一天他們終究會感知到那份精神的。

希望藉由自己的創作讓大眾意識到藝術與生活的聯繫，雖然這些都是我的故事，但我相信有了共鳴就能夠衍生出有別於每位不同觀者的藝術形式啟發，透過這樣的傳遞方式進而豐富社會大眾對於生活美學的發展，藝術源自生活，生活始於人。

CHIC

2015 ~ 2018

If what you see is what you want to draw down, I feel the result is rather boring. From my experience, usually the closer the drawing is to the reality, the less the thoughts behind a drawing, unless the model or setting is carefully arranged by the artist. However, Reality and Realistic are not the same thing. I am not the kind of artist who's always drawing. I can't imagine the lifestyle totally devoted to drawing. I'd rather spend time travelling, watching movies, reading magazines, comics, playing toys, even idly thinking nothing or something, which may enrich the inspiration of my creatives and continuous passion. Inspiration, as the word conveys, it is sensual, which provokes me of a same subject, under different time frame and emotion, the way I express in drawing would be totally different. Therefore, I would enjoy re-drawing my old artwork after a period of time, and the result is always very interesting. What's magical is that, no matter how much I have made progress skillfully, I could never express 'the feeling' from the first drawing.

如果看到的和想畫的完全一致,那麼結局想必是相當無趣的吧。以我的經驗來說,通常畫的愈接近現實,對於畫作本身是愈沒有想法的,除非模特兒或佈景是自己所精心安排的。然而,現實與寫實又是兩回事。我並不是那種無時無刻都在畫畫的人,我沒有辦法想像將所有的時間全部投入繪畫當中的生活方式。旅行、電影、雜誌、漫畫、玩具甚至發呆冥想,我寧可把坐在畫桌前鑽牛角尖的時間花費在這些事情上,反而更能豐富我在創作上的靈感和永續的熱忱。靈感這事,如同字面上給人是感性的,有時候回想起來,同樣的主題在不同時間、情緒下表現居然會截然不同,所以每隔一段時間我都喜歡再將舊作重新詮釋一次,結果總是非常有趣。奇妙的是,技法上改變或精進了,但卻怎麼也沒辦法畫出第一張裡面的「感覺」。

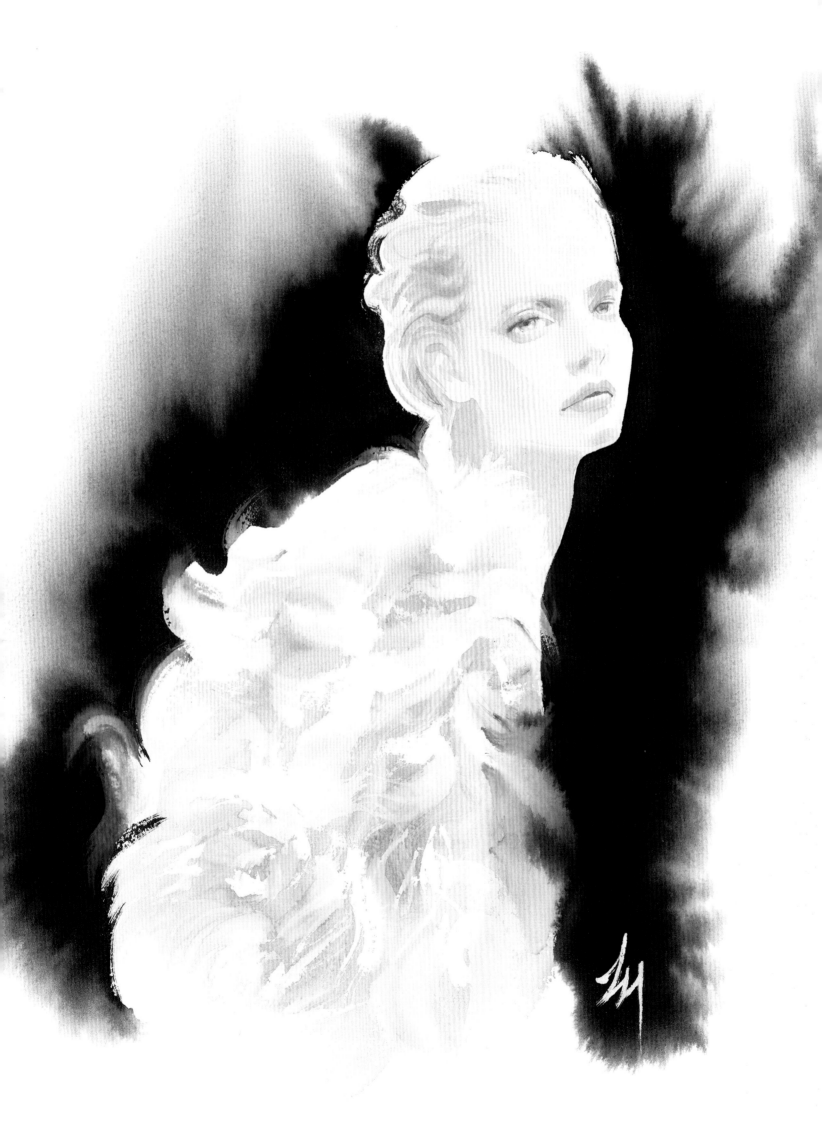

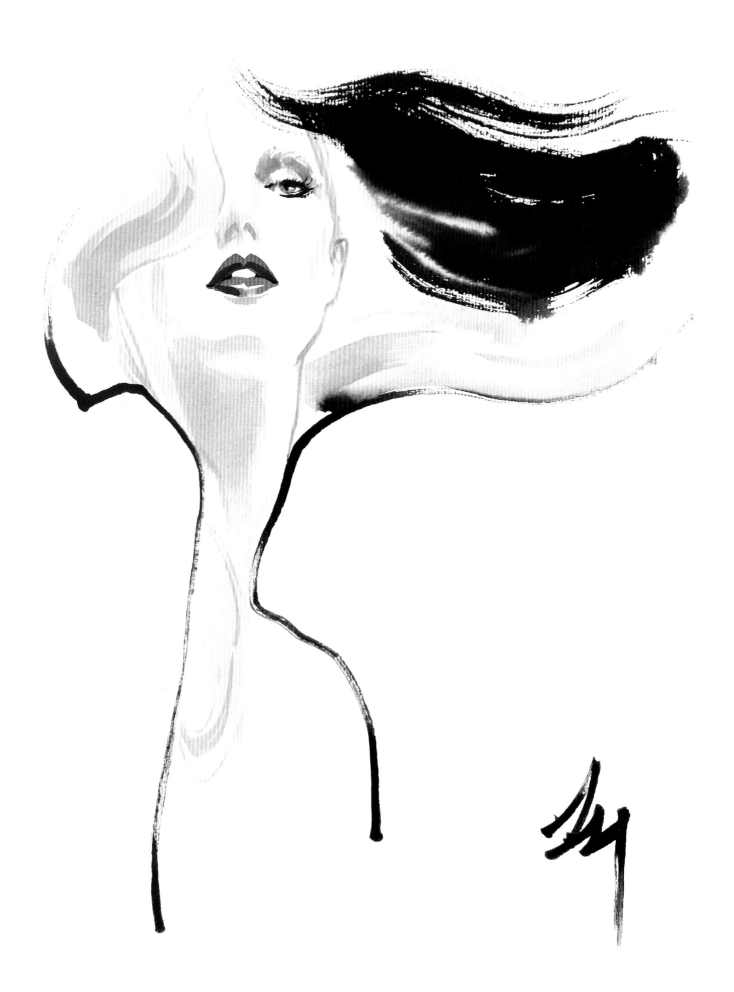

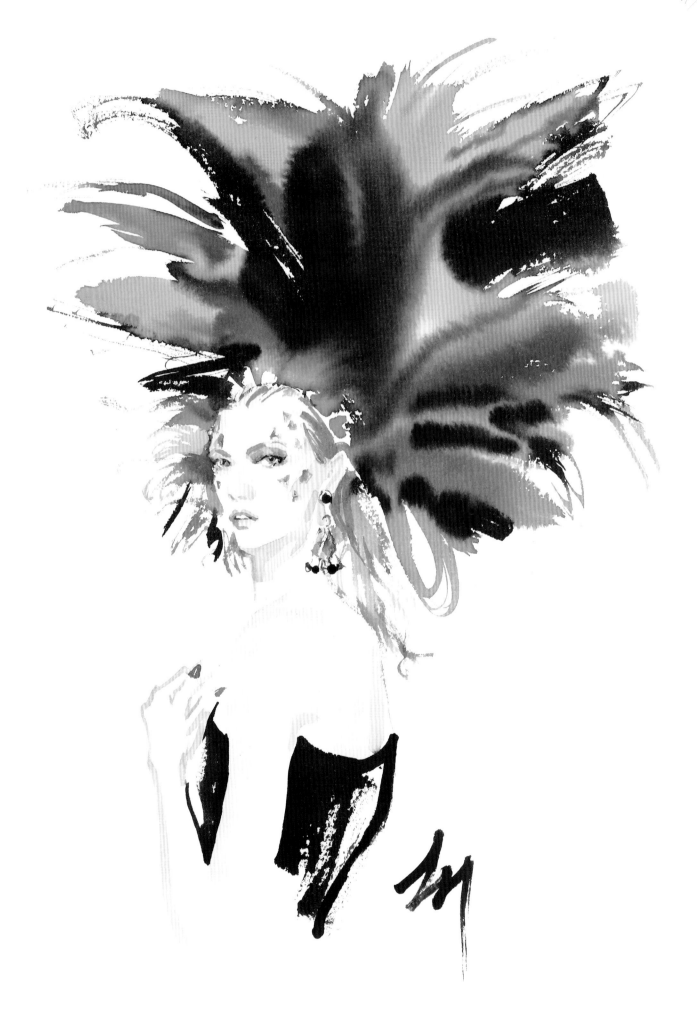

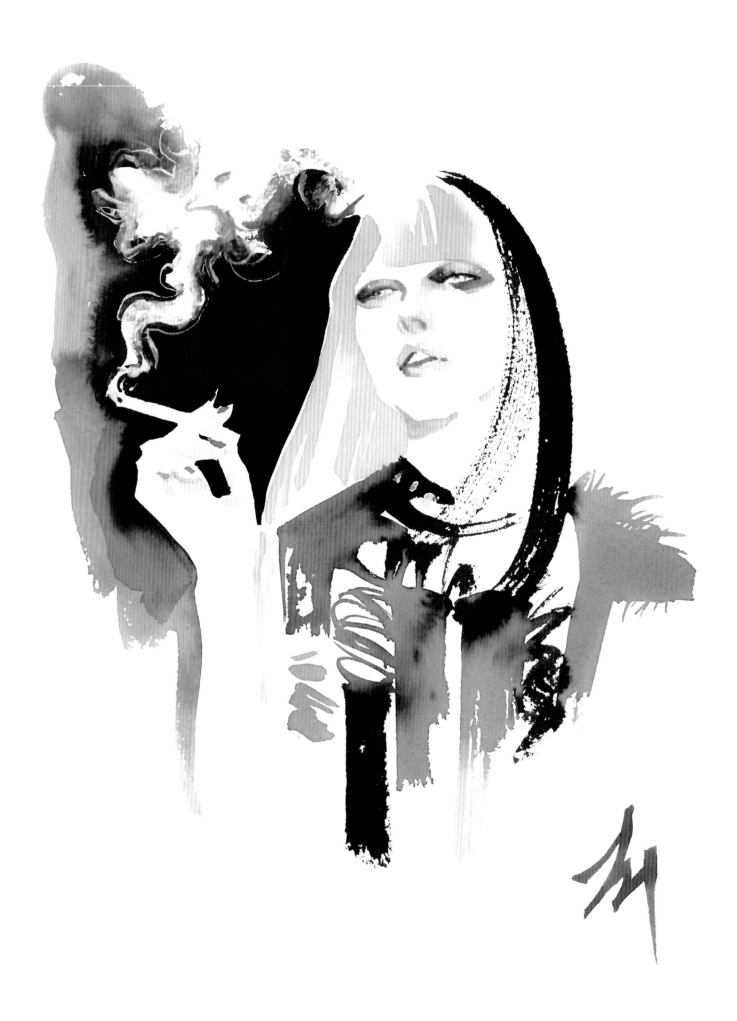

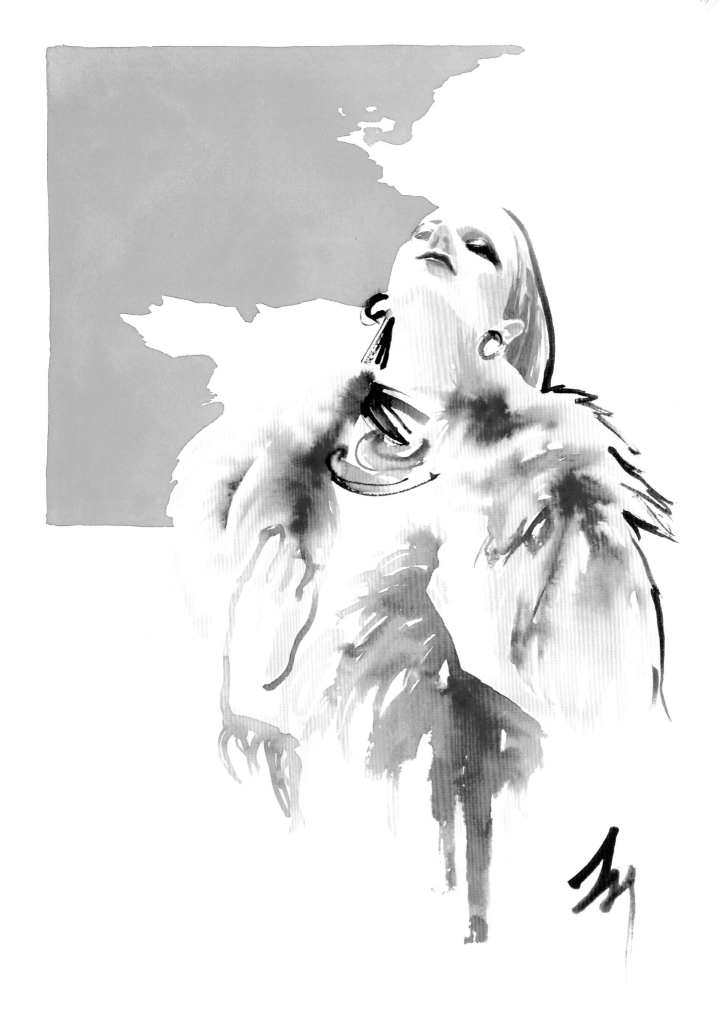

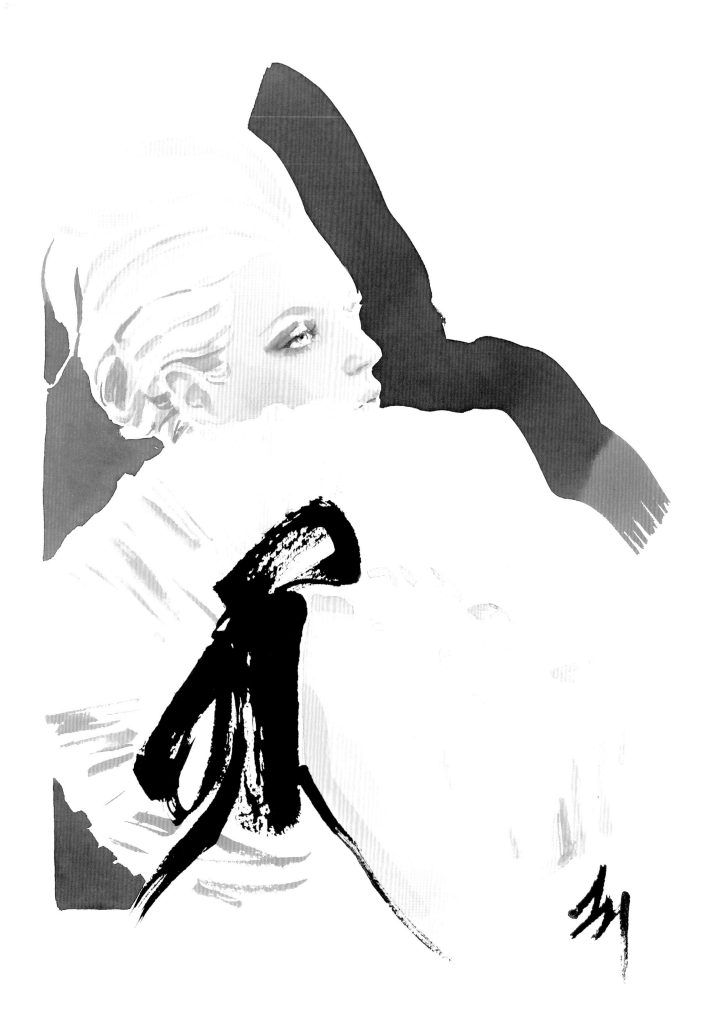

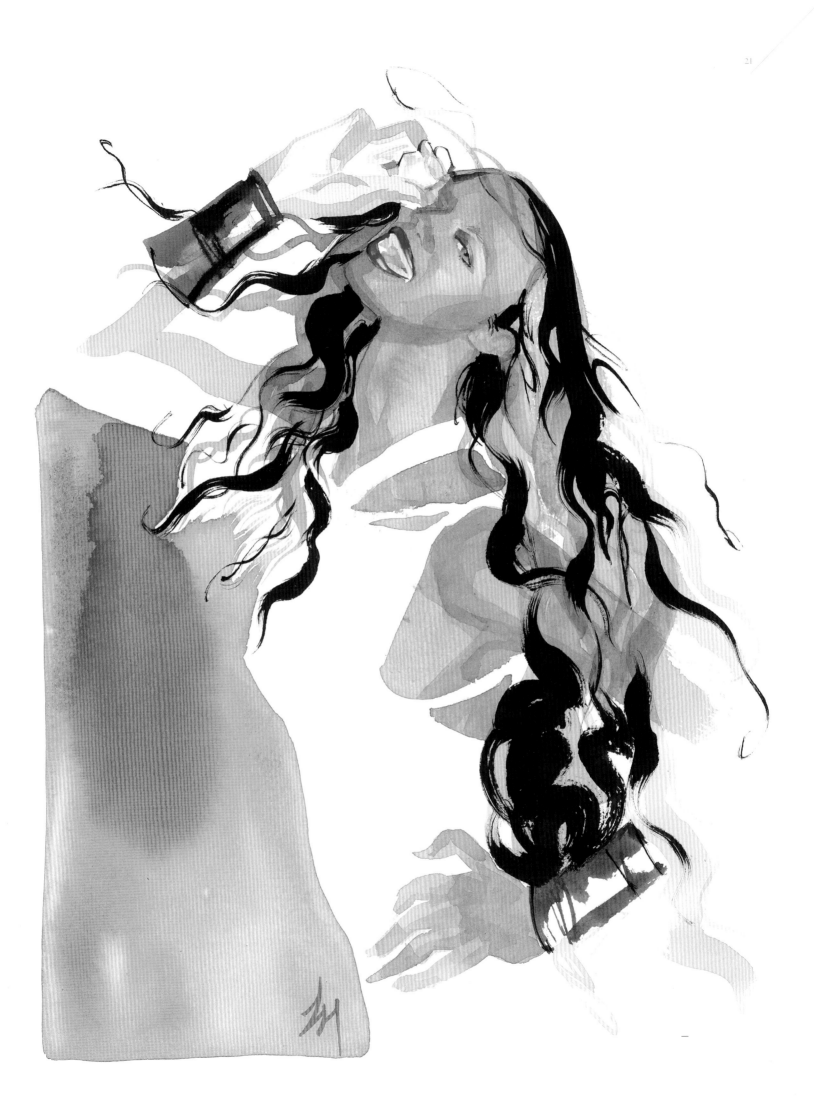

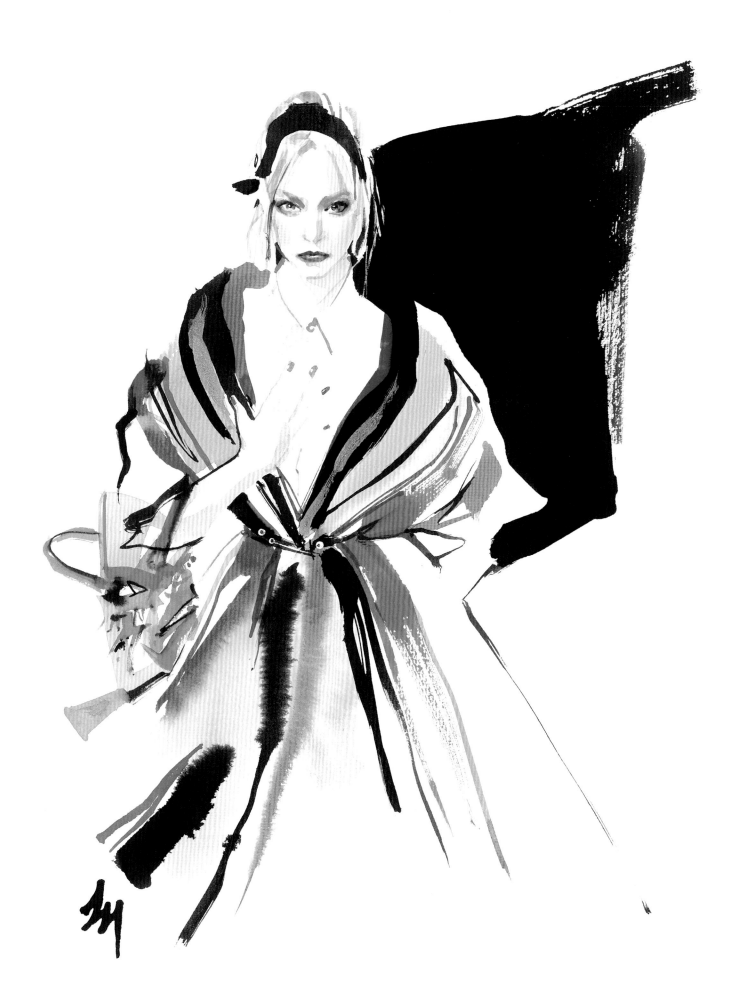

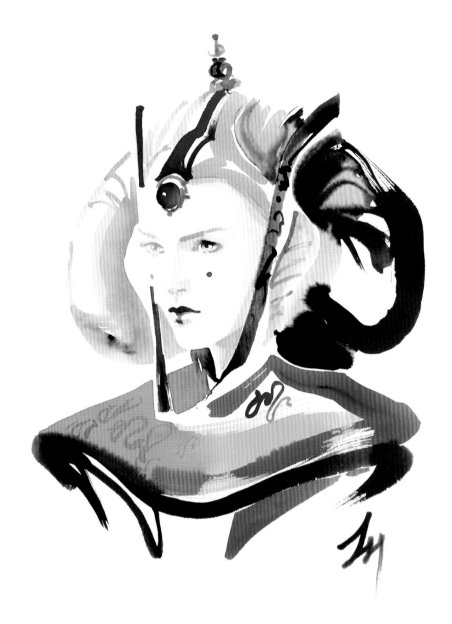

Relationship **Of The Limbs**

The most critical part for drawing a body is to plan for the relationship of the limbs. To coordinate the attitude of the body is to get a hold of the structures of the bones and muscles, i.e. the anthroponomy before analyzing its attitude and angle. Nonetheless, it is the most difficult part. The limbs and the body would fall apart once there are any structural discrepancies which do not conform to a certain angle.

四肢關係是在做好身體之前最關鍵的計畫。姿態的協調性不外乎掌握骨骼、肌肉的結構（解剖學），再來才去分析姿態和視角，而這也是最不容易的部分，只要不符合這個角度下應有的結構變化，四肢和身體立刻就會分崩離析。

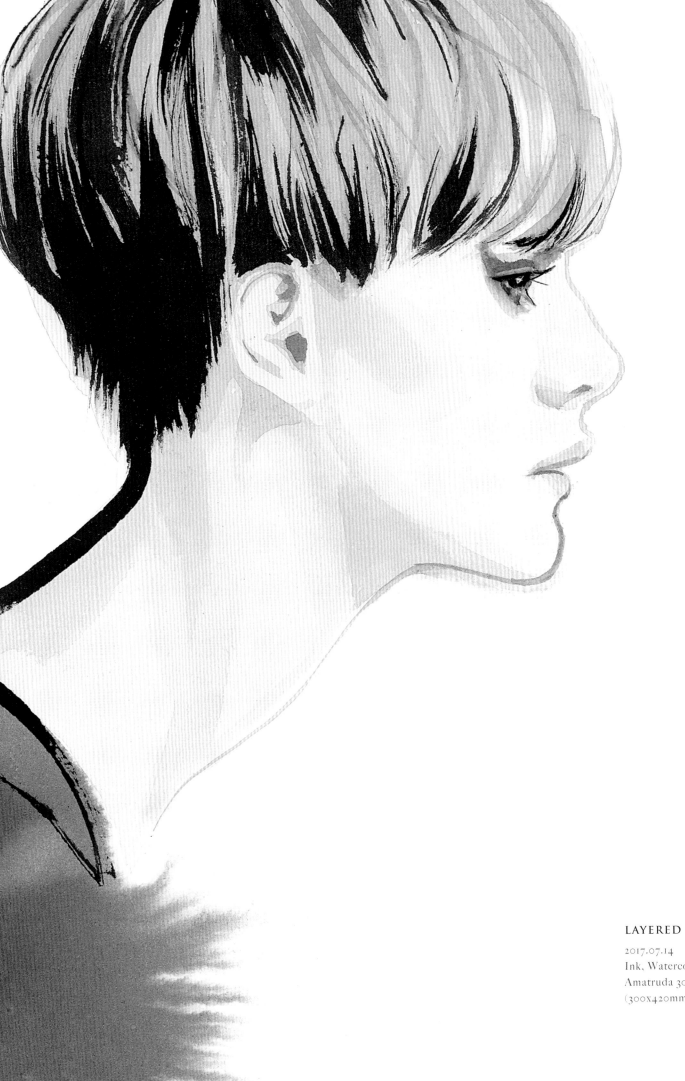

LAYERED

2017.07.14
Ink, Watercolour
Amatruda 300g
(300x420mm)

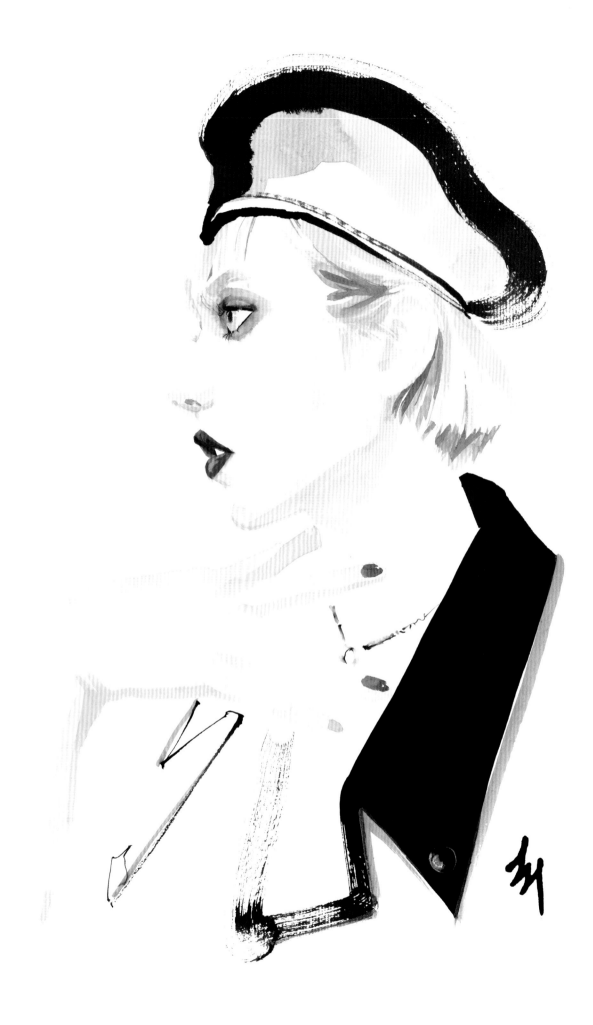

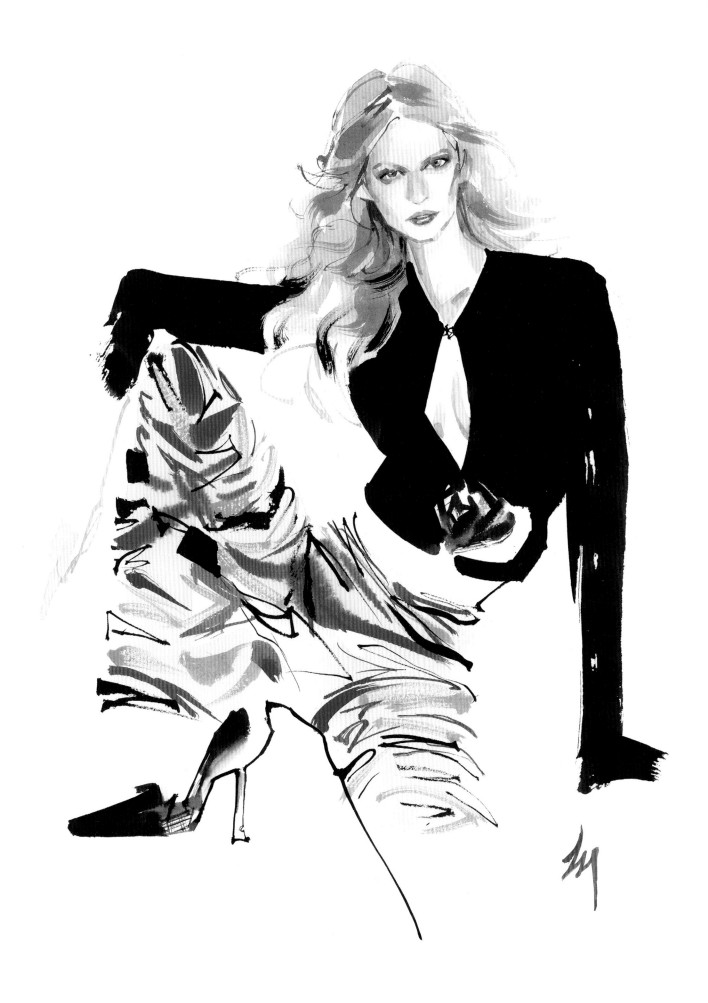

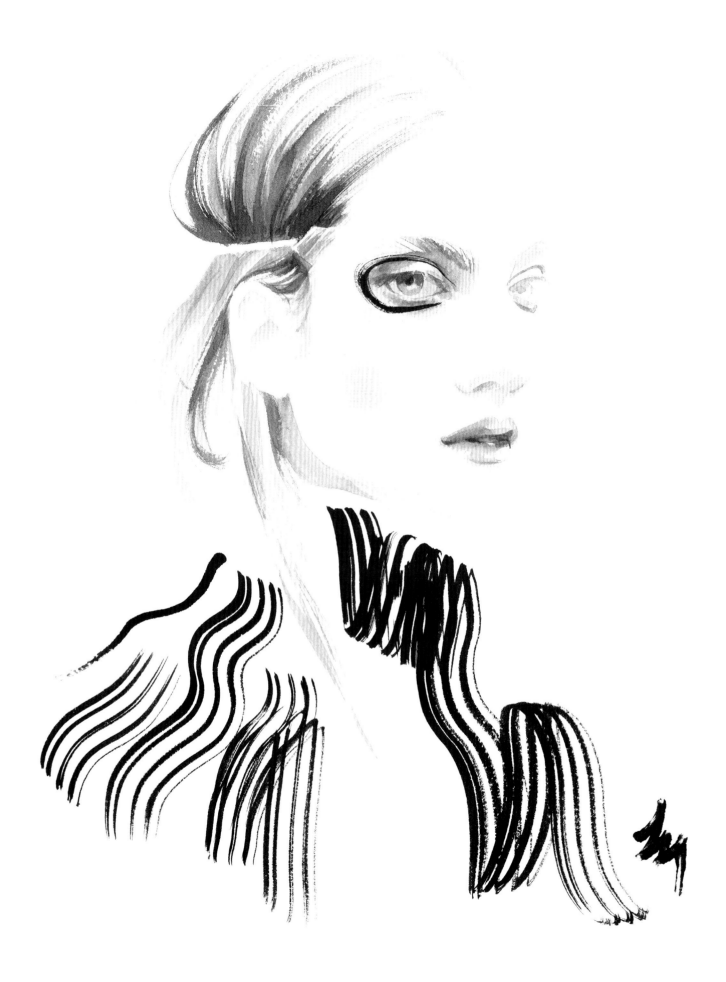

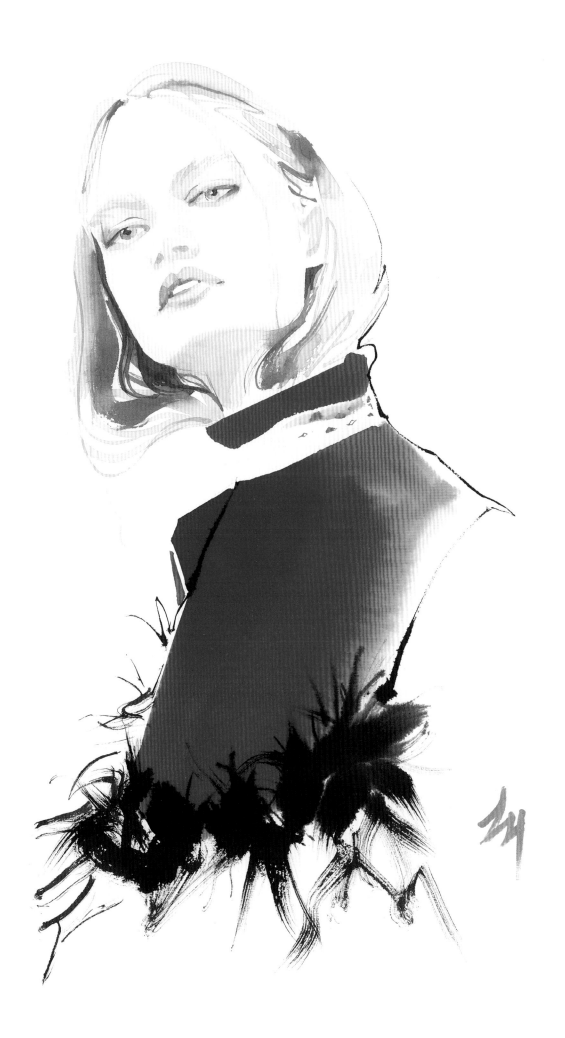

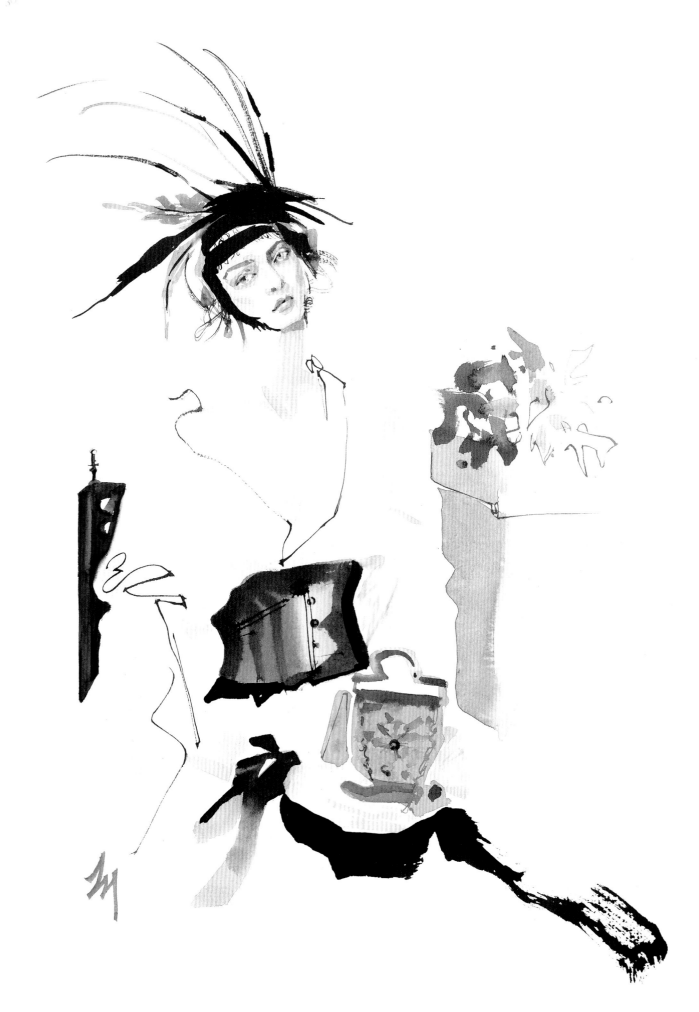

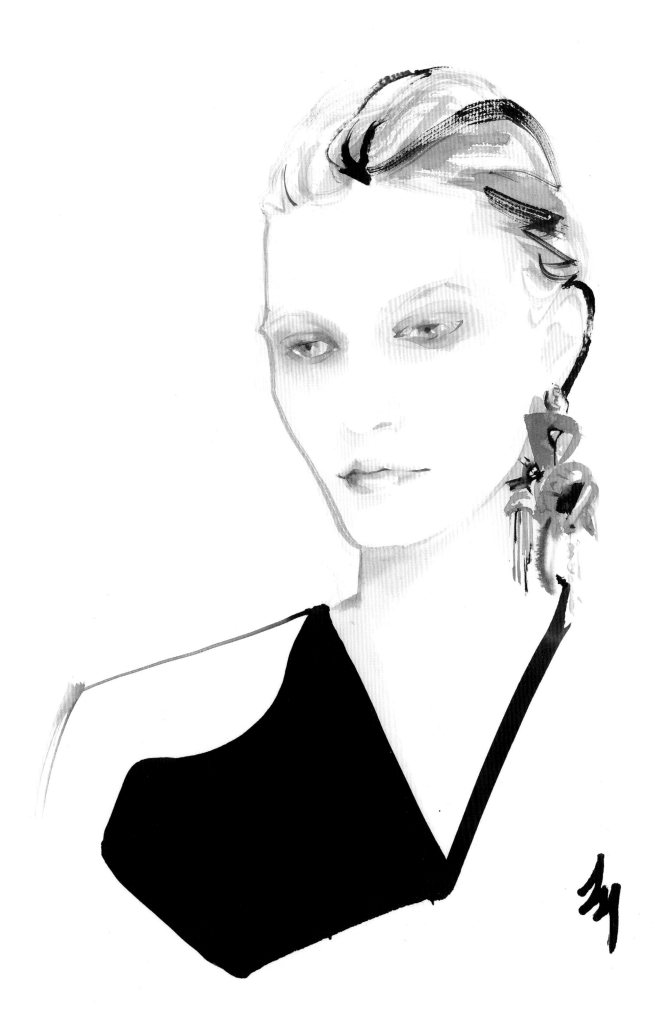

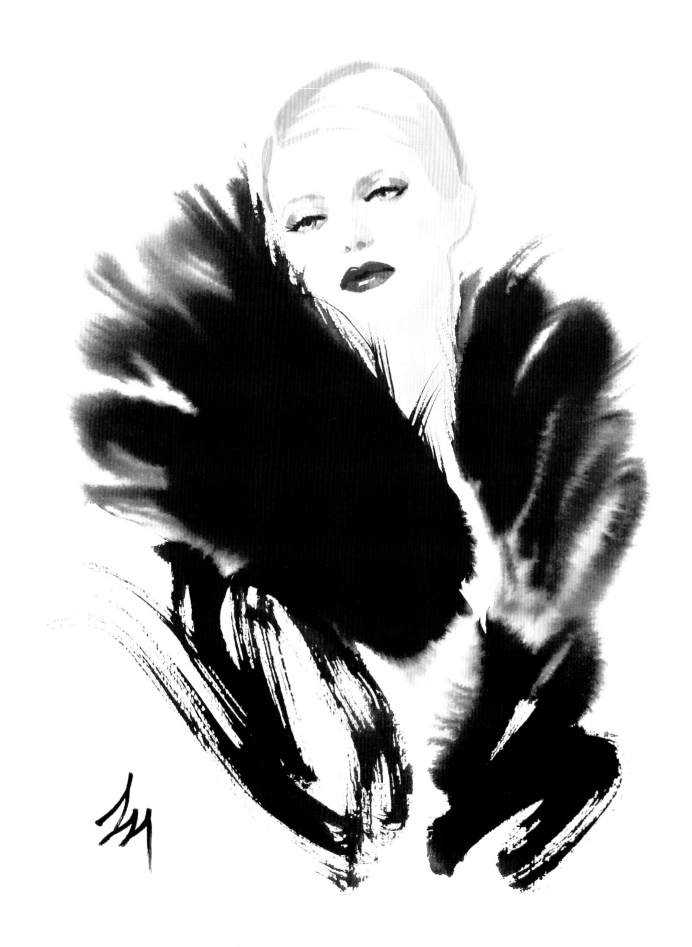

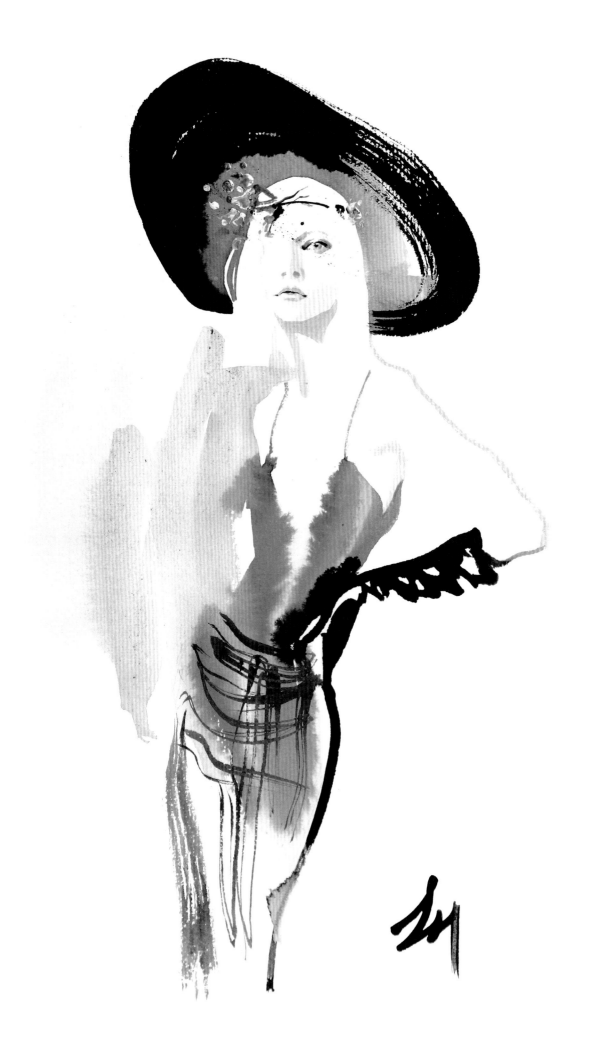

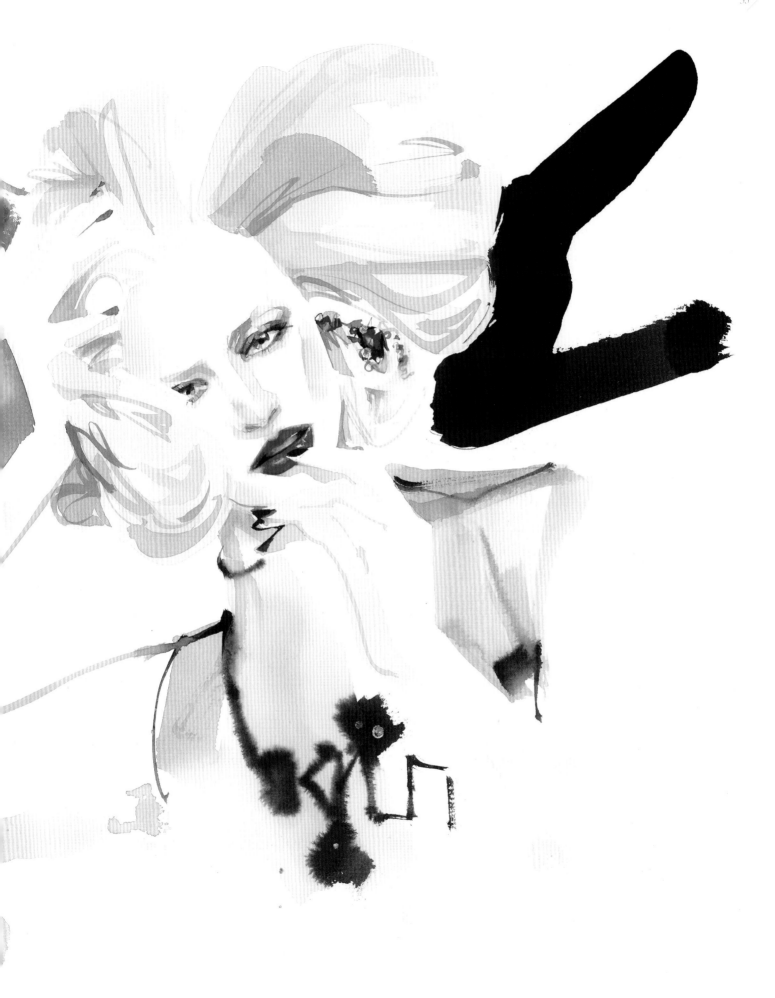

Think More
And Draw Faster

Before finishing a drawing, no one would know how much time you have spent on thinking twist and turn for the composition; after completing a drawing, it is not hard to tell by your strokes of how much time had been wasted. Therefore, I always remind myself, think more, and draw faster, even for practice, I keep this way.Understanding is for Practice, Practice is for Habit, Habit is for Control, Control is for Creation.

畫一張畫前，沒有人會知道你在構圖上輾轉了多少時間；畫一張畫後，卻不難由筆觸中看出你冤枉了多少時間。因此我常常會提醒自己，想久一些，畫快一點，就算只是在練習的時候也是一樣。明白為了練習，練習為了習慣，習慣為了掌握，掌握了才創作。

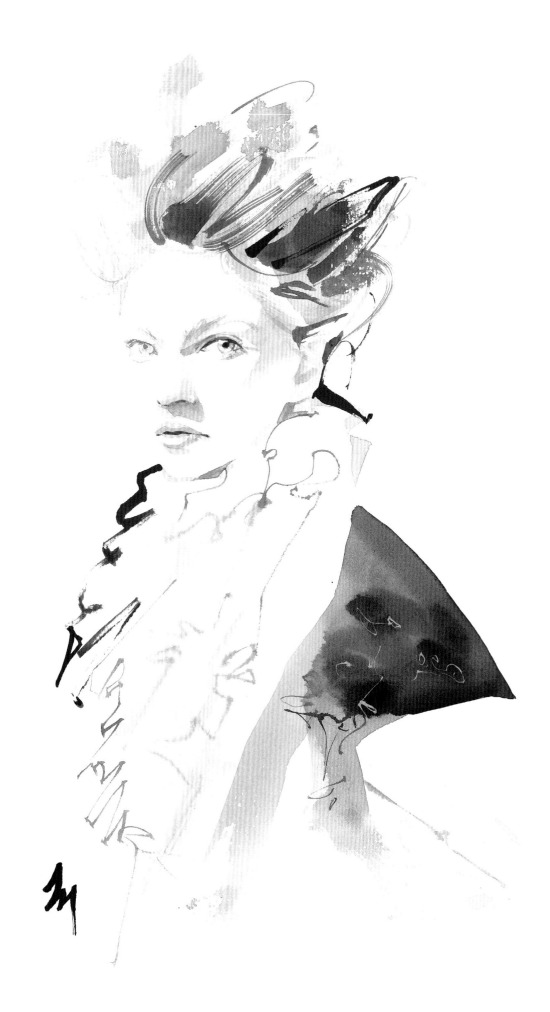

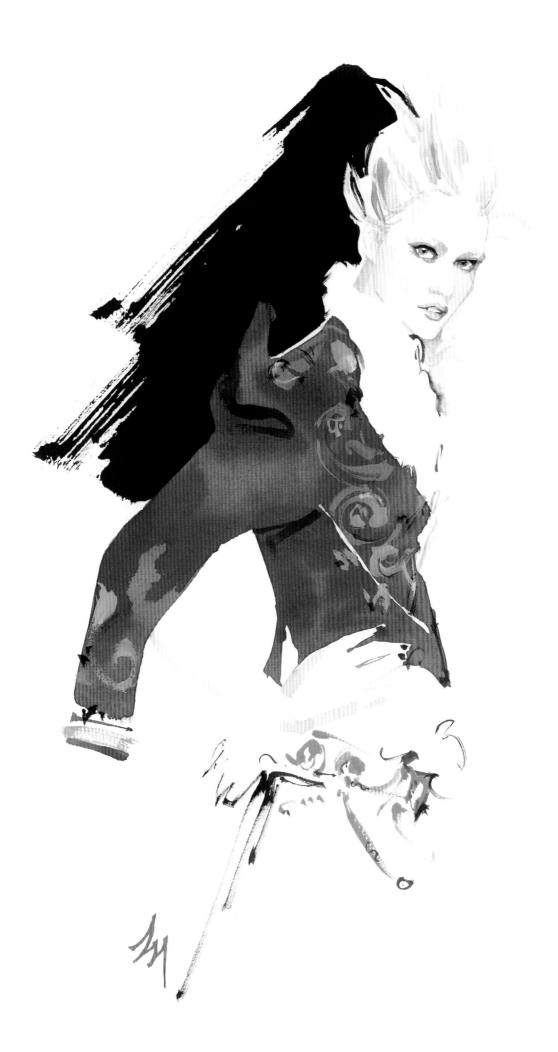

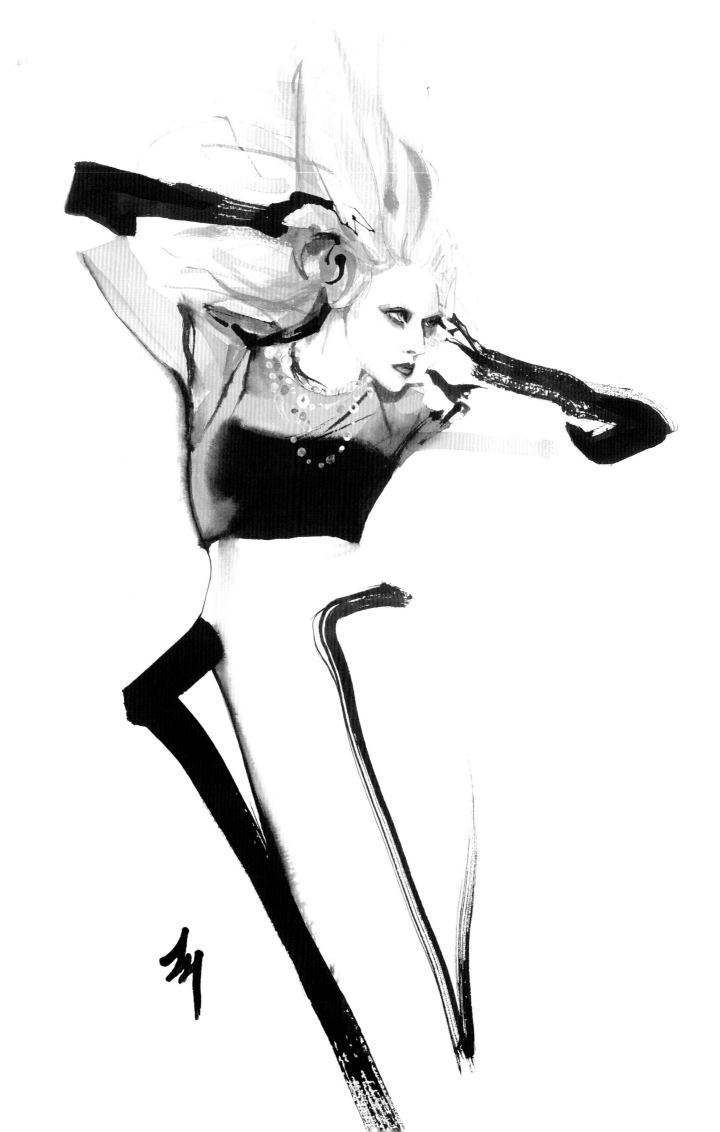

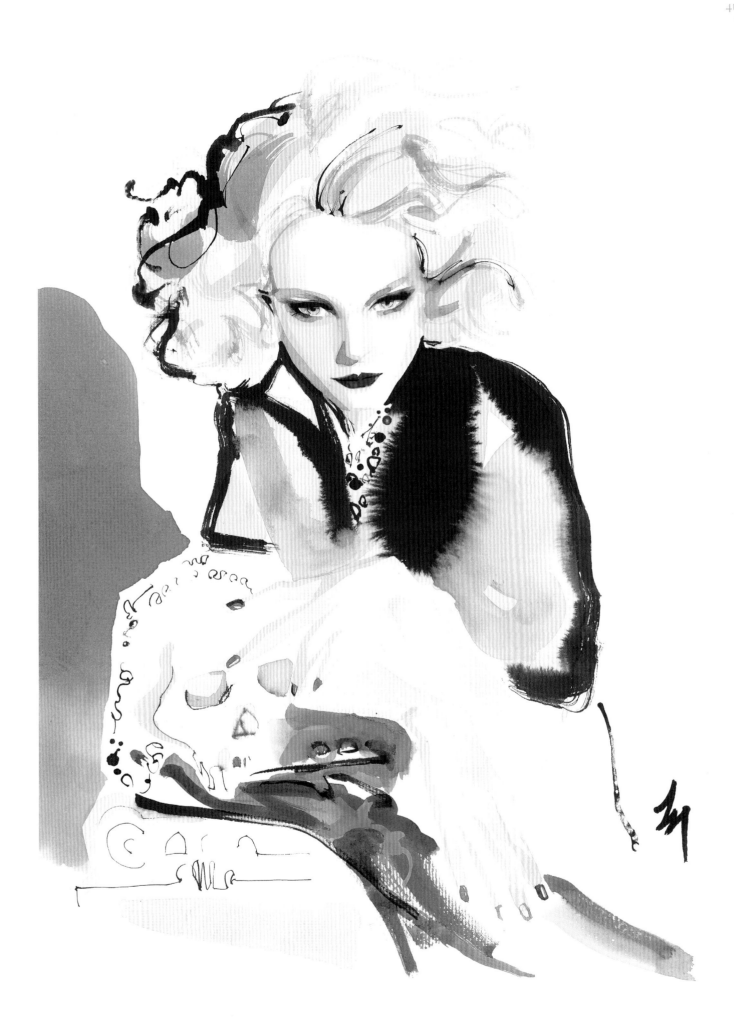

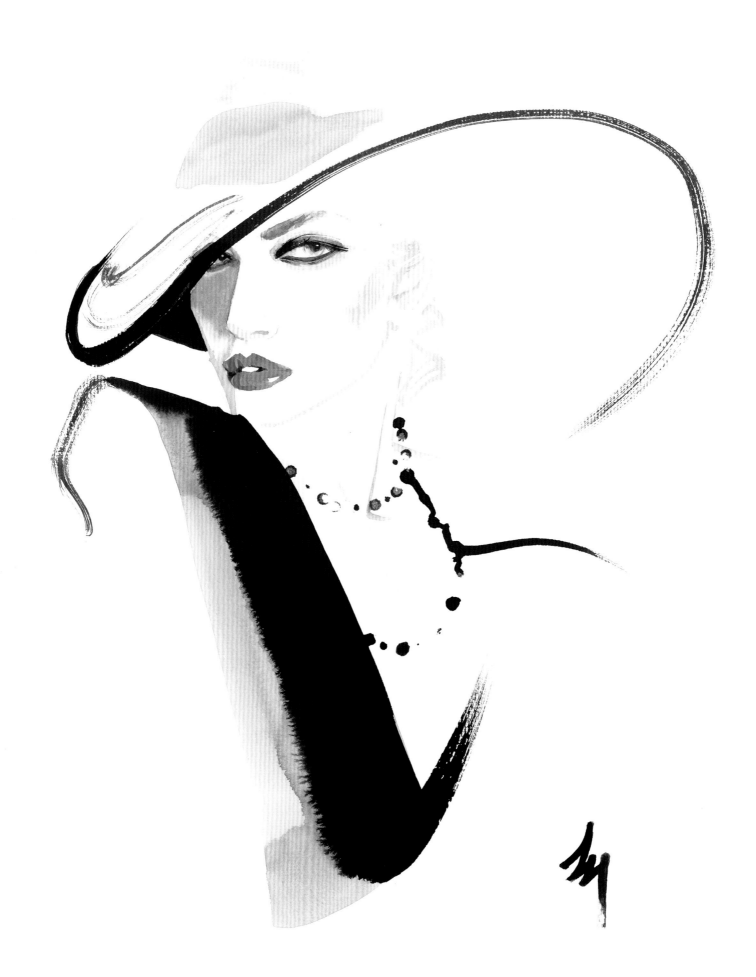

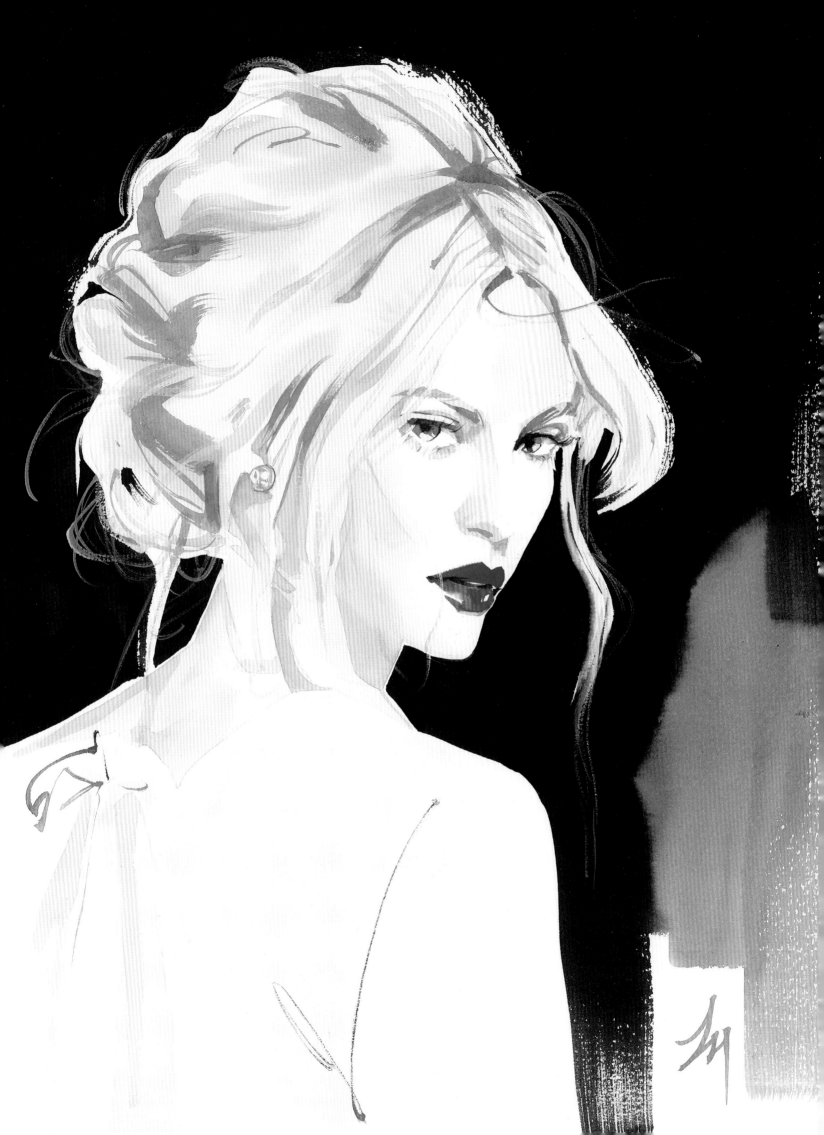

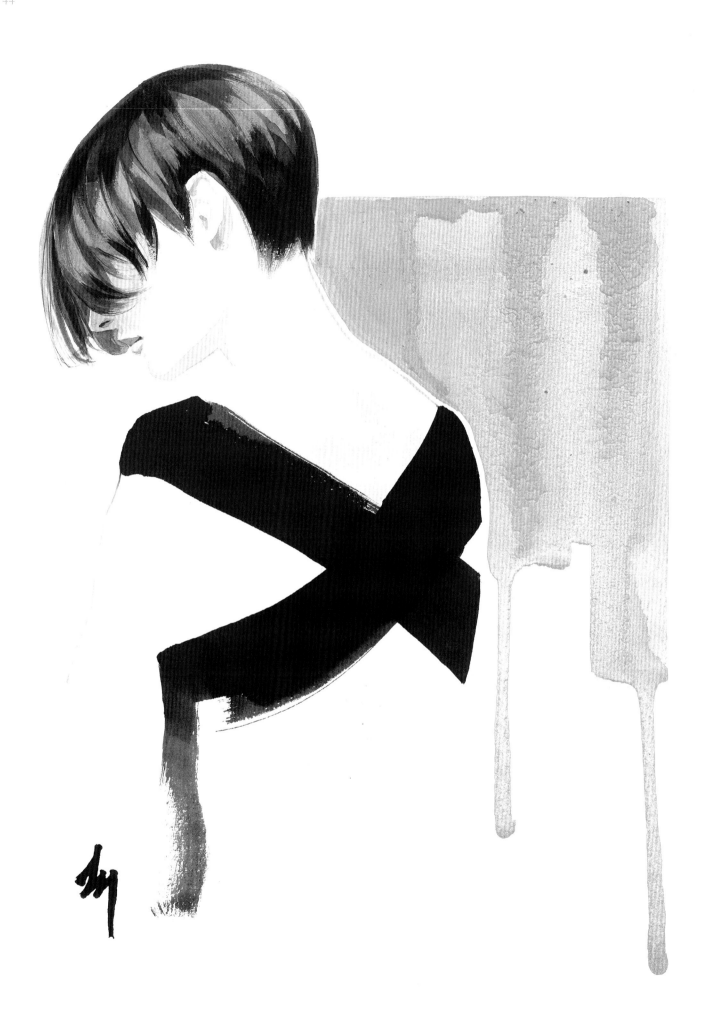

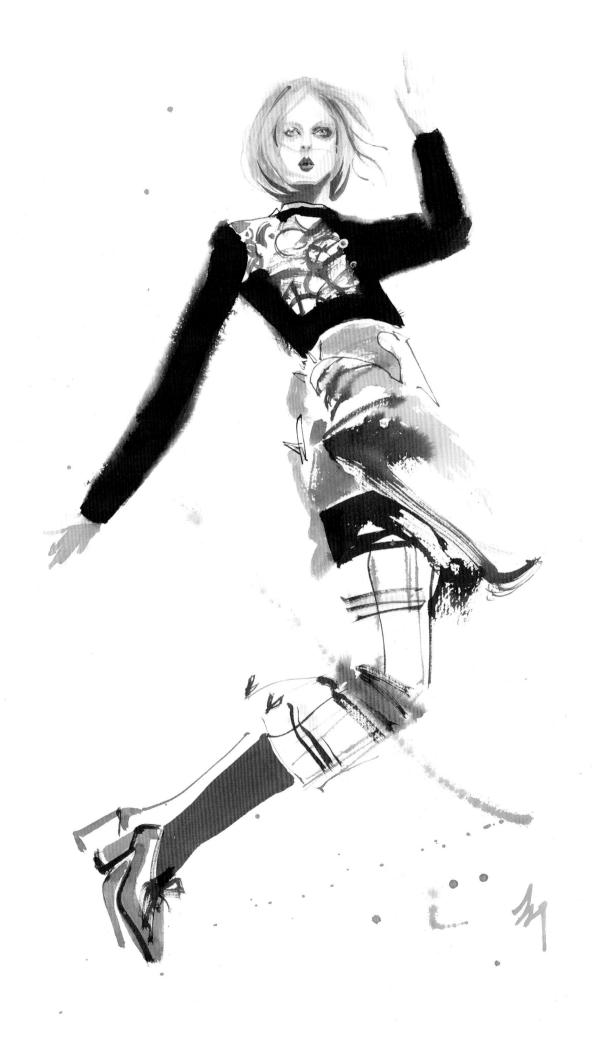

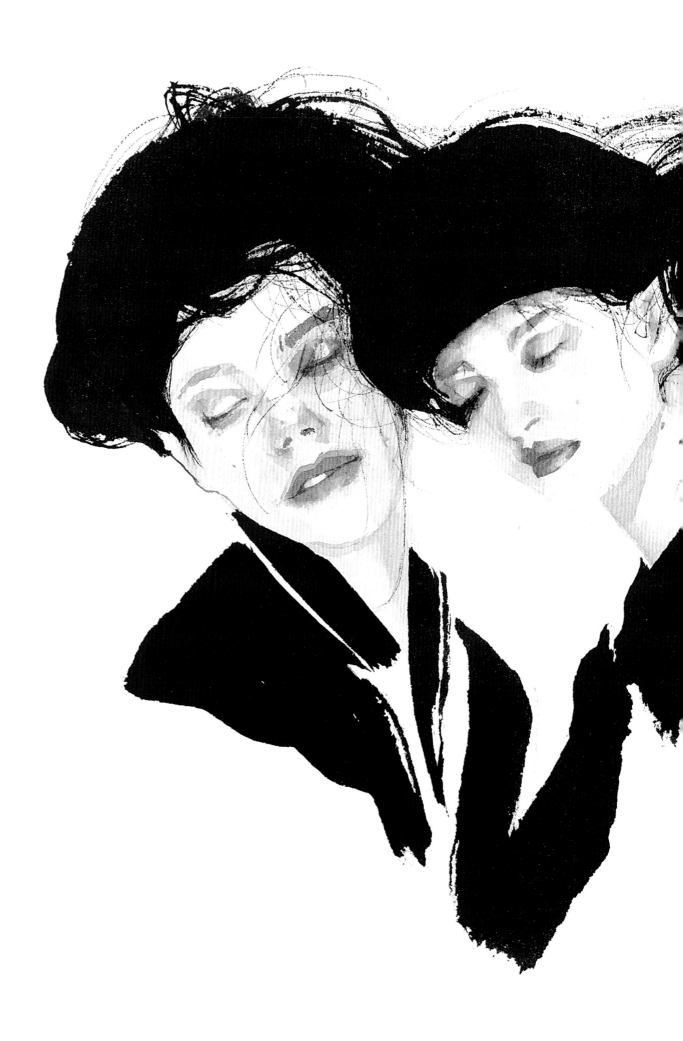

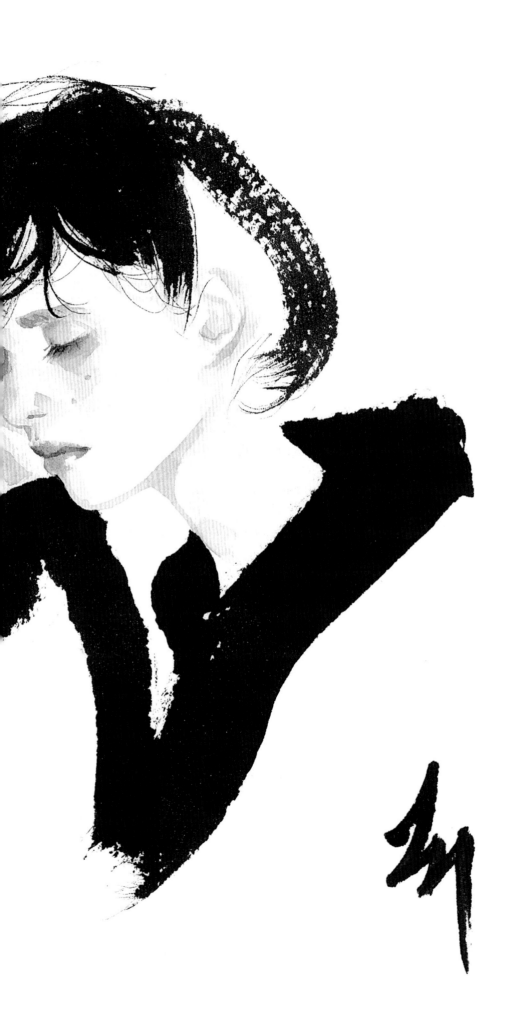

P.38 COURTLY
2018.05.08
Ink, Watercolour
Amatruda 300g
(300x420mm)

P.39 MAHARAJA'S JACKET-
ALEXANDER MCQUEEN
2015.06.05
Ink, Watercolour
Amatruda 300g
(300x420mm)

P.40 FRENZY
2018.10.08
Ink, Watercolour
Amatruda 300g
(300x420mm)

P.41 CHARM
2018.08.18
Ink, Watercolour
Amatruda 300g
(300x420mm)

P.42 PEEP
2017.08.14
Ink, Watercolour
Amatruda 300g
(300x420mm)

P.43 BROADWAY
2017.05.16
Ink, Watercolour
Amatruda 300g
(300x420mm)

P.44 ANXIETY
2018.08.16
Ink, Watercolour
Amatruda 300g
(300x420mm)

P.45 CAPER
2018.07.05
Ink, Watercolour
Amatruda 300g
(300x420mm)

P.46 SYMBIOTIC
2018.01.13
Ink, Watercolour
Vergé ARCHES 300g
(210x300mm)

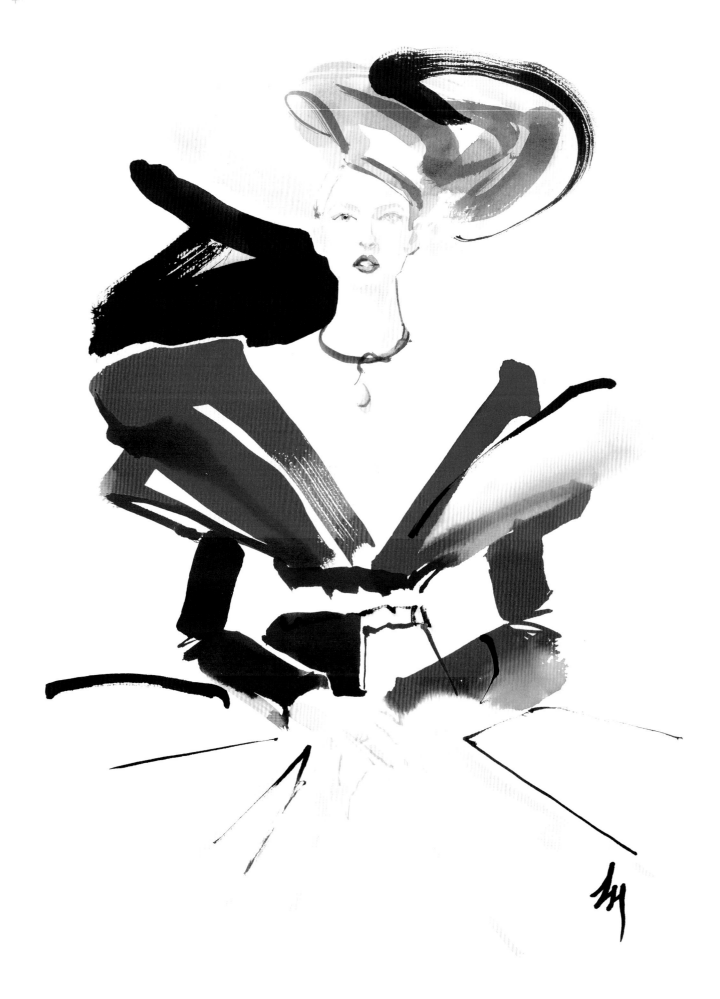

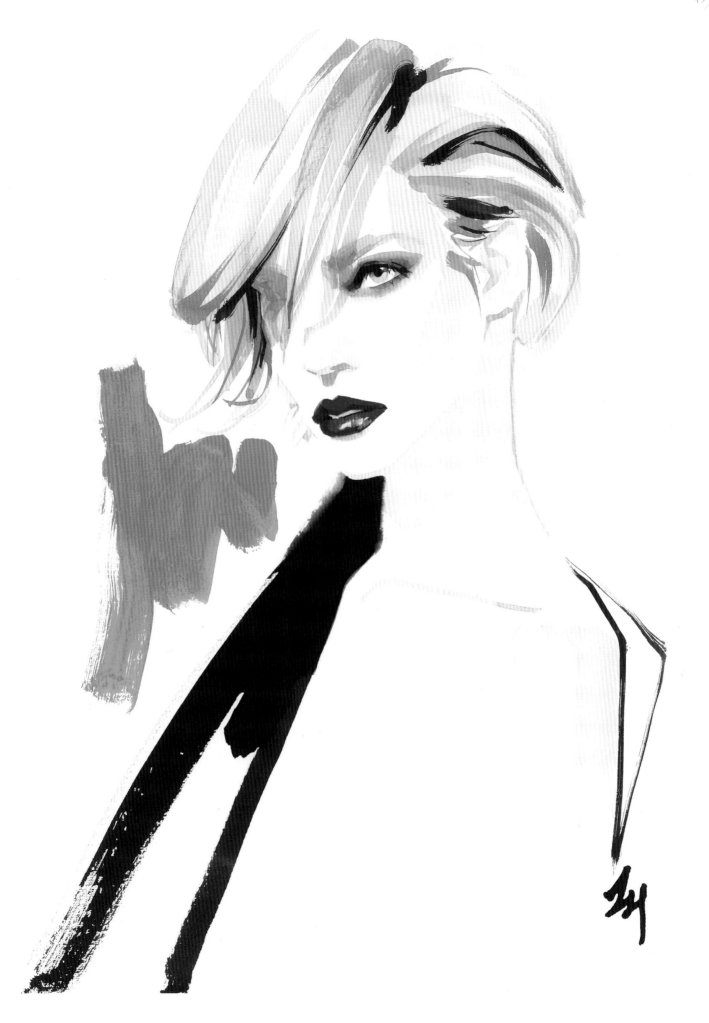

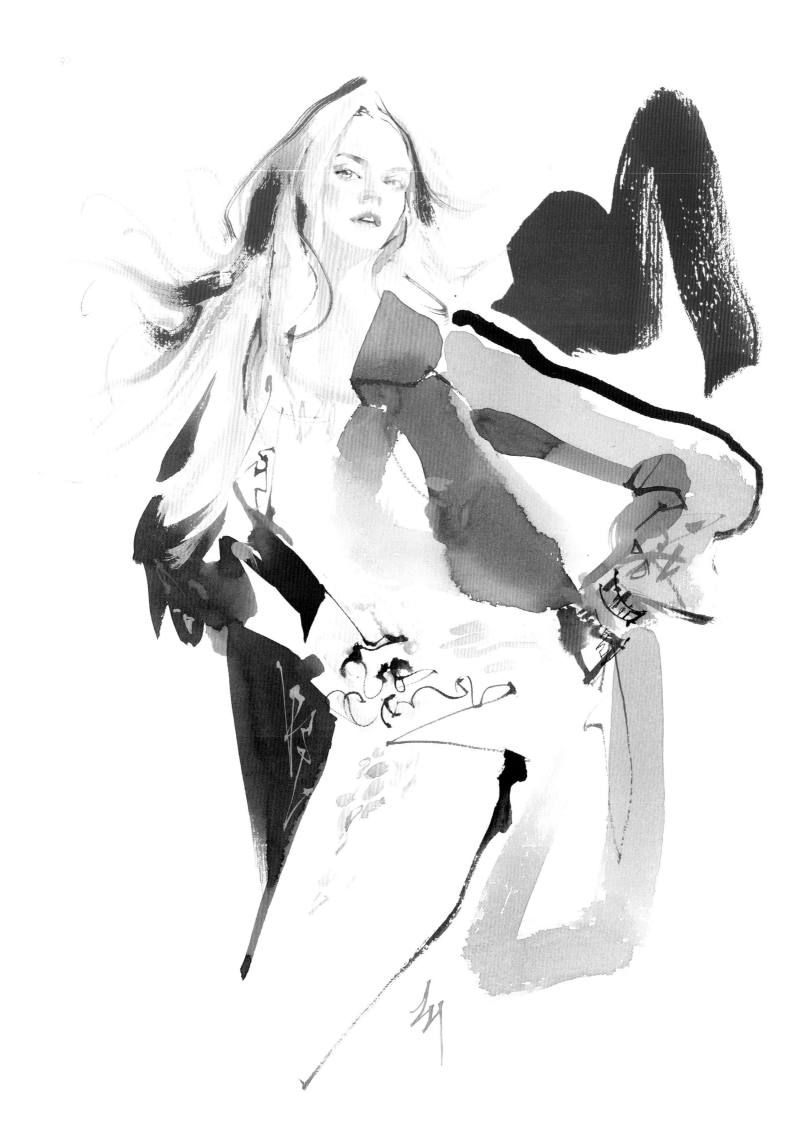

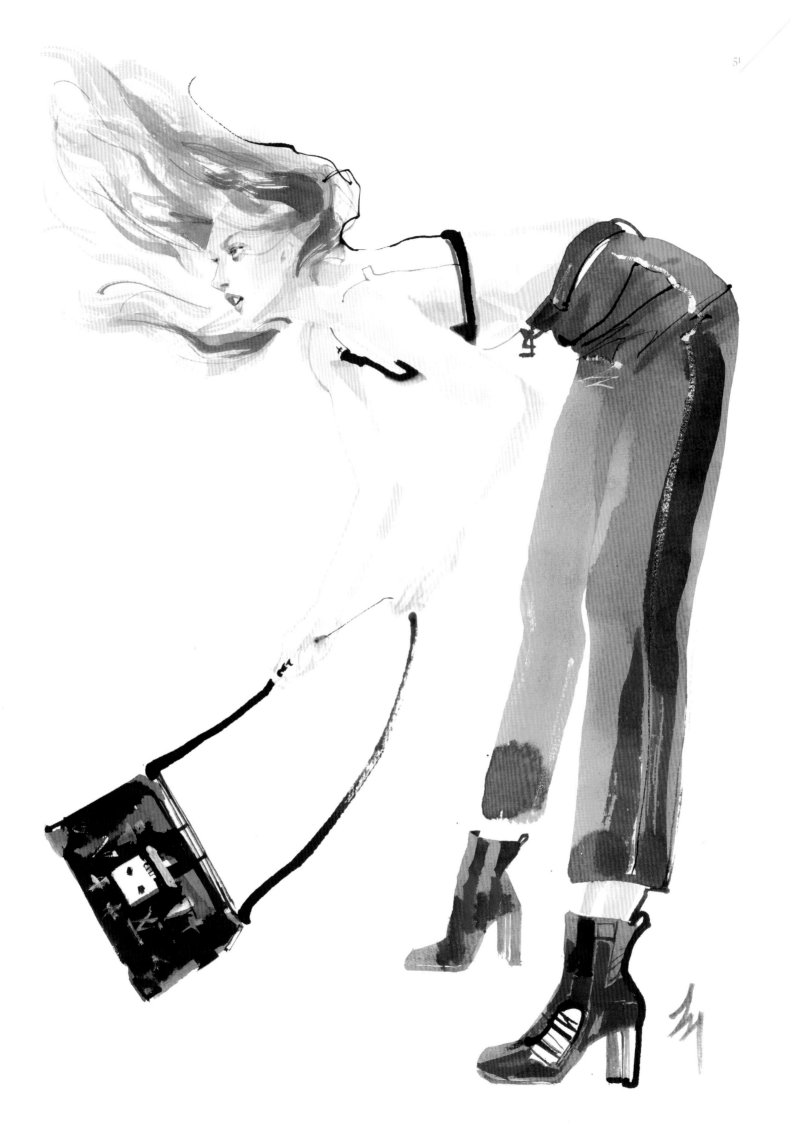

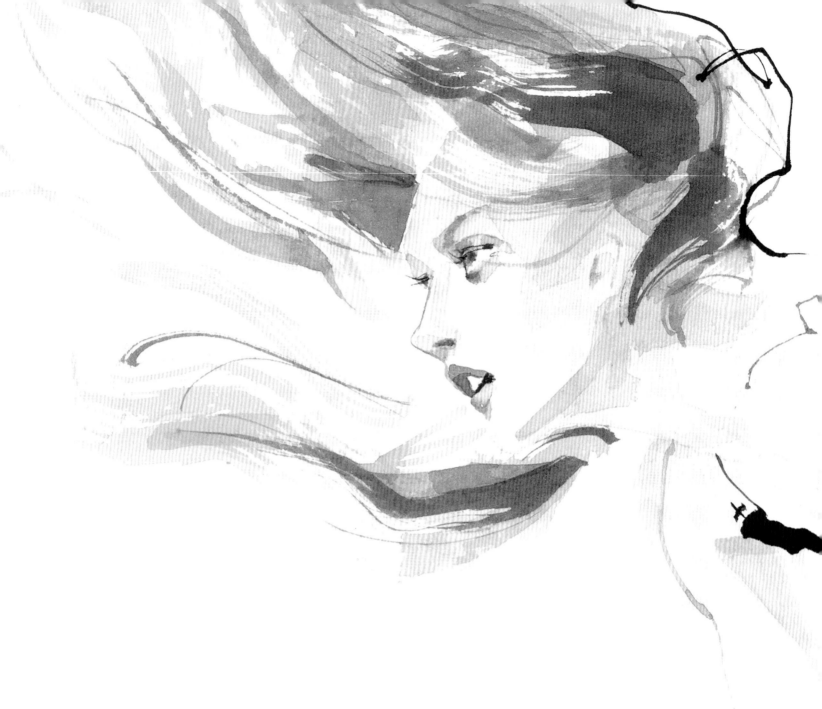

Conquered My Fear By Curiosity

When I was a student, I always conquered my fear of drawing watercolor by curiosity. My source of fear is "white paper" and "only one chance of drawing right". Along the way, every drawing has become an adventure, fear has been replaced by excitement and expecting. I have adjusted my attitude towards drawing to be as usual as having a meal, not having it as a last supper. "The failure is the best teacher of success" has always been my motto. Frankly, what I have learned from thousands of practice is much more than what teacher had taught me in school.

在學生時期畫水彩，常常會用好奇心來戰勝自己的恐懼，「白紙」和「只有一次機會的下筆」就是恐懼來源。一路過來，現在每次的創作都已行同一場探險，沒有了懼怕，取而代之的是興奮與期待。將自己畫畫時的心態調整成跟吃飯一樣習以為常，不是當作最後一餐去創作。「失敗乃成功之母」是從以前到現在給自己的座右銘，老實說，我從自己成千上萬次的練習中所學習到的，比學校老師教給我的還要多更多。

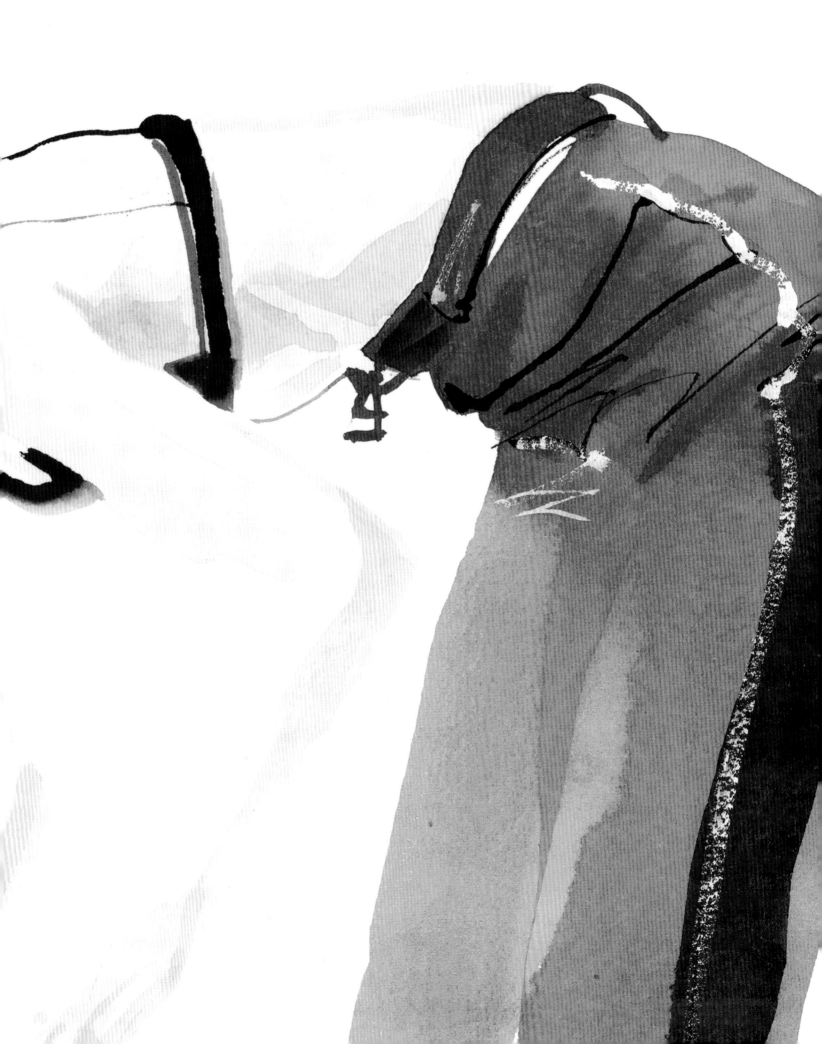

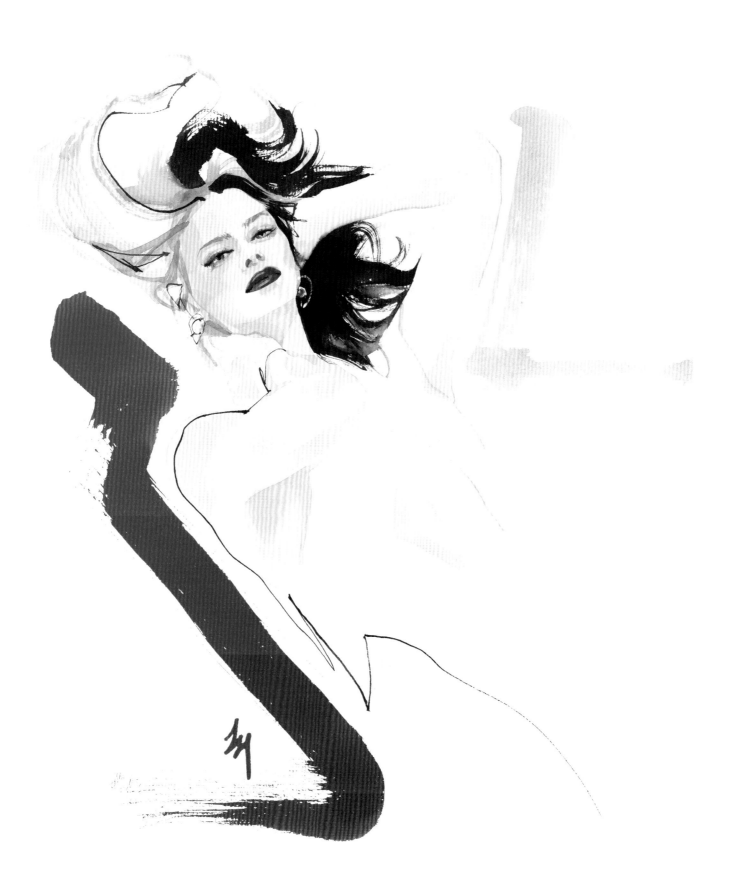

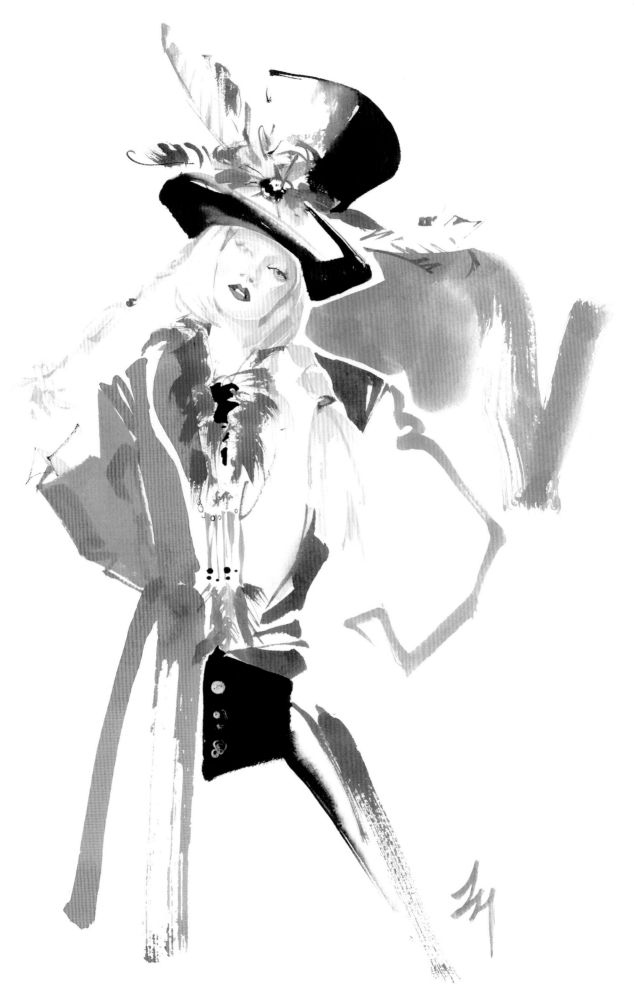

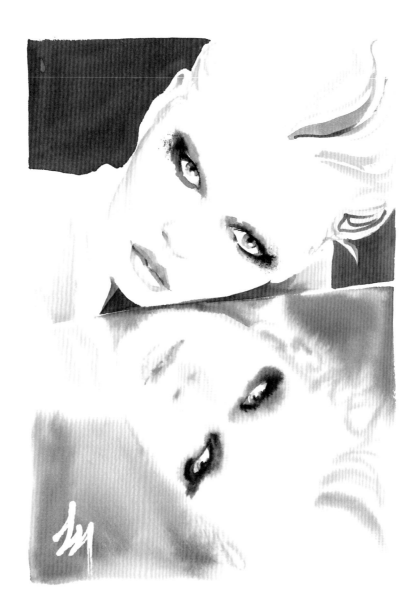

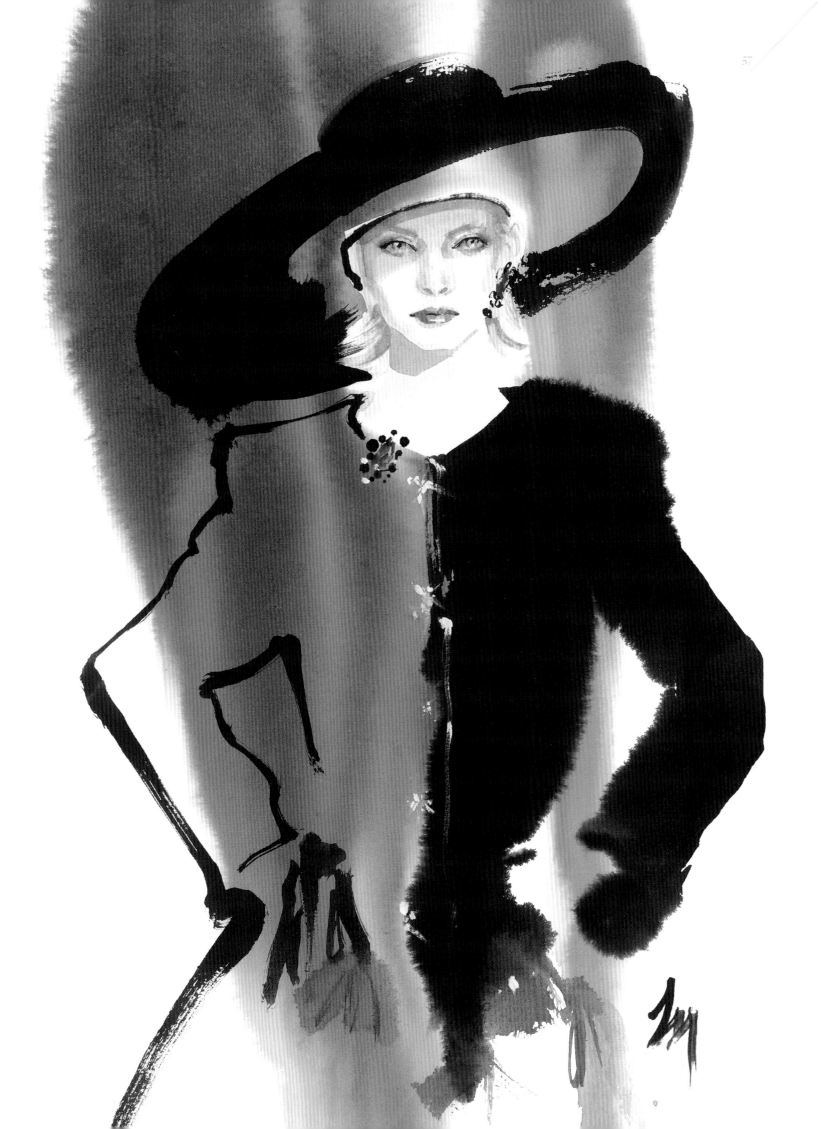

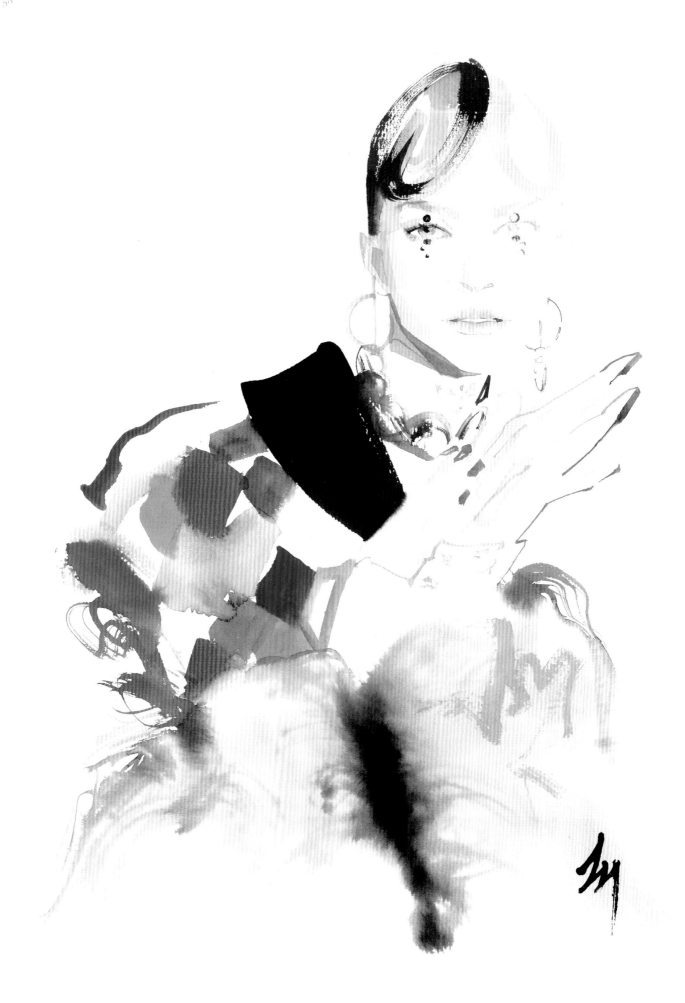

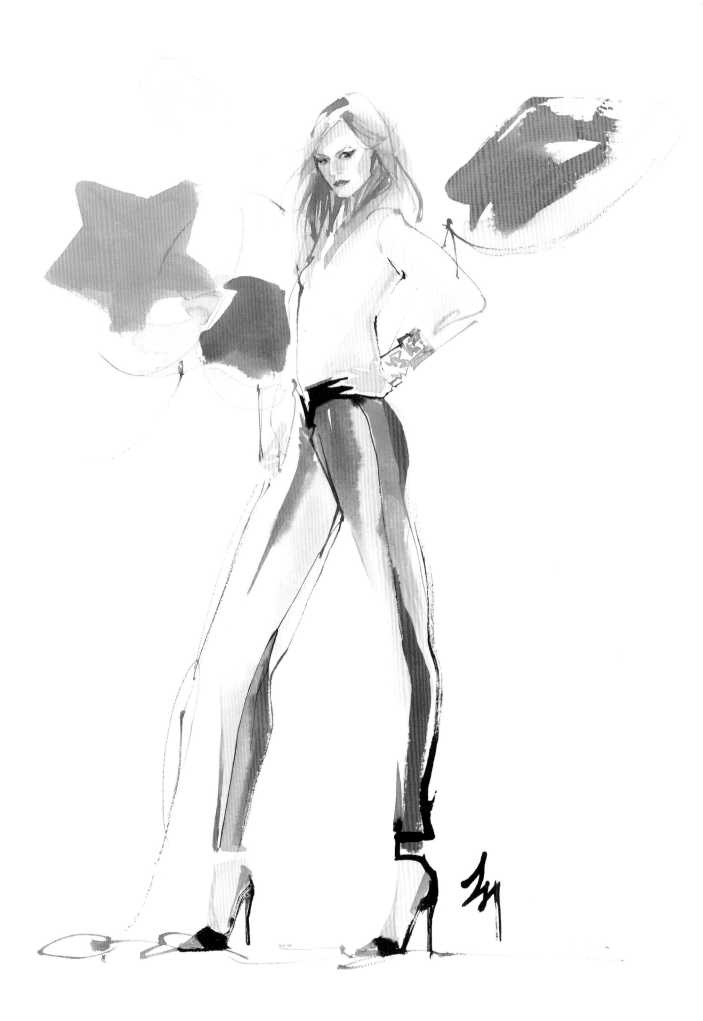

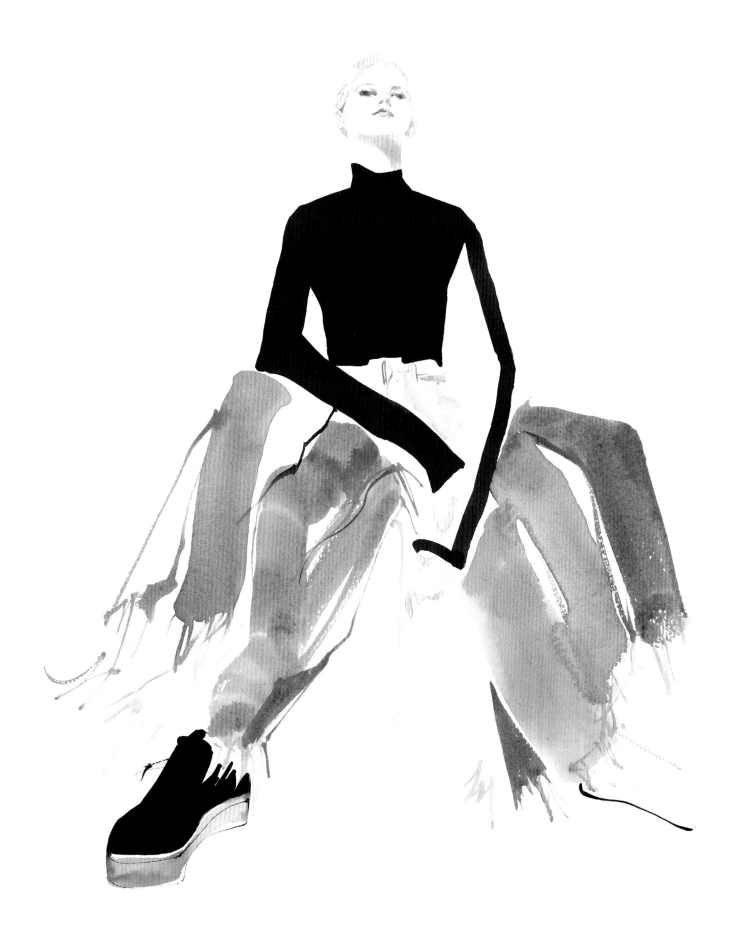

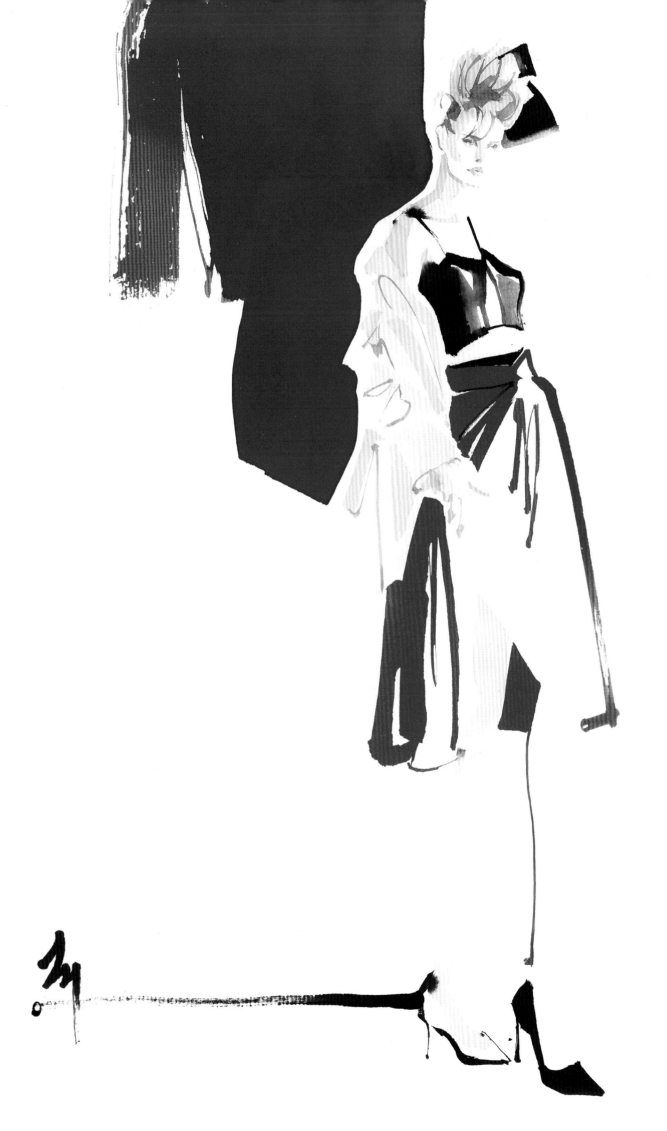

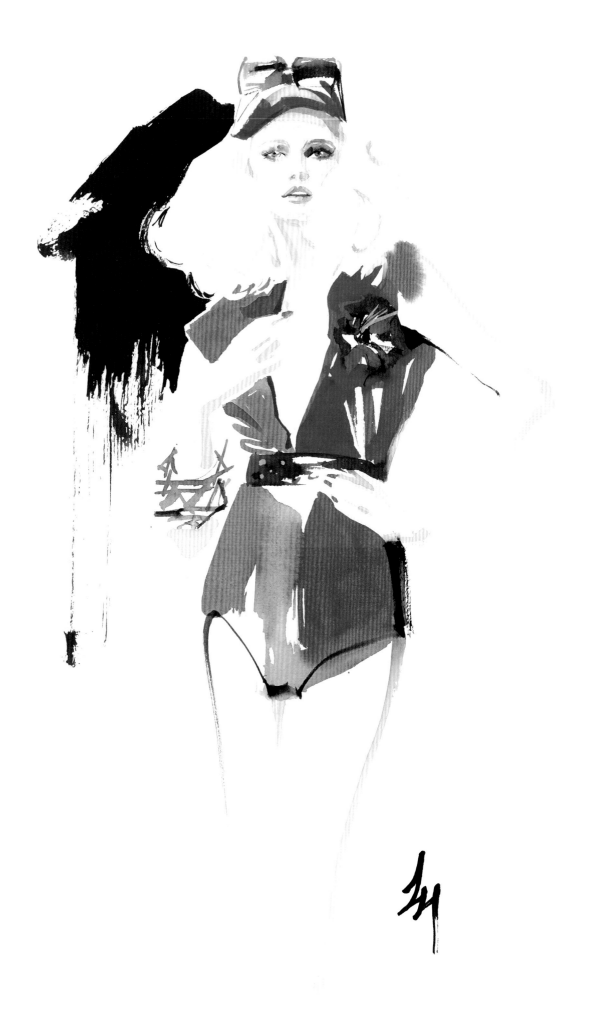

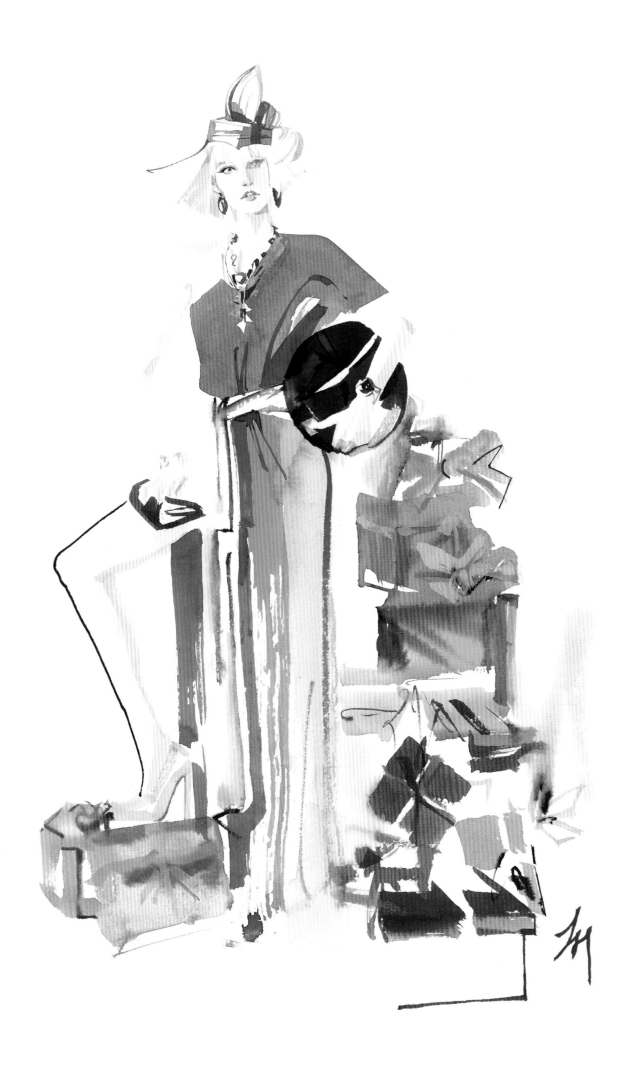

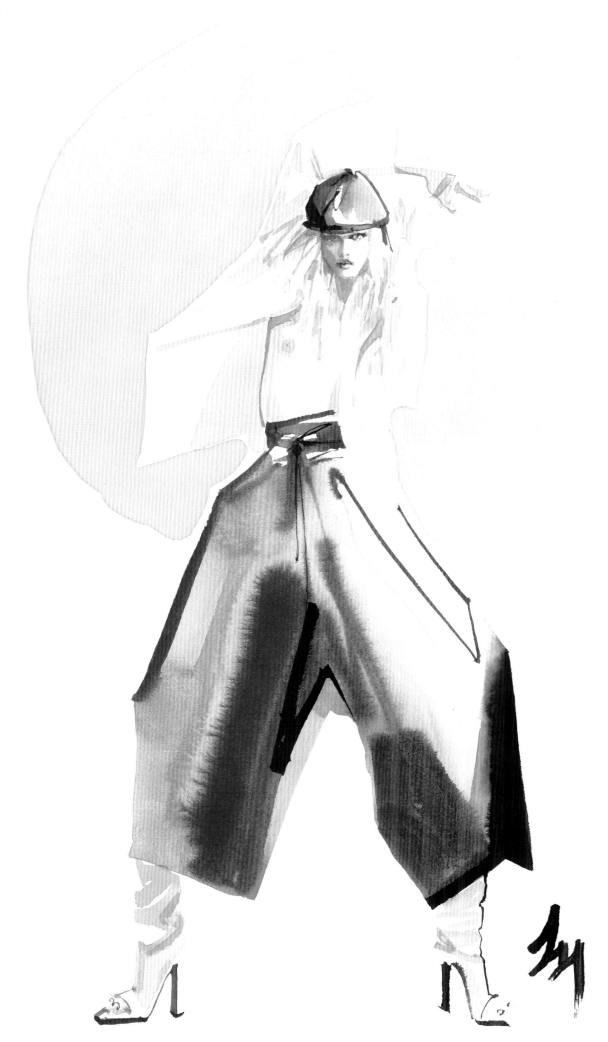

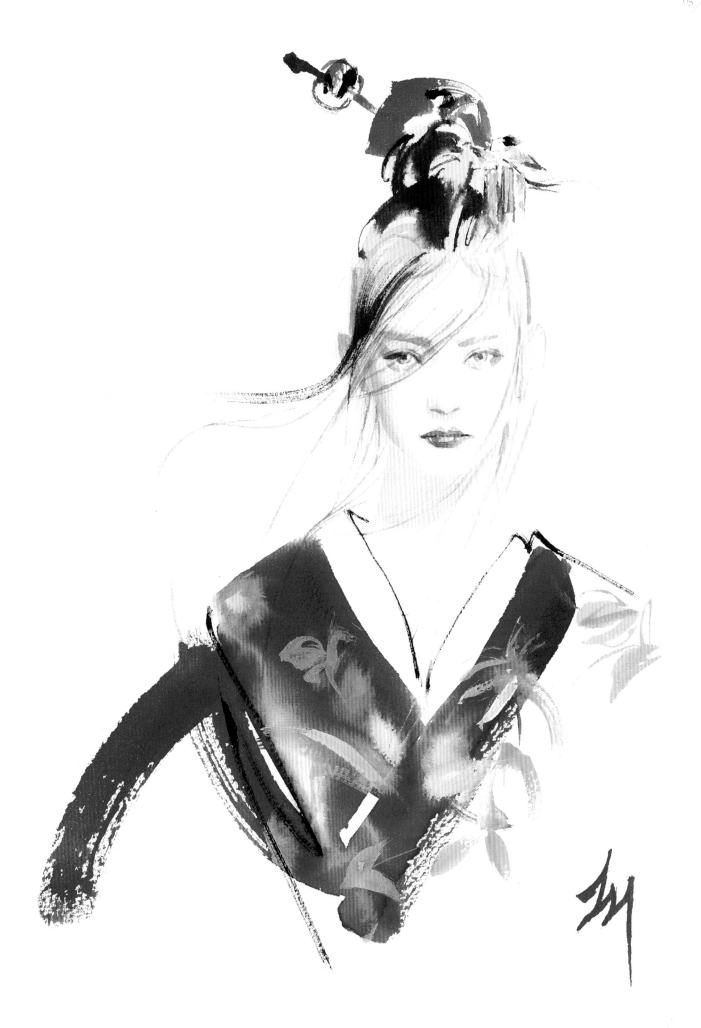

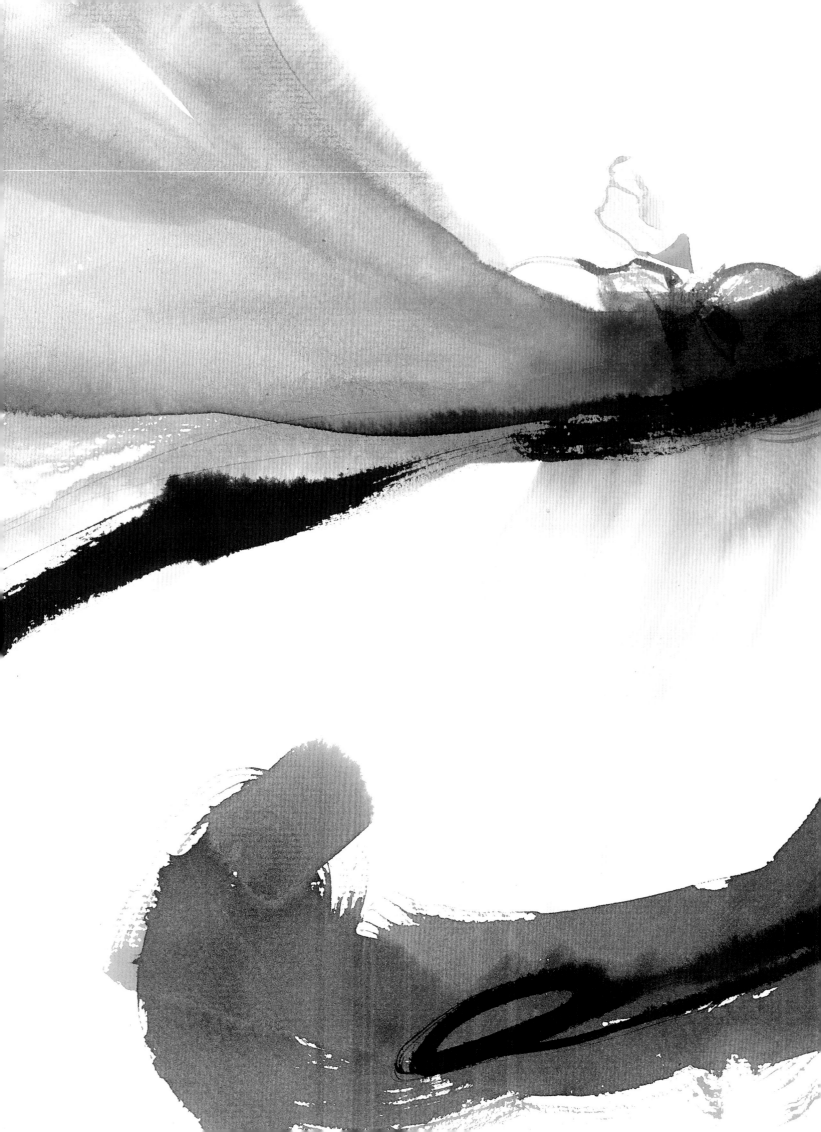

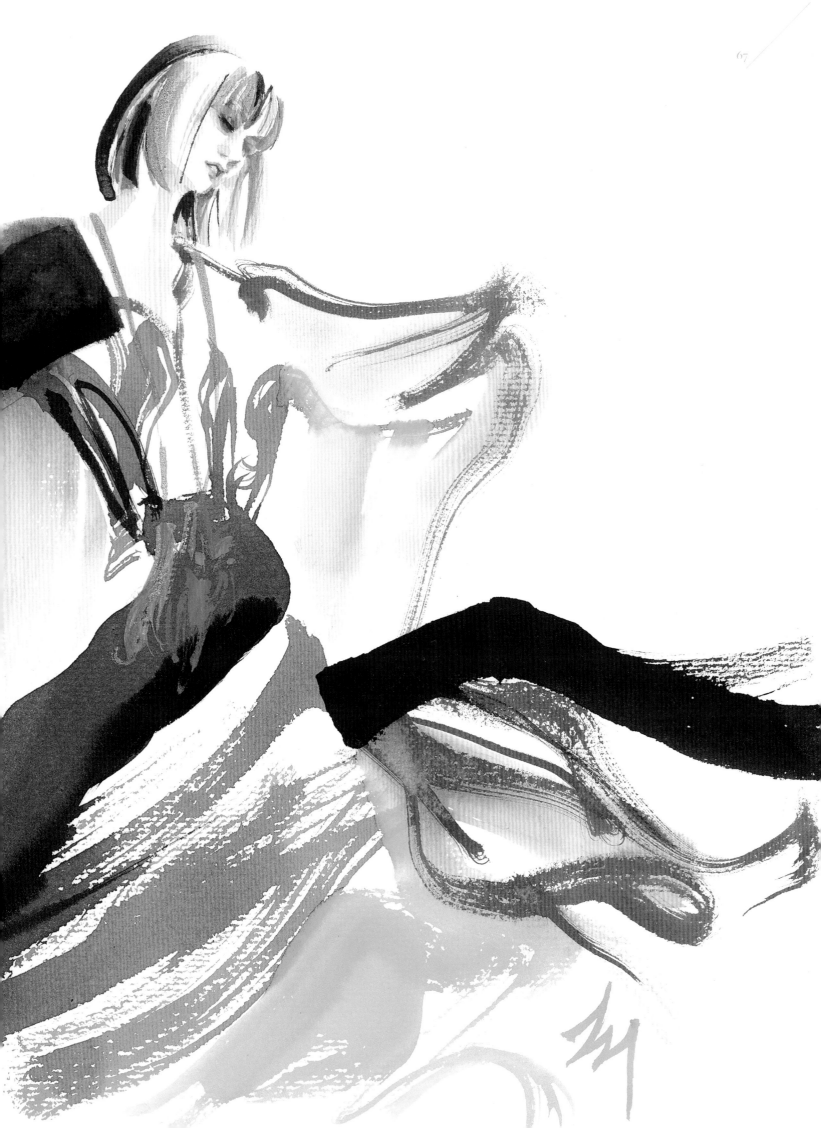

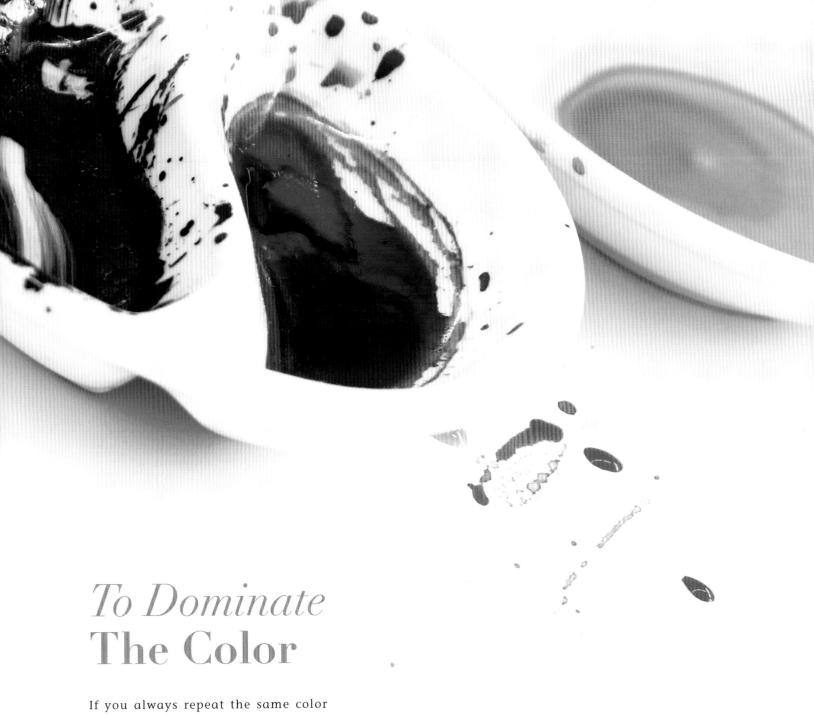

To Dominate
The Color

If you always repeat the same color blending, you will always have the illusion of painting the same painting, which will only make the acumen of color gradually dull, not creating your style. First imagine a multi-colored design, cleanse the paint on your palette, squeeze red, yellow, and blue to start again. Be brave to try different colors. To dominate the color, rather than being dominated by the color.

如果總是在重複一樣的色彩調配，就會有老是在畫同一張畫的錯覺，這樣只會使色彩敏銳度漸漸死去，而並非風格的朔造。先構想一套多彩多姿的設計，將你調色盤上的顏料洗乾淨，擠出紅、黃、藍重新出發，然後勇於嘗試、研究調色，要去支配色彩，不是被色彩支配。

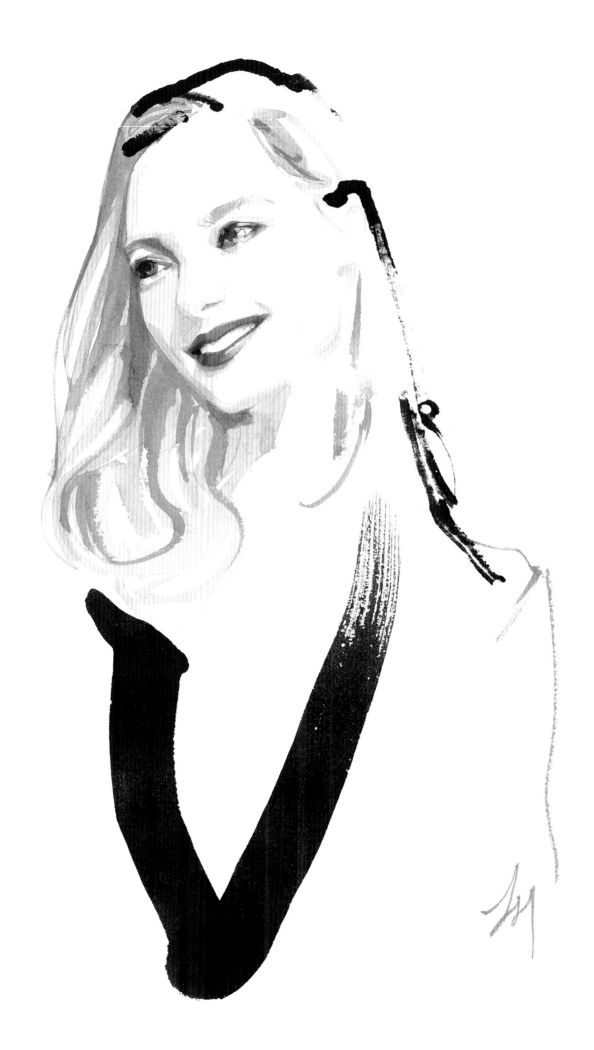

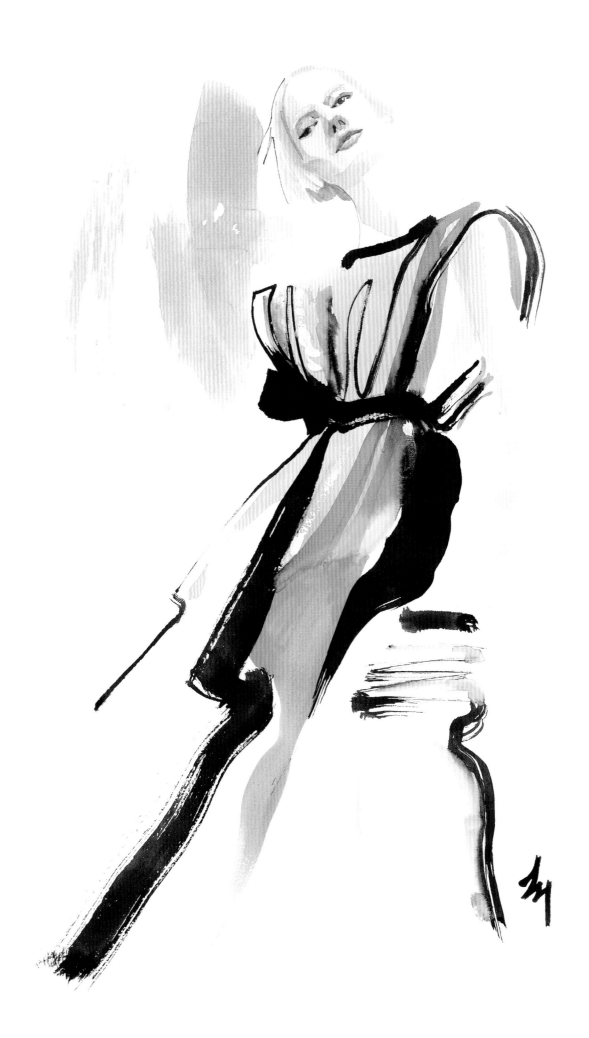

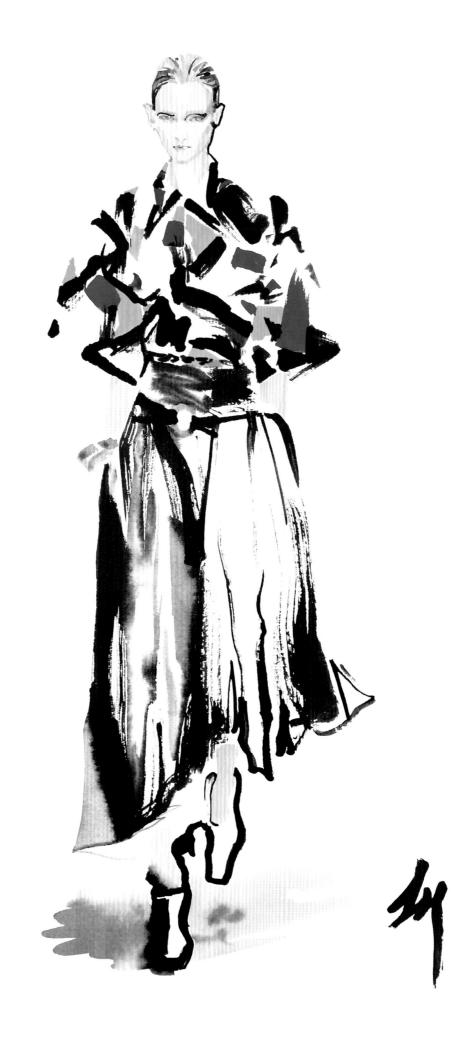

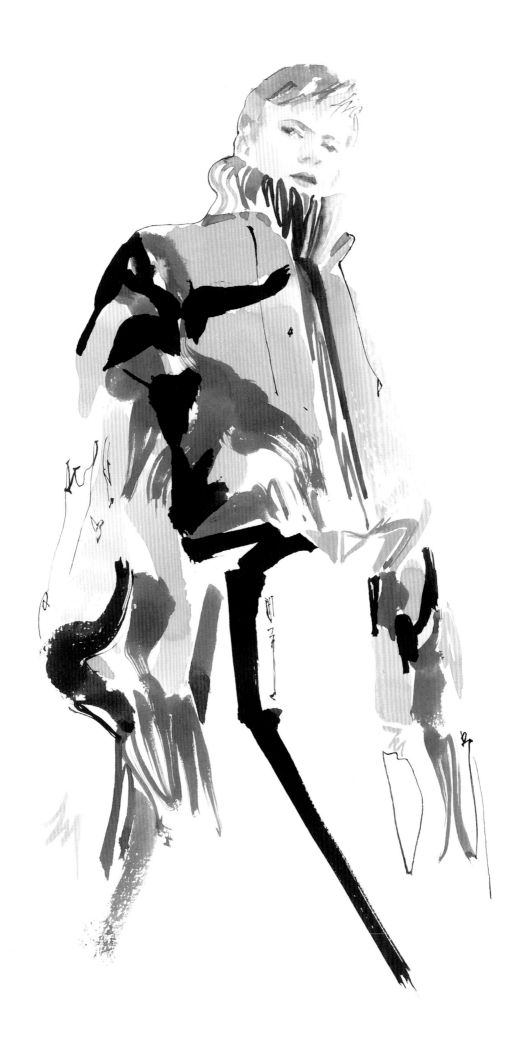

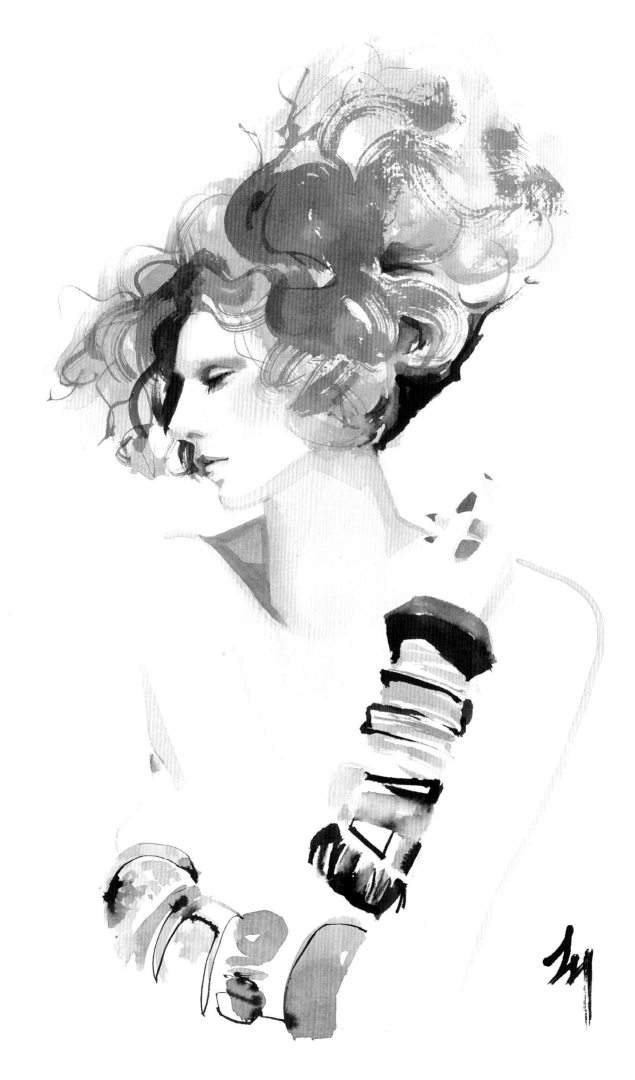

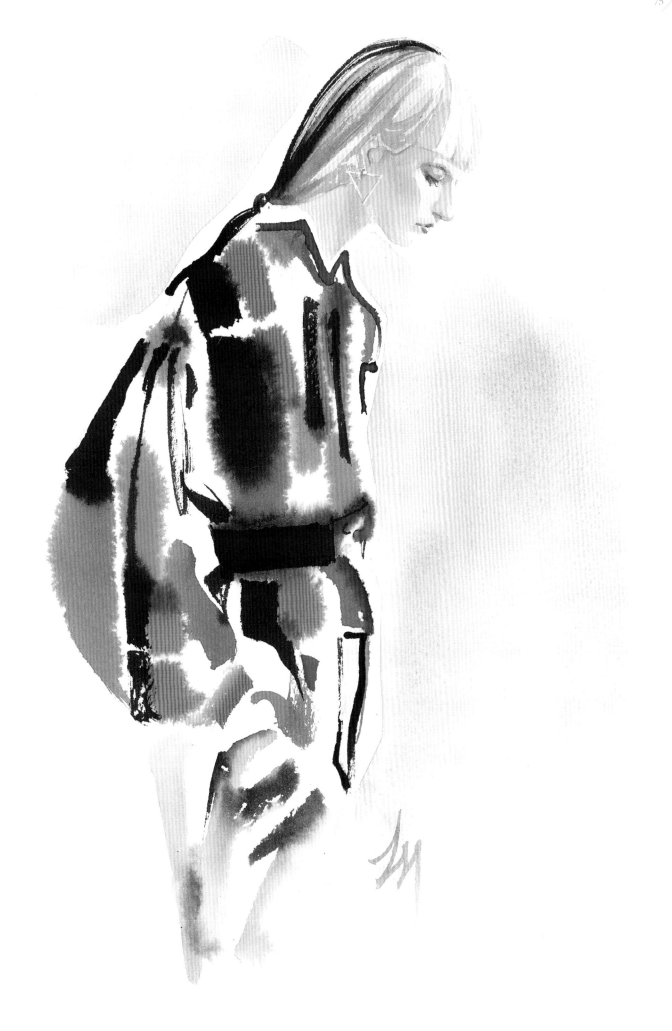

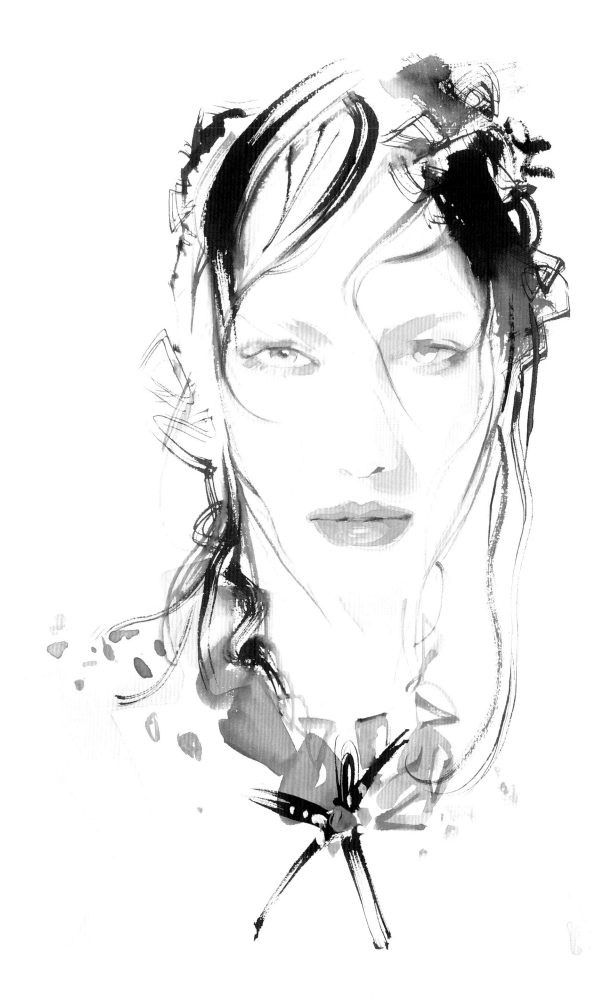

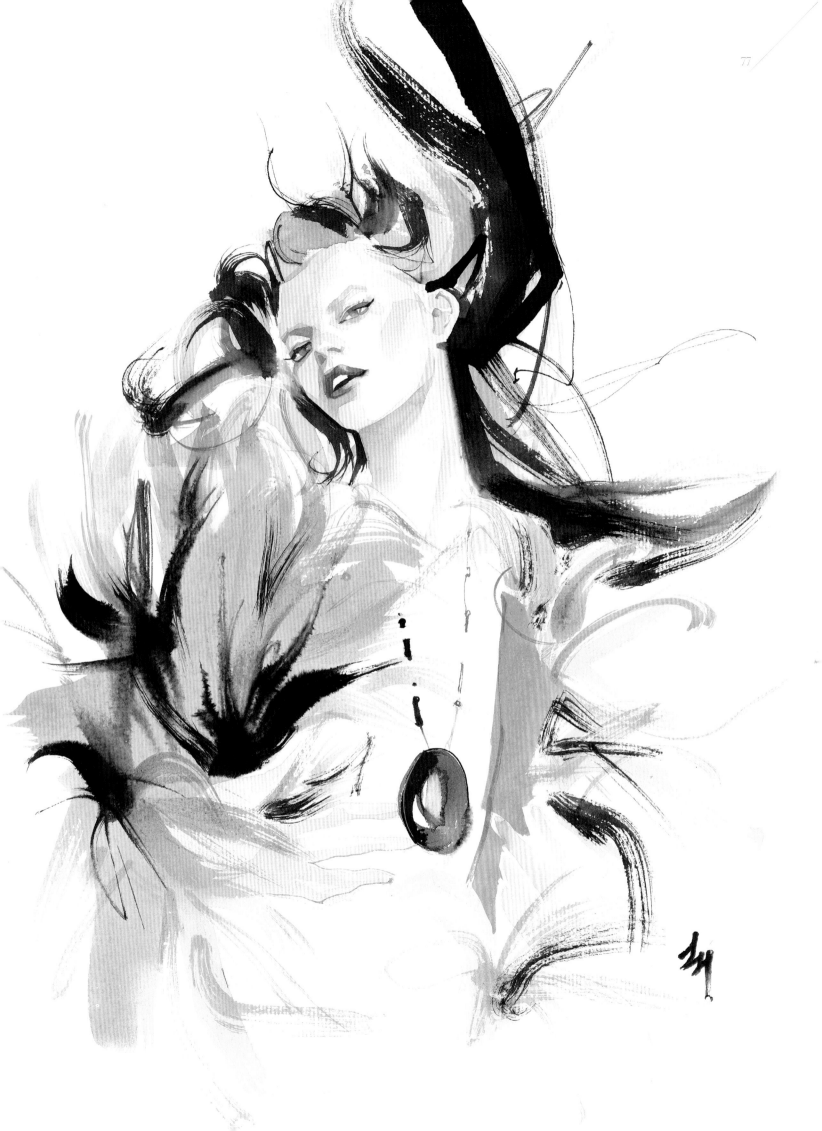

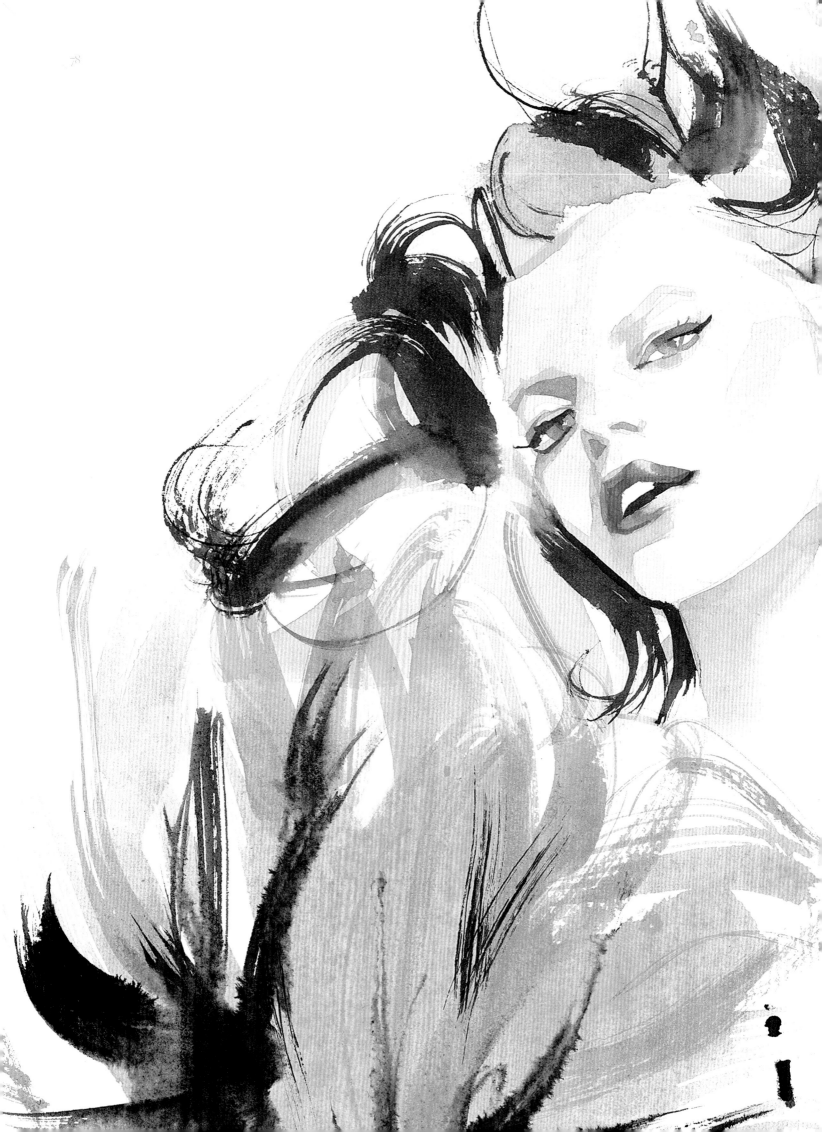

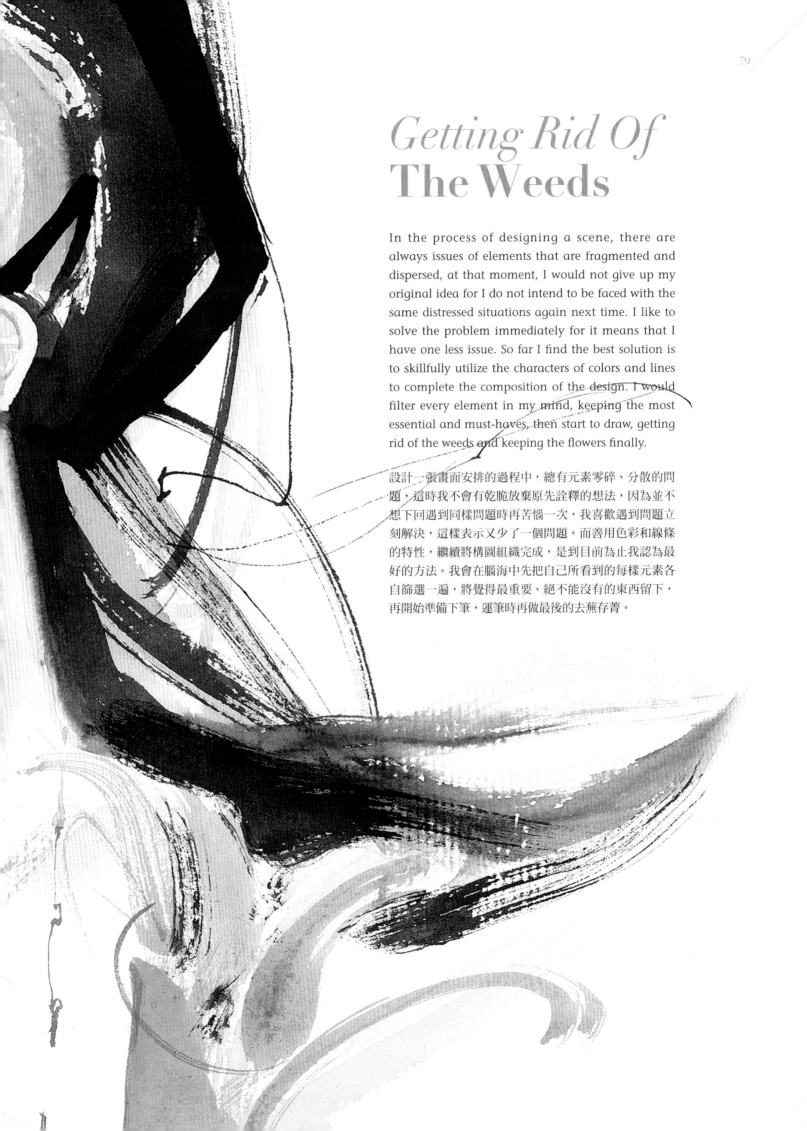

Getting Rid Of The Weeds

In the process of designing a scene, there are always issues of elements that are fragmented and dispersed, at that moment, I would not give up my original idea for I do not intend to be faced with the same distressed situations again next time. I like to solve the problem immediately for it means that I have one less issue. So far I find the best solution is to skillfully utilize the characters of colors and lines to complete the composition of the design. I would filter every element in my mind, keeping the most essential and must-haves, then start to draw, getting rid of the weeds and keeping the flowers finally.

設計一張畫面安排的過程中，總有元素零碎、分散的問題，這時我不會有乾脆放棄原先詮釋的想法，因為並不想下回遇到同樣問題時再苦惱一次，我喜歡遇到問題立刻解決，這樣表示又少了一個問題。而善用色彩和線條的特性，繼續將構圖組織完成，是到目前為止我認為最好的方法。我會在腦海中先把自己所看到的每樣元素各自篩選一遍，將覺得最重要、絕不能沒有的東西留下，再開始準備下筆，運筆時再做最後的去蕪存菁。

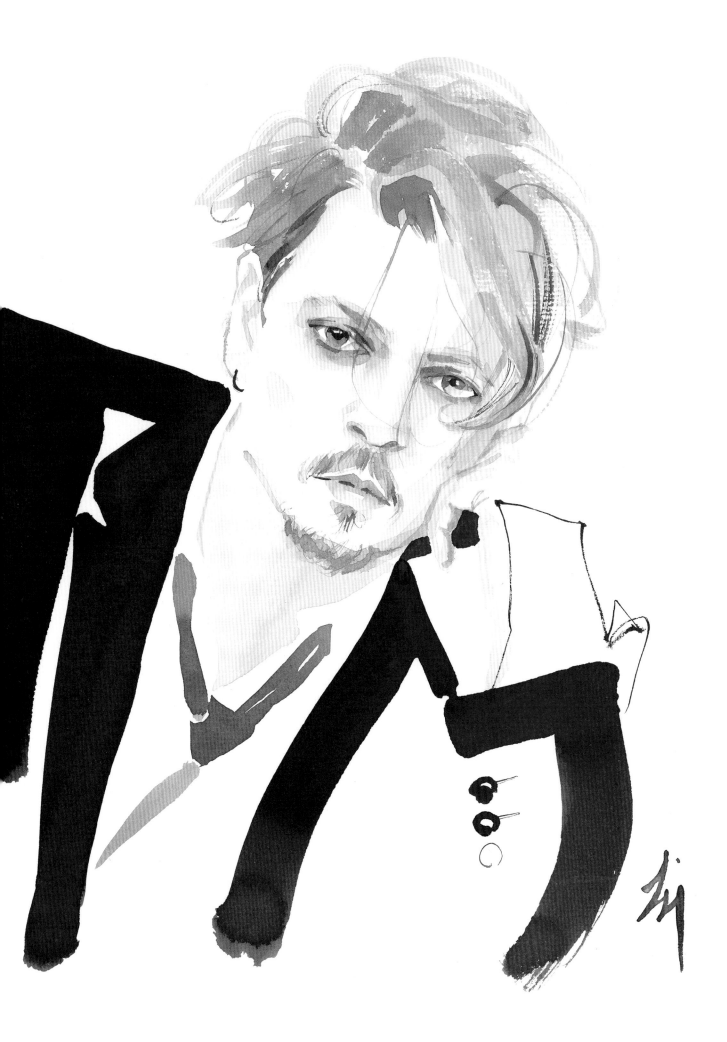

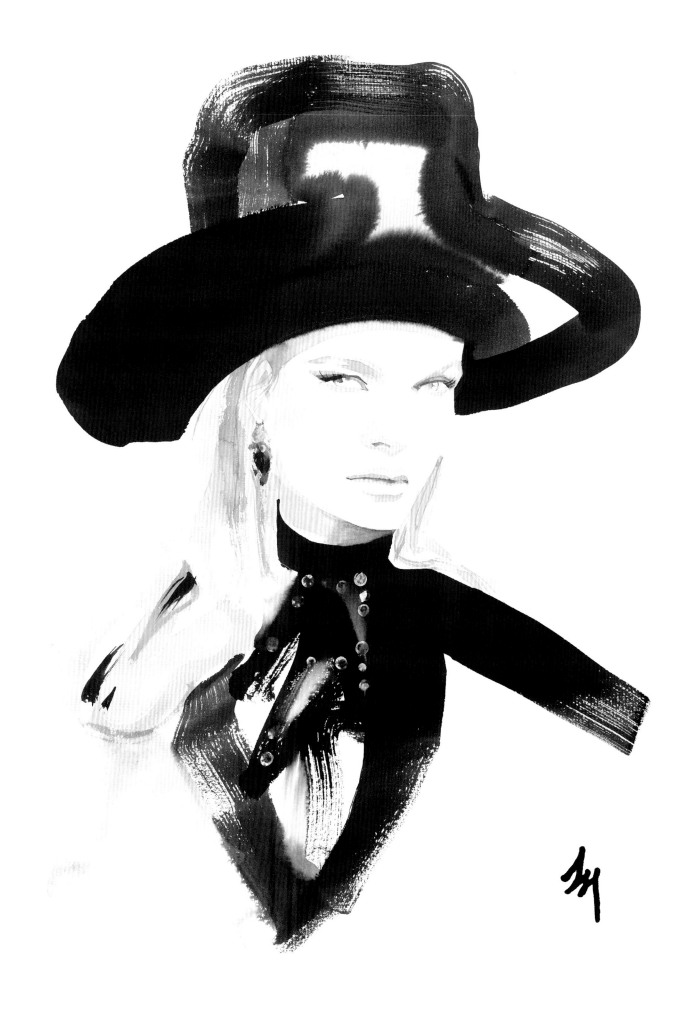

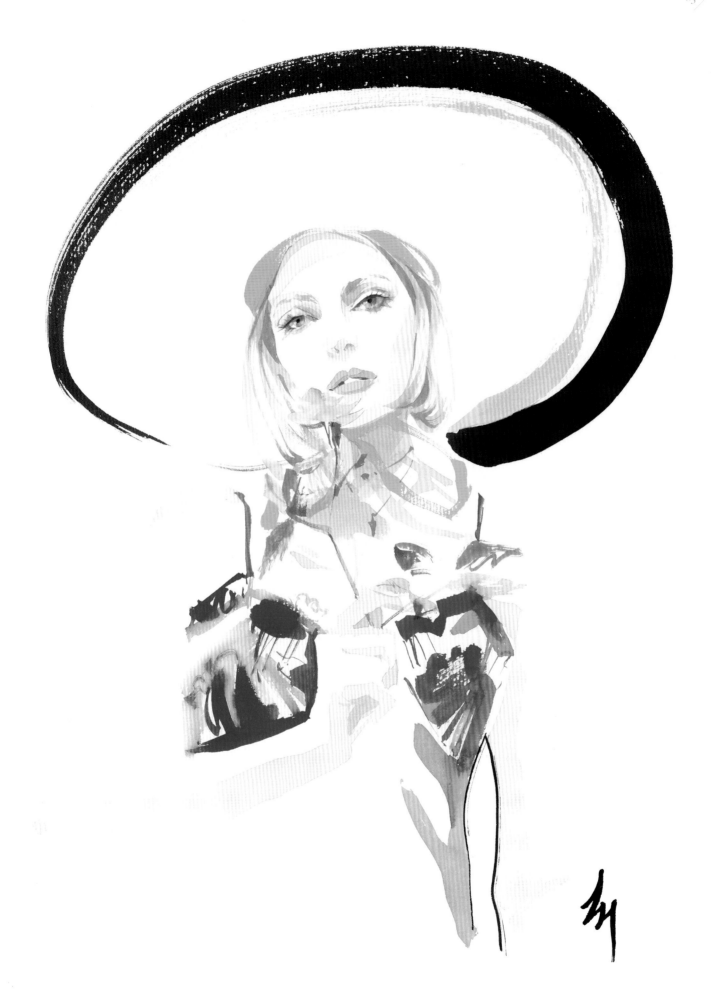

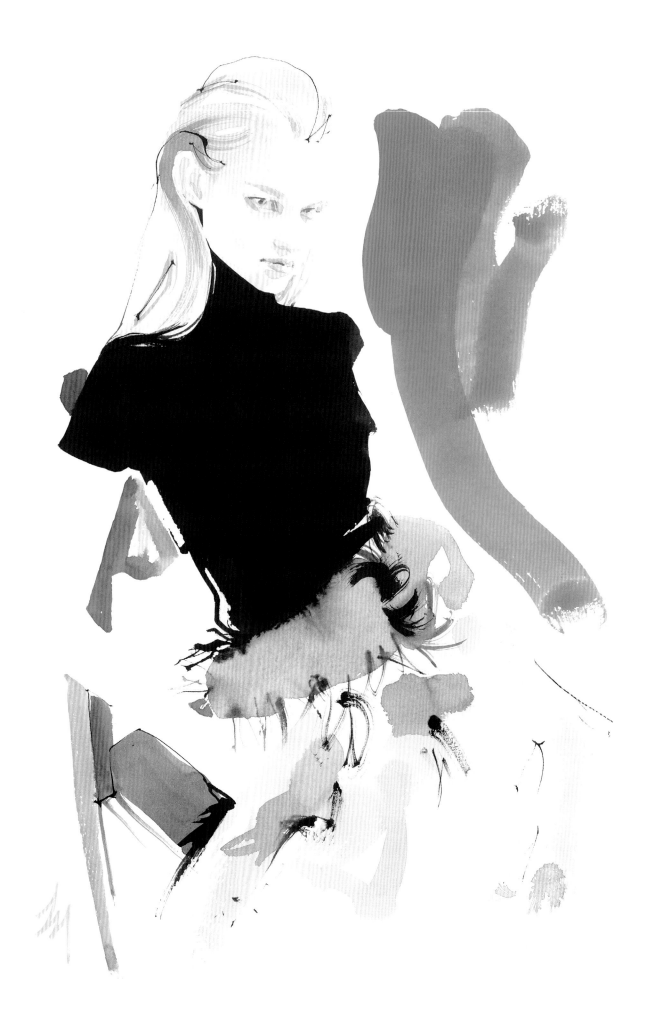

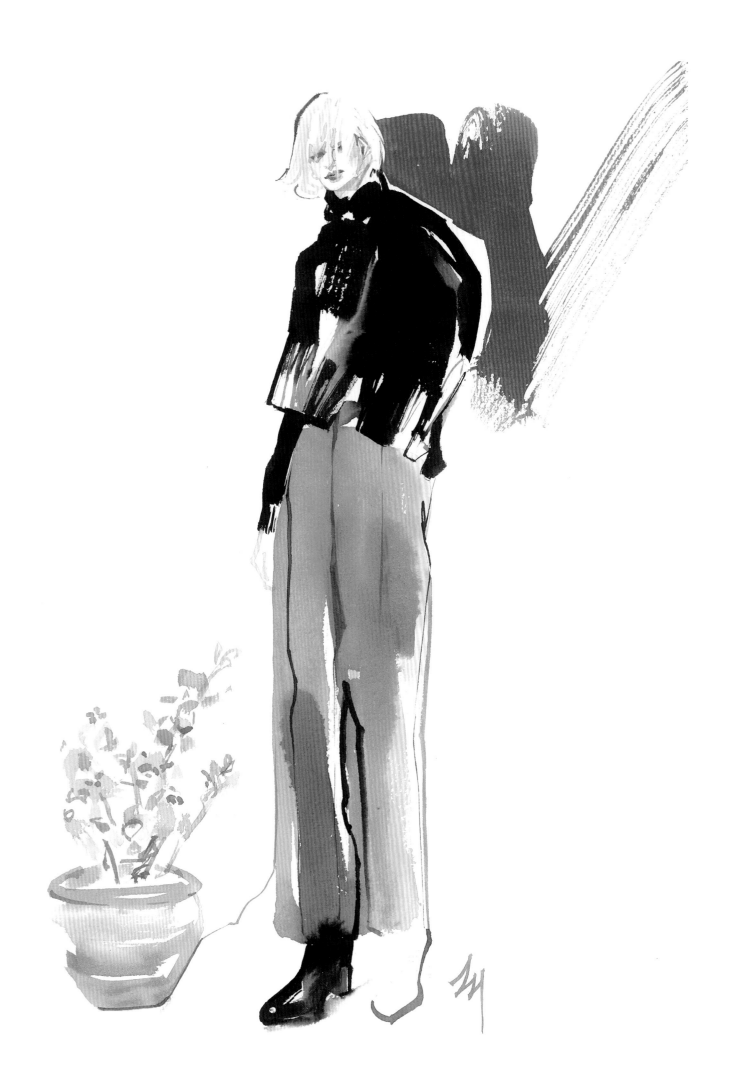

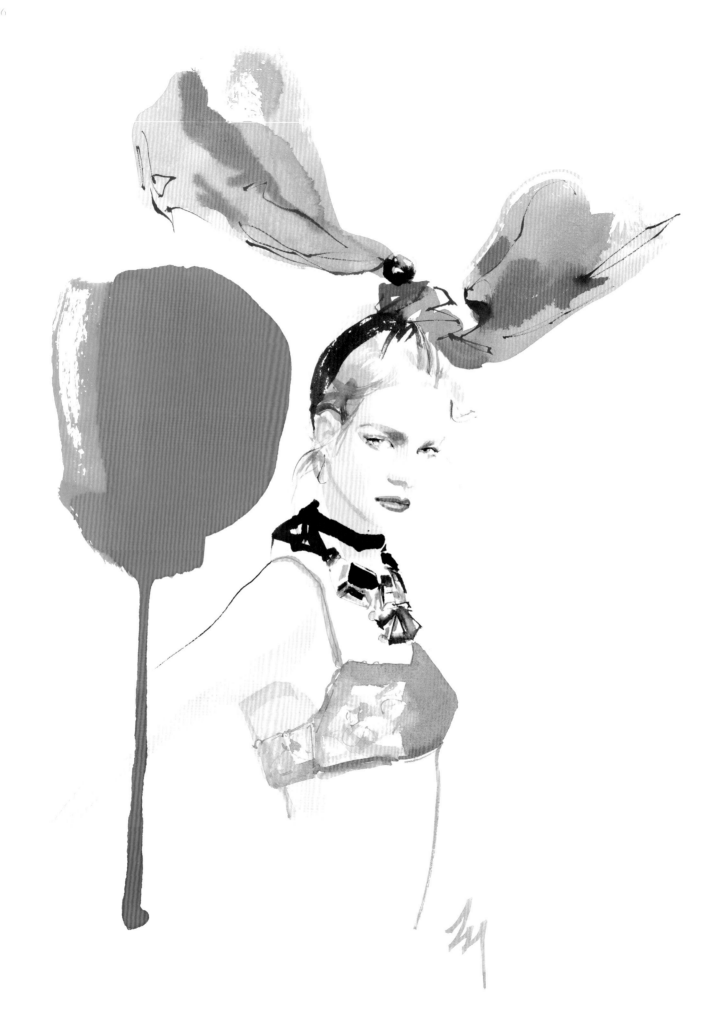

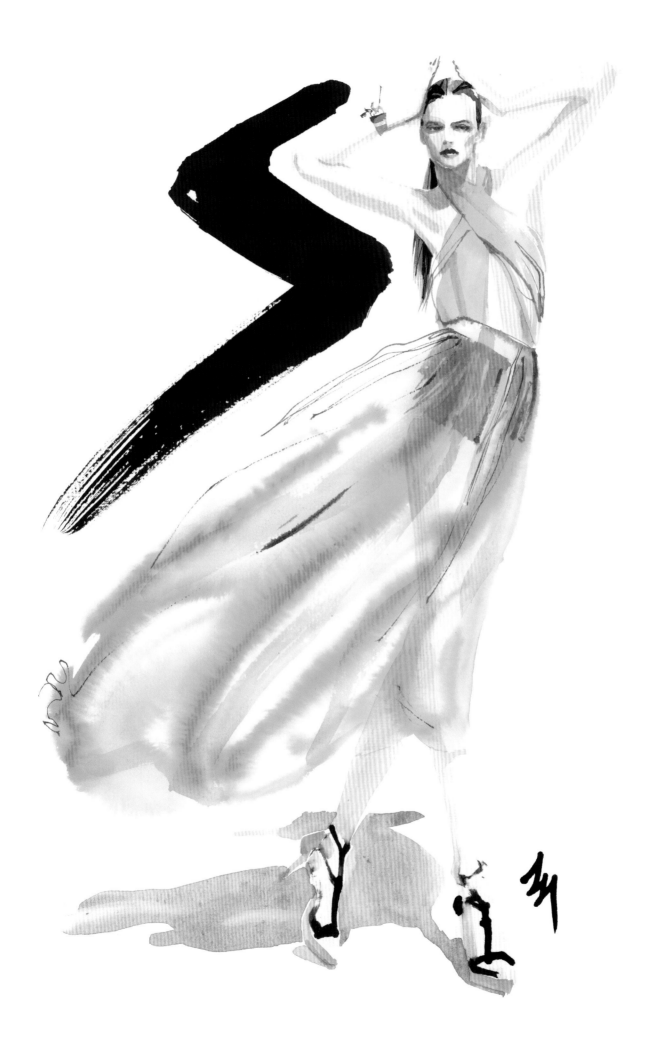

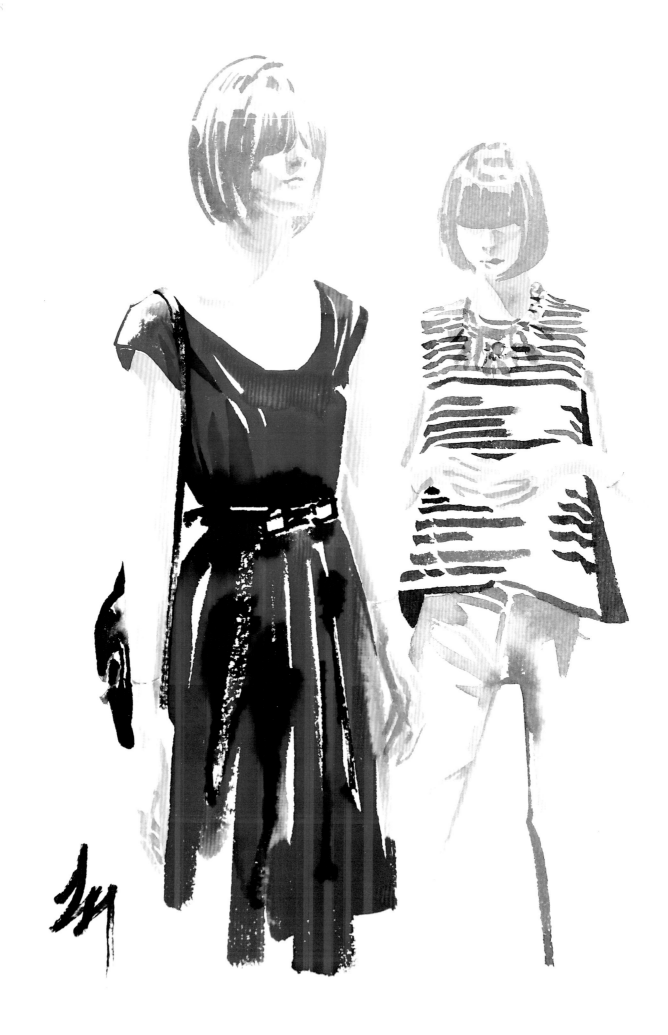

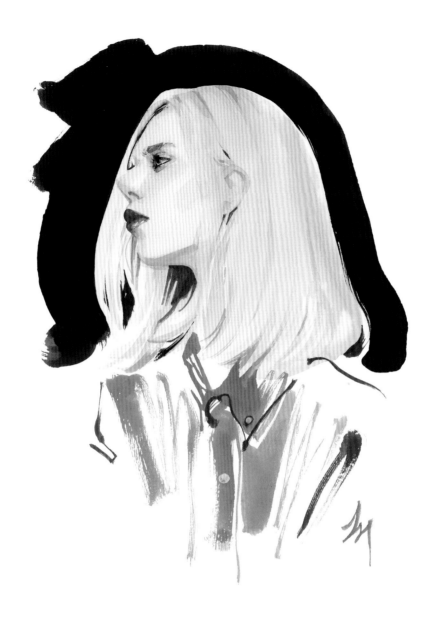

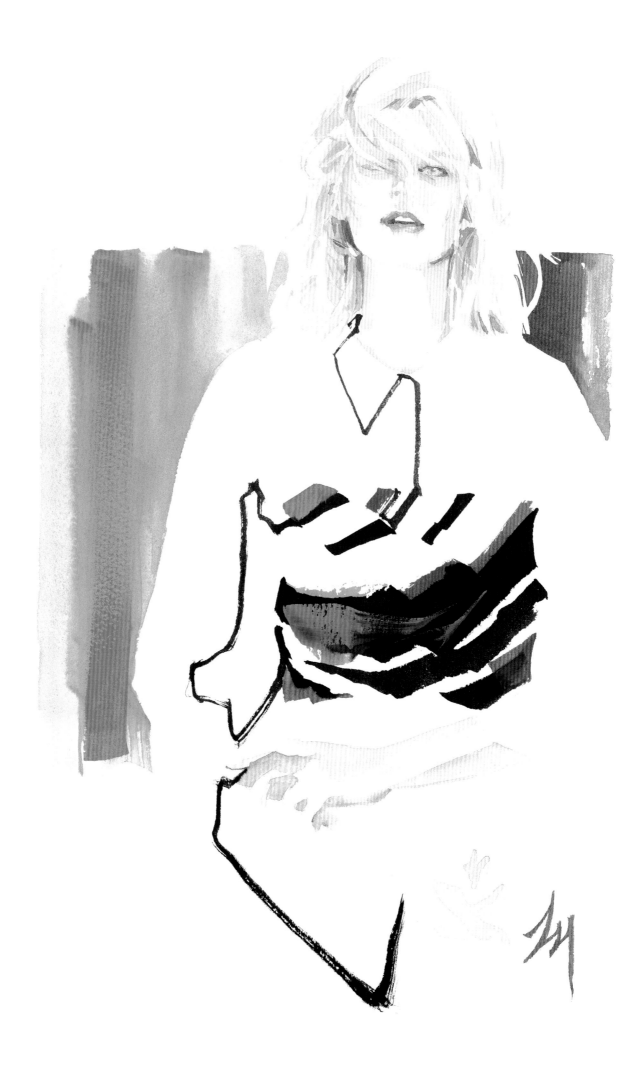

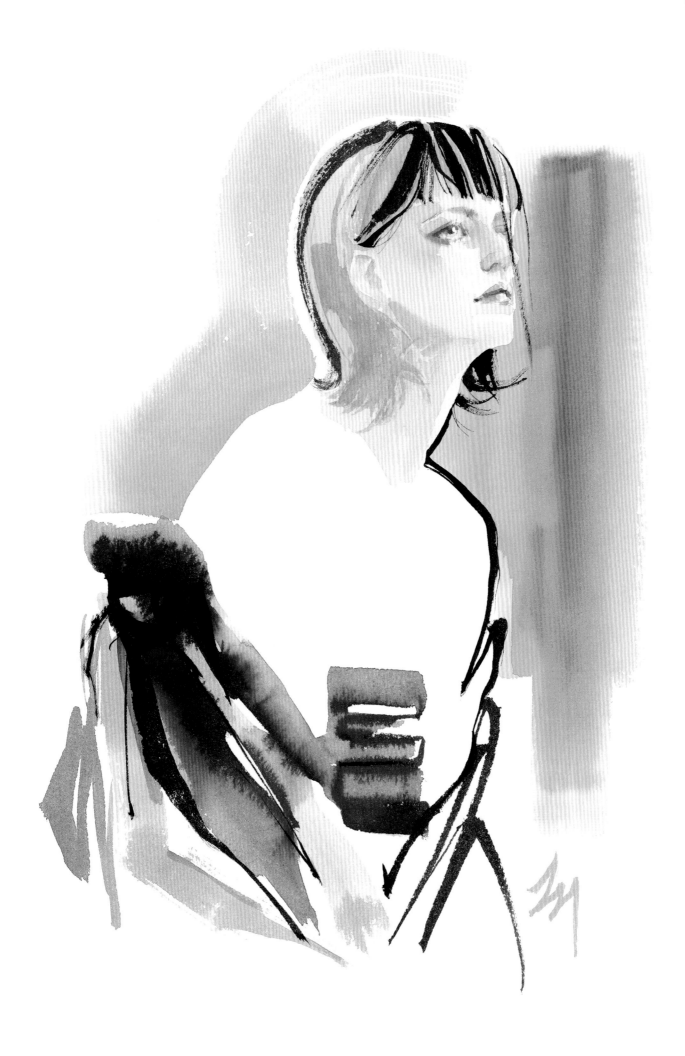

What is often referred to as "**Air Sensation**"

The existence of the background, whether it is necessary or not, all depends on how it echoes to the objects on the foreground. What is often referred to as "Air Sensation", i.e. the spaciousness in a drawing, can be more complete when being formed by the background. Some painters only pay attention to the portrait on the foreground, neglecting the purpose of background and drawing it casually which seems placing the portrait in a space where it does not belong to, making viewers breathlessly and feeling it is too redundant. The relationship between the portrait and the background is balanced by the proportion of composition and the utilization of colors. If you are drawing the background after the portrait is done, you should observe first what is needed for the portrait. Plan the hue, brightness, area, location, feeling it without value or coordination, if you do not have any feeling toward the first drawing, then continue to draw the second one, the third one, until you feel it is matched.

背景的存在價值、需要與否,都取決於和前景人物的相呼應關係。我們都常常聽到畫面裡的空氣感,其實藉由背景來塑造才是最完整的,有些人常常只注視著前面的人,甚至其細節的吹毛求疵,忽視了背景的作用且隨意帶過,就好像這個人處在一個不屬於他的空間裡,令人窒息一樣,有種不畫背景還比較好的畫蛇添足感。 人與背景的關係,不外乎構圖比例與用色的平衡感。若人物結束後才畫背景,應該先去觀察你的主角需要什麼?規劃好明度、彩度、區域、位置,沒有數值或座標的去感受,一張沒感覺就再第二、第三張,直到契合為止。

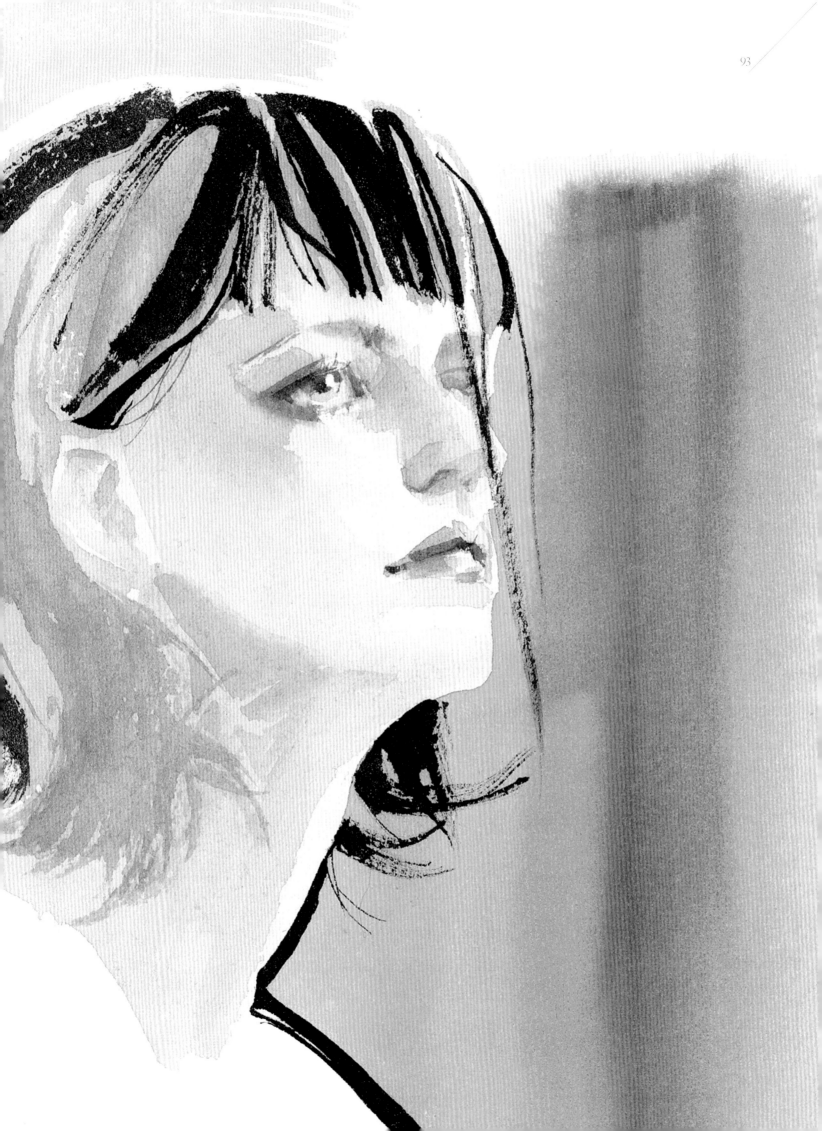

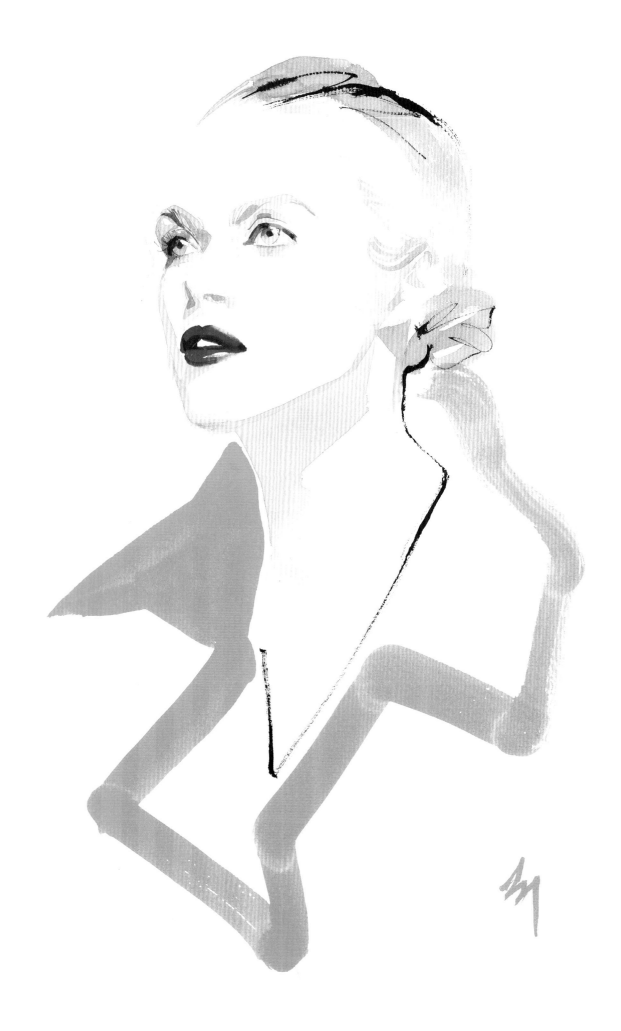

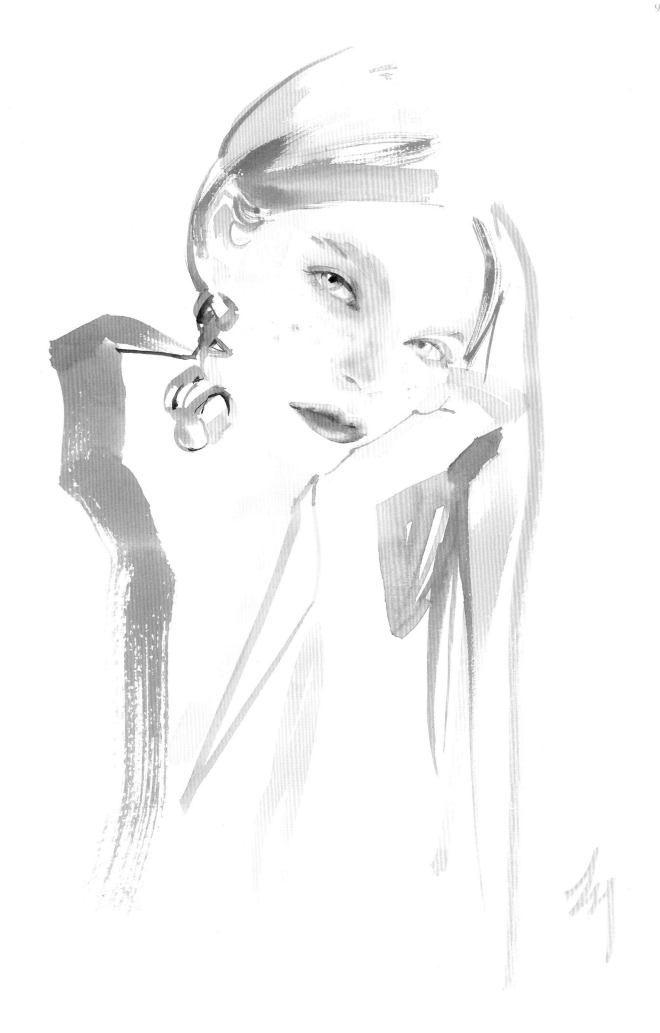

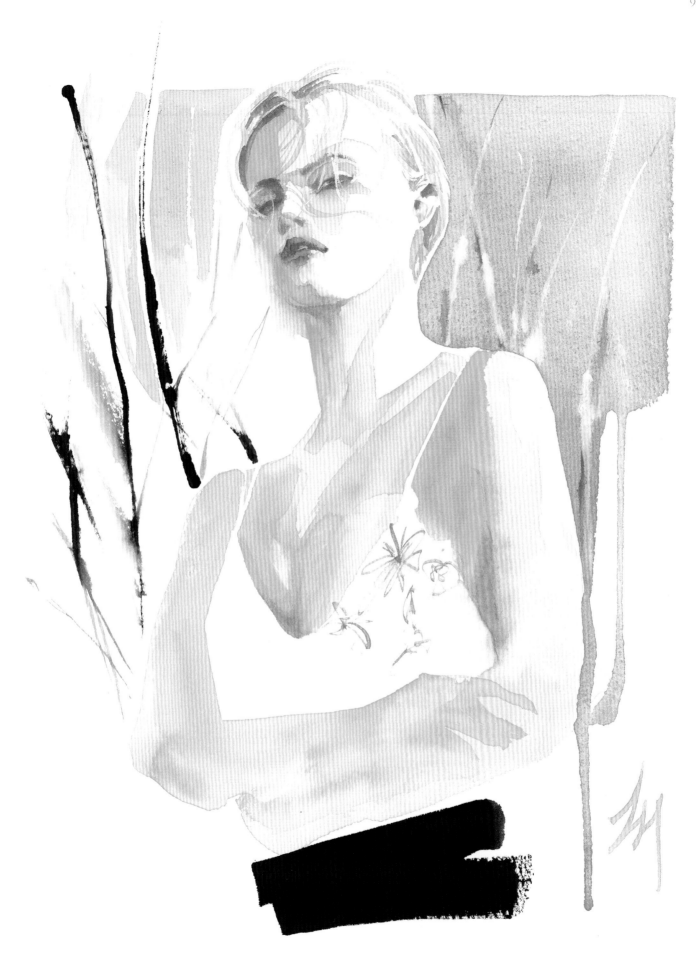

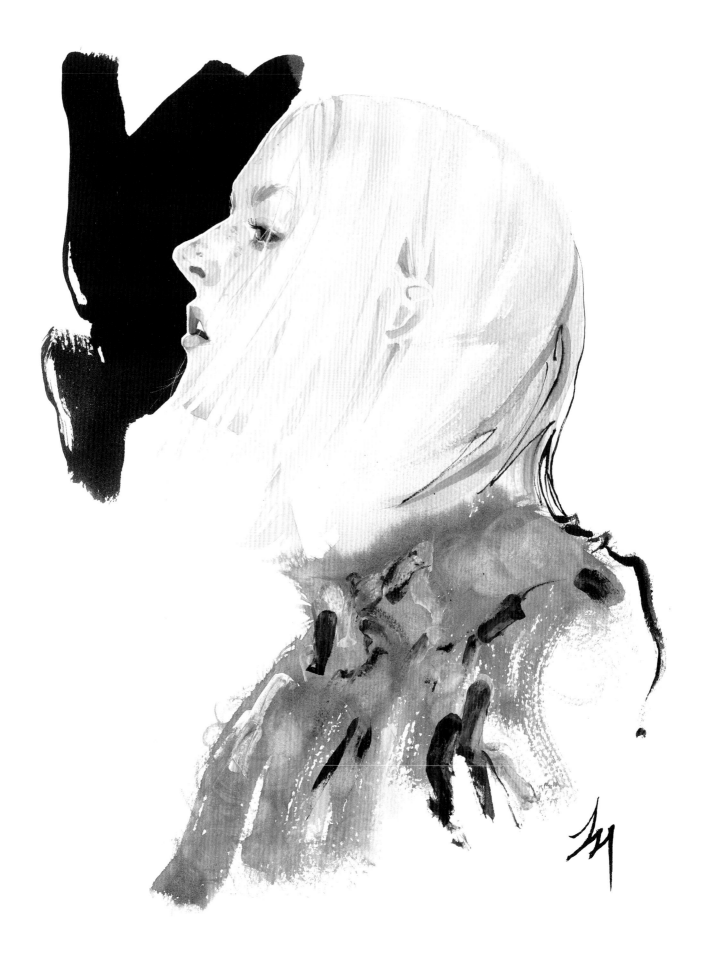

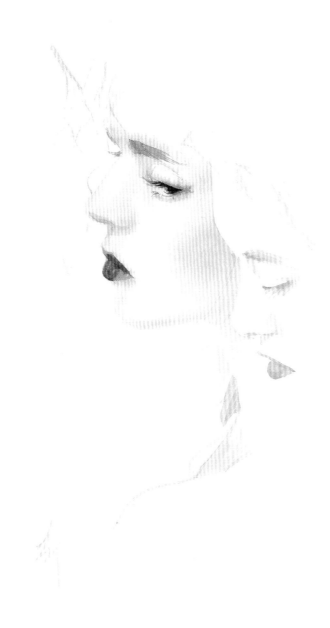

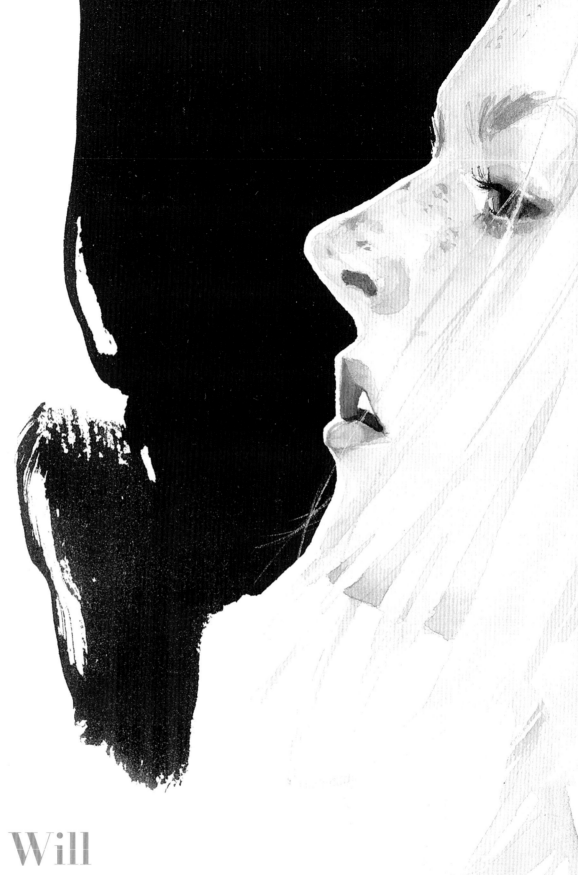

Forced
By My Will

They are fiercely bringing my sin to trial. Stinging public opinions
prickles the vulnerability of humanity, paralyzing the simplest ego.
Forced by my will, I am determined to walk on the road of victory.

他們正在用力審判我的罪，如刺的輿論，狠狠戳著人性的脆弱，癱軟最簡
單的自我，而我的意志驅使，我打算走一條光榮之路 。

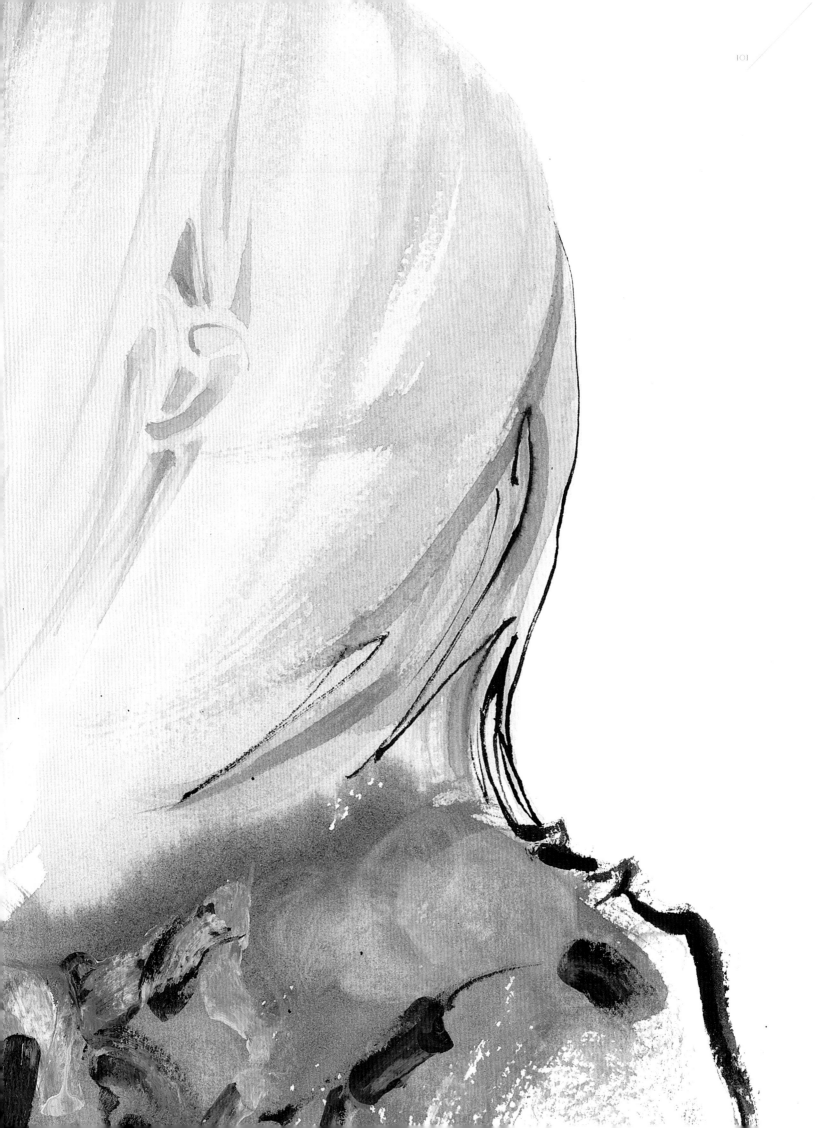

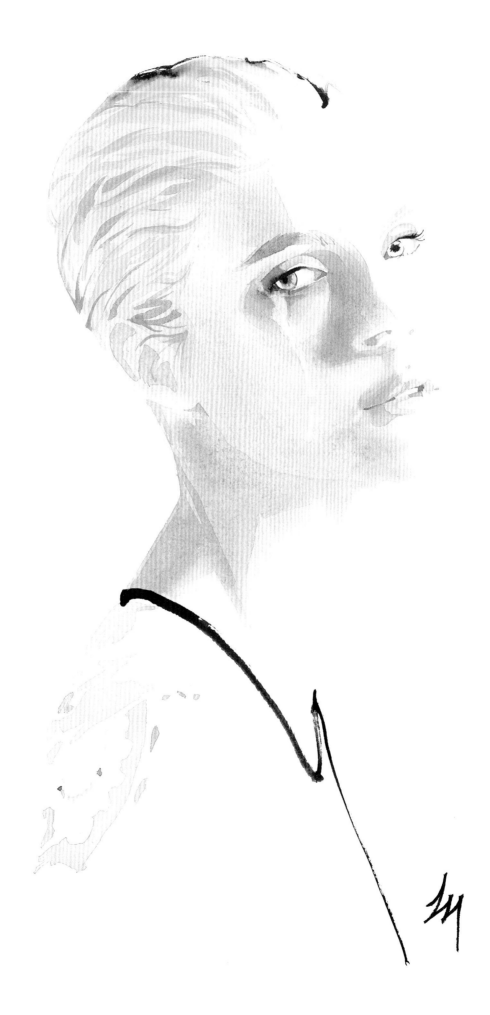

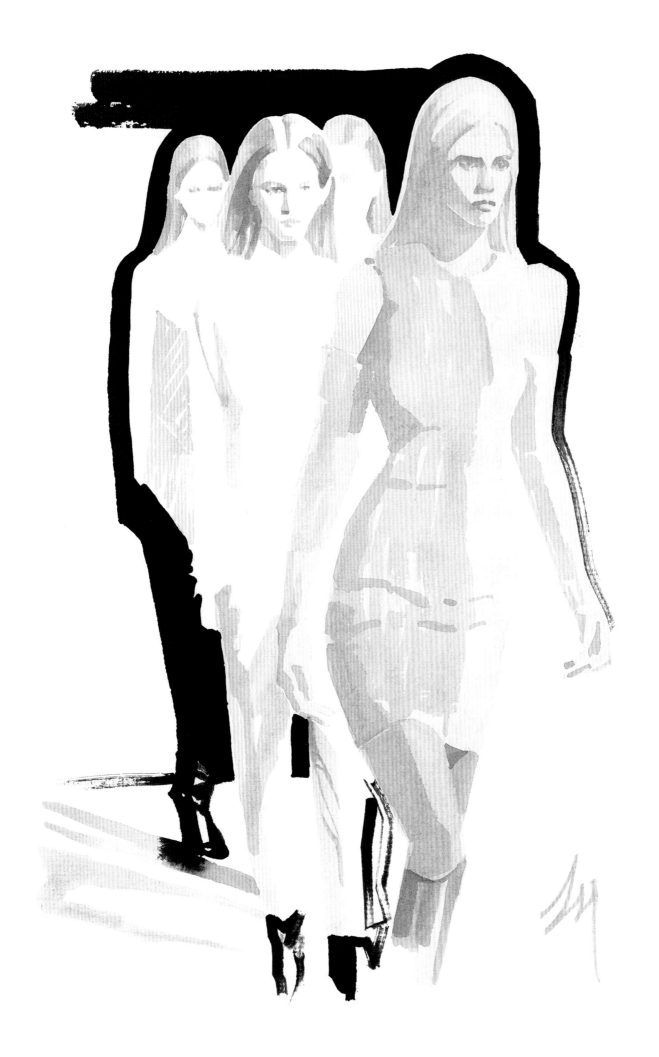

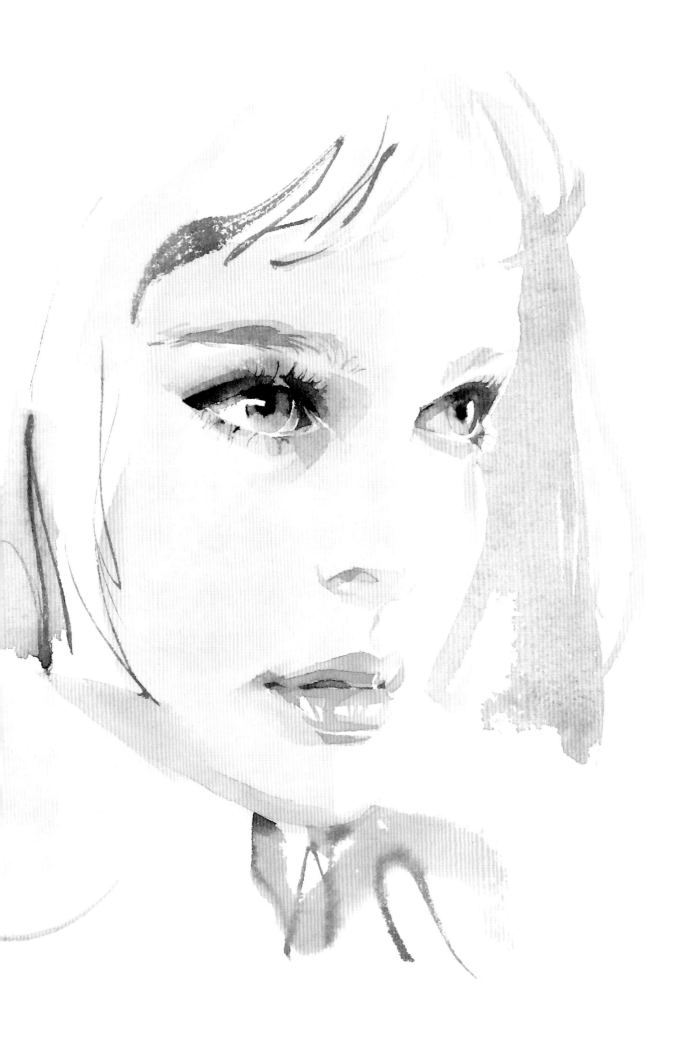

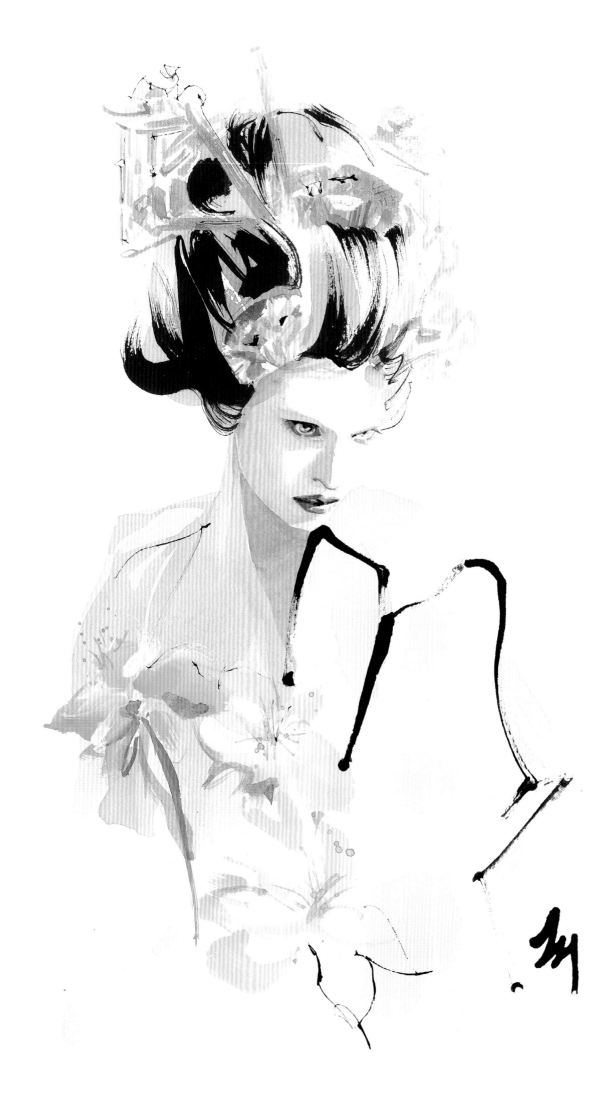

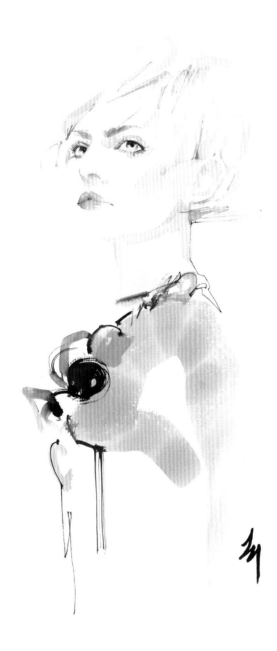

The Oldest Paper Mill In Europe
"Amatruda"

In Amalfi, Italy, Amatruda is the oldest paper mill in Europe. Since the middle of the 13th century, it follows the traditional way of hand-making each paper, so each piece of paper has different hand-made traces. It does not contain chemicals, uses natural materials such as cotton and cellulose, is acid-free, chlorine-free, and non-toxic. It is suitable for long-term preservation and is the official paper for the official use of the Vatican.

About four years ago, I came into contact with Amatruda's paper. Usually in store, it is marked as a special paper for writing with ink. As the main media I utilize are watercolor mixed with ink, I certainly would not miss the chance to try it, especially I had tried all brands of watercolor papers before.

Precisely speaking, Amatruda is printmaking paper rather than watercolor paper, but I never care about the title on the surface. It makes more sense if it's meaningful. In order to study the differences between different moisture, pigments, and inks on paper, I have even tested the sketch papers of various brands. There are even special lines that watercolor paper can't show. Although it is beautiful, the sketchpaper itself cannot withstand the rendering of water and wrinkles, and the color saturation is also insufficient. Amatruda's paper texture and velvety touch, color saturation, restoration ability after being exposed to lots of ink, the smoothness after rendering is the best. It is my favorite paper for art creation.

在義大利的 Amalfi，歐洲歷史最悠久的 Amatruda 手工造紙廠，從十三世紀中葉時期至今堅持傳統手工獨立製作每一張紙，所以每一張紙的邊緣都會有著不同的手工痕跡。不添加化學藥劑，使用棉花、纖維素等天然材料，無酸、無氯、無毒，適合長期保存，為梵帝岡官方的指定用紙。

大約是在四年前接觸到 Amatruda 的紙張，通常店家都是標榜墨水的書寫專門用紙，本來就是以水彩混合水墨為主要創作主軸的我，當然不會錯過嘗試看看，在這之前早已將一般美術材料行的所有品牌的水彩紙都至少畫過一次了。

Amatruda 精確來說是版畫紙不是水彩紙，但我從不會在意表象上的稱謂，本身有意義才最重要。以前為了研究不同水分、顏料、墨等等在紙上能呈現的差異性，連各廠牌的素描紙也都實驗過，之中甚至還有水彩紙無法沒辦法表現出的特殊紋路，雖然很美但紙張本身卻承受不了水份的渲染而變皺，色彩飽和度也明顯不足。Amatruda 的紙面紋理與絲絨般的觸感、色彩飽和度還有大量的水墨渲染過後的平整度恢復，是我在創作時最喜歡使用的一種紙張。

PREVIOUS
PAINTINGS
2010~2014

I will never stop changing the way I draw. Many artists narrow down what they can draw or how they draw it. I always feel unbelievable to people with such thoughts. Looking at the children revokes us that they are drawing by instincts. I don't mean to learn their way of scrabbling, rather, I don't think it's necessary to put your "style" as the first priority. It will automatically come one day, not affirmatively for how long, but as long as you constantly draw out of what you intend to in discipline. Even if you don't limit what you can draw, people can still feel ："You" from your drawings.

There are no rules as to the ways of practice. One may continuously repeat drawing the same thing to the heart's content. When feeling frustrated, just temporarily escape from it and come back, even forgetting about the original subject and re-start a new one. This may so-called playing-hard in the drawing world. After all, what is intended is not simply a drawing, but to keep that essential initial passion. The methodology may seem to be fooling around but the objective is still loyal.

我永遠不會讓自己停止改變畫法。很多人為了在風格上有所定位，狹隘的限制自己只能畫什麼或一定要怎麼畫，常常對於有這樣想法的人感到不可思議。可以去看小朋友畫畫就會再回想起來，事實上他們幾乎是想到什麼就畫什麼的思路，並不是要學他們那樣塗鴉，而是沒有必要將「畫風」這件事情擺在第一，持續的在既有的繪畫秩序裡畫出想畫的之後，不能肯定的說是多久之後，但有一天它會自動送上門來，就算不限制自己只能畫什麼，從畫裡還是能感受到「你」。

繪畫並沒有制式的練習方式規範。可以不斷的重複地進行同一張直到快心遂意，或是失意時暫且逃避到有了想法再回過頭來，甚至直接忘了它朝另外的主題重新發展，算是繪畫世界裡的不擇手段吧。畢竟要的不只是那一張畫，而是那個重要的初衷。方法或許有些花心，不過目的依舊忠誠。

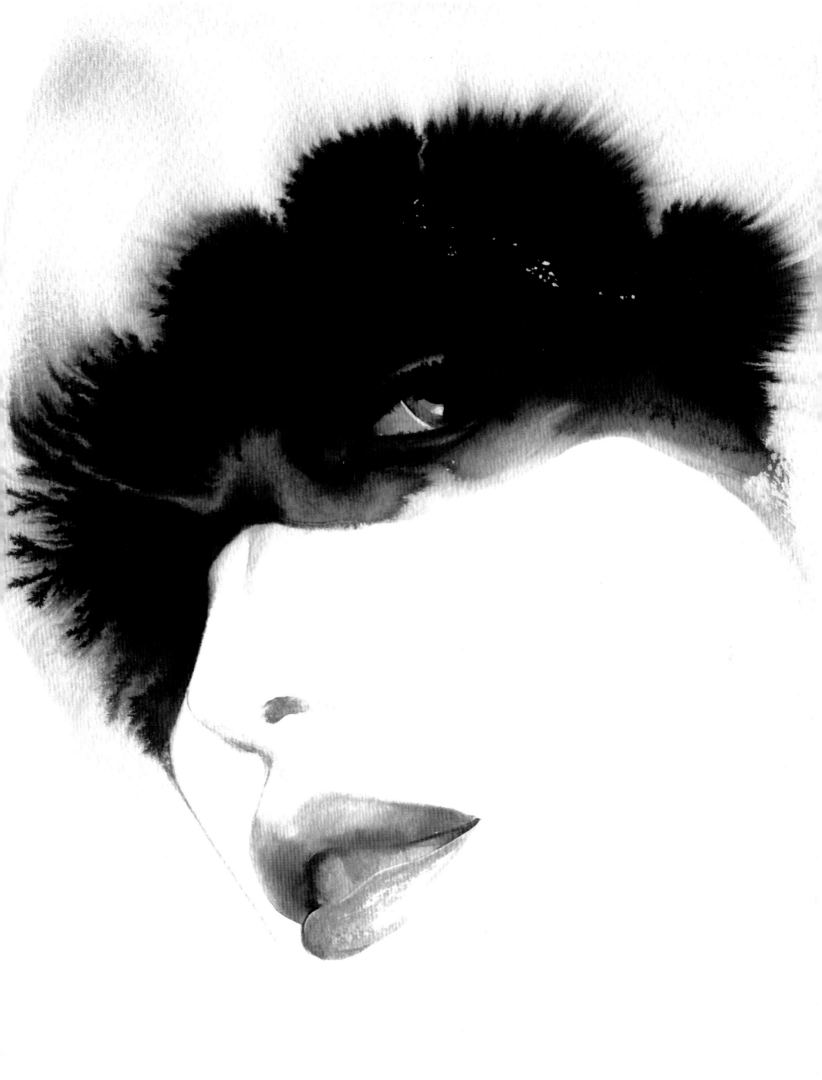

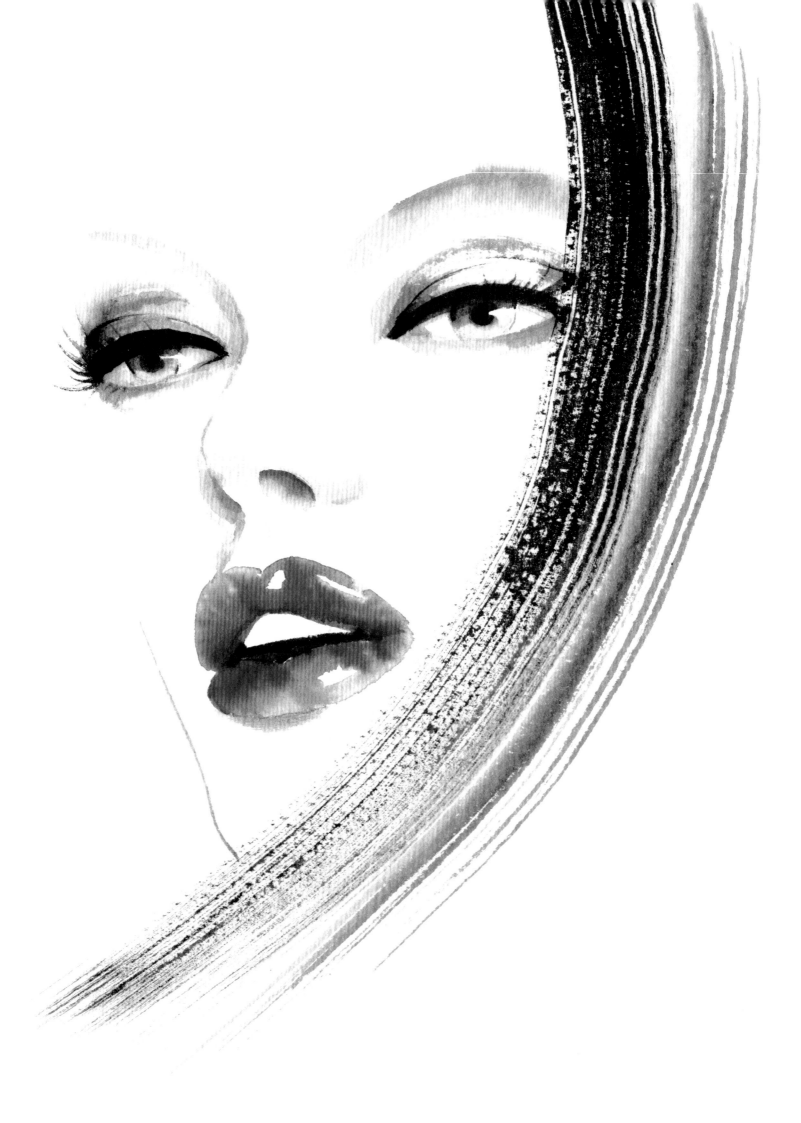

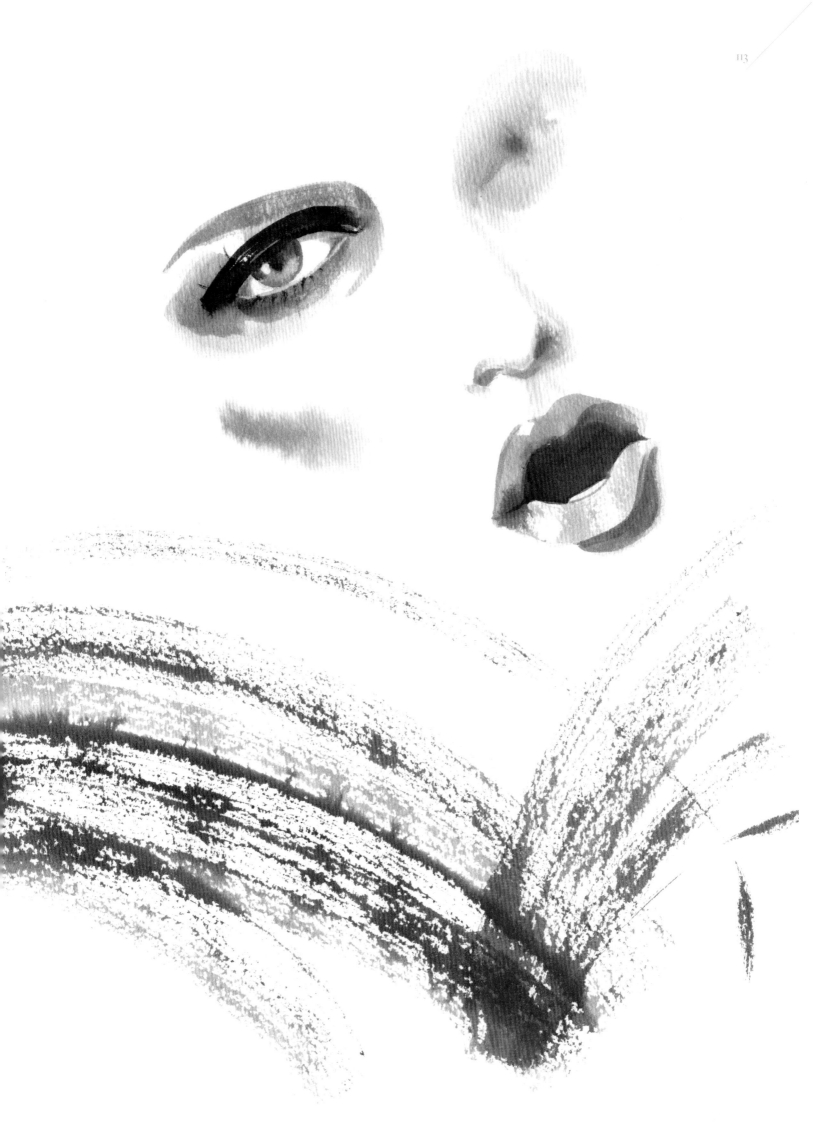

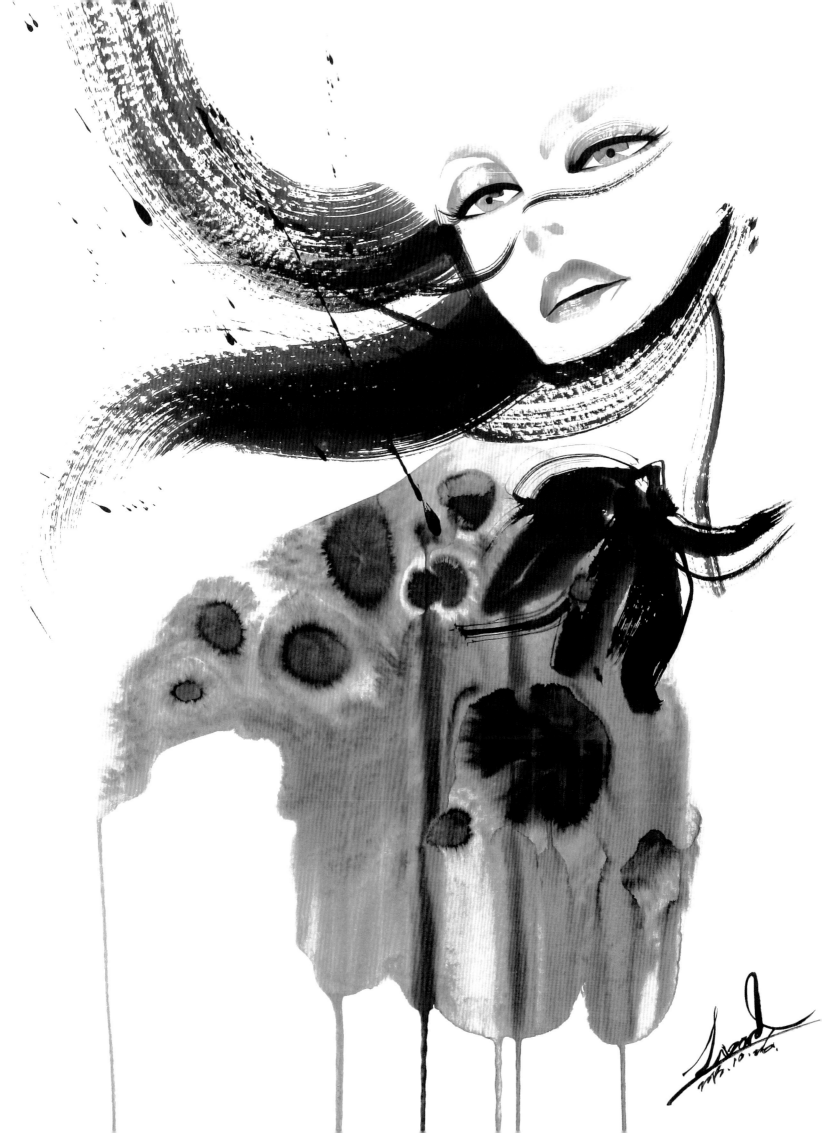

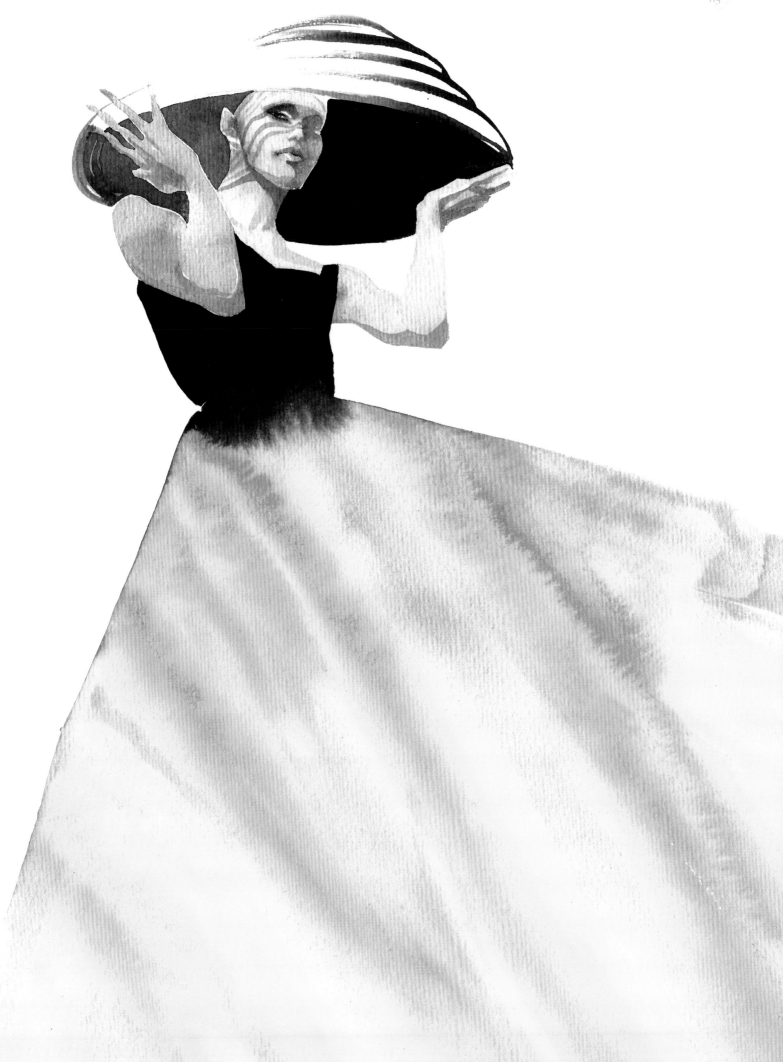

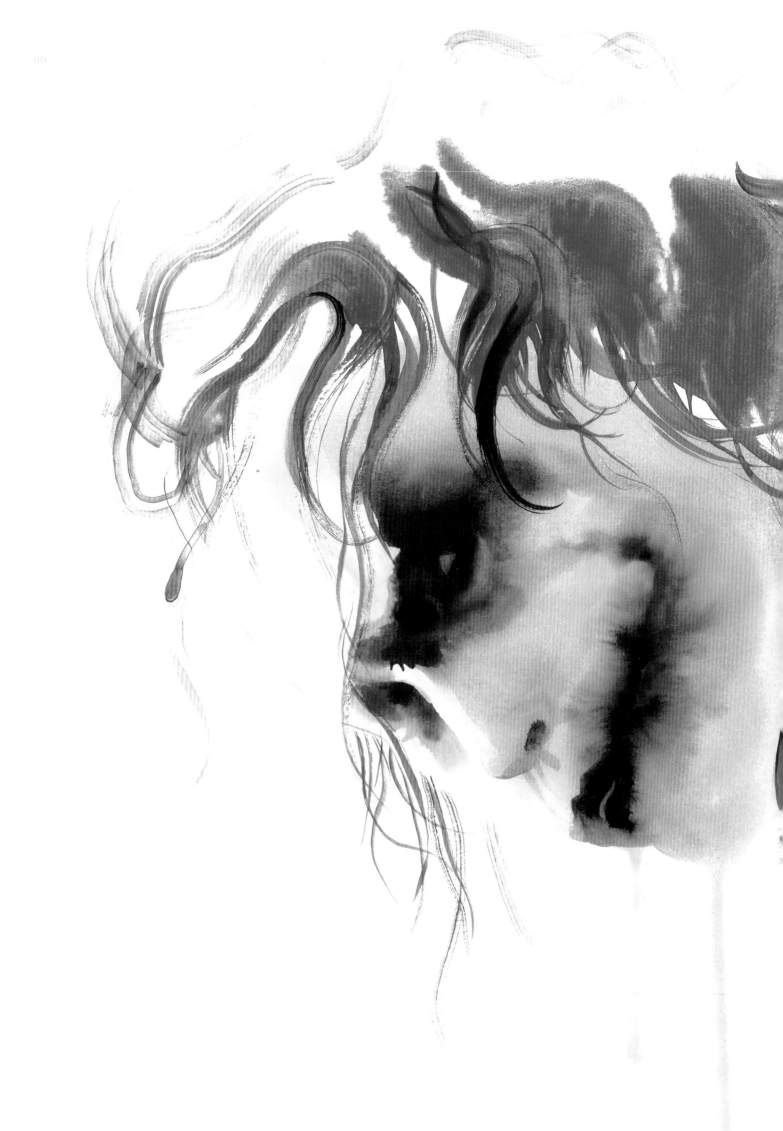

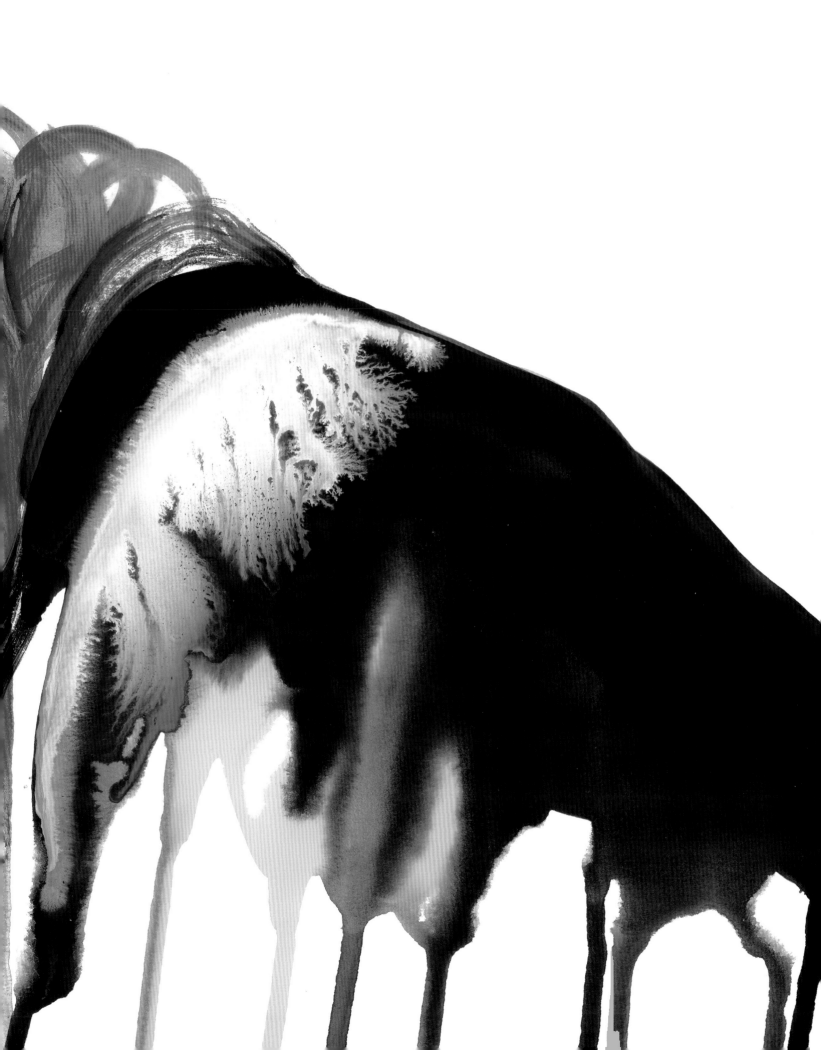

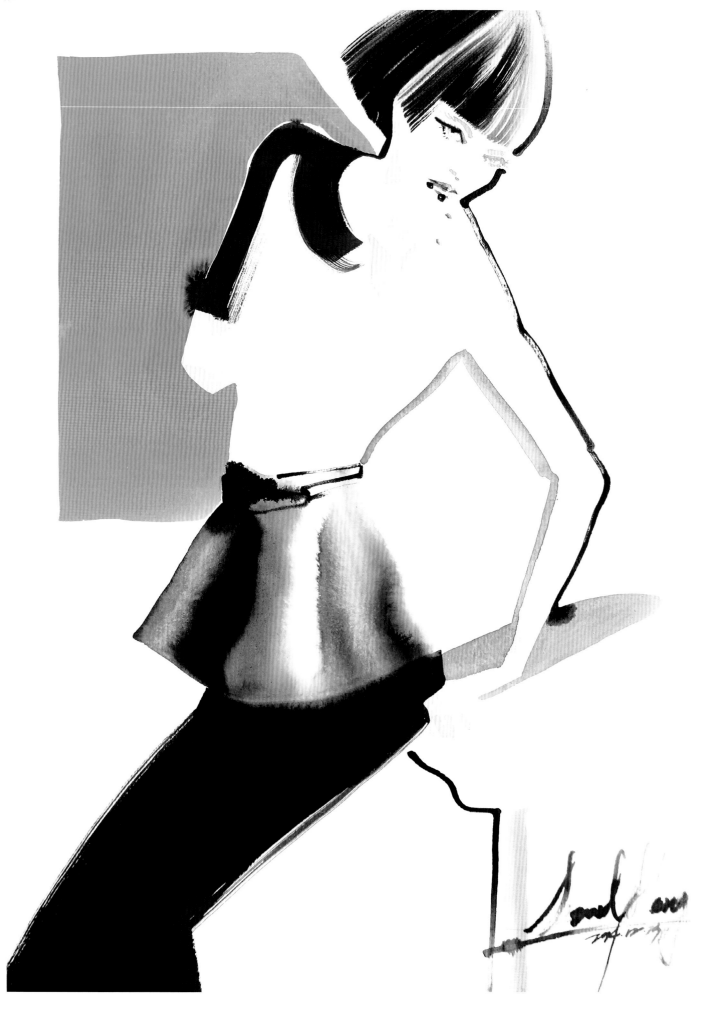

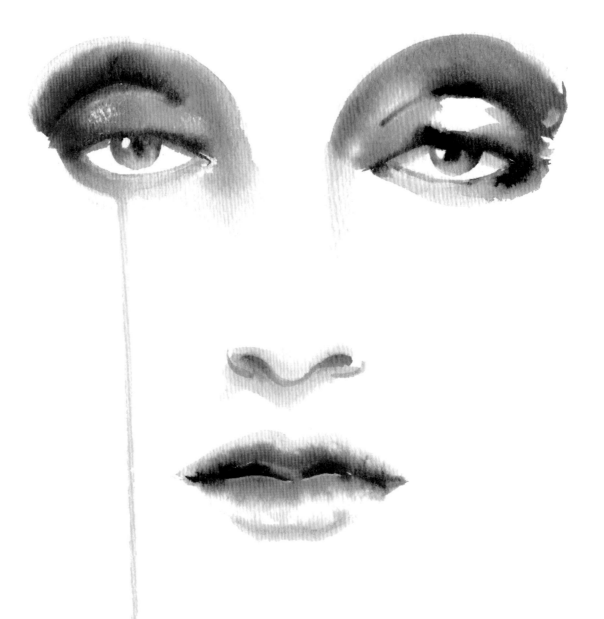

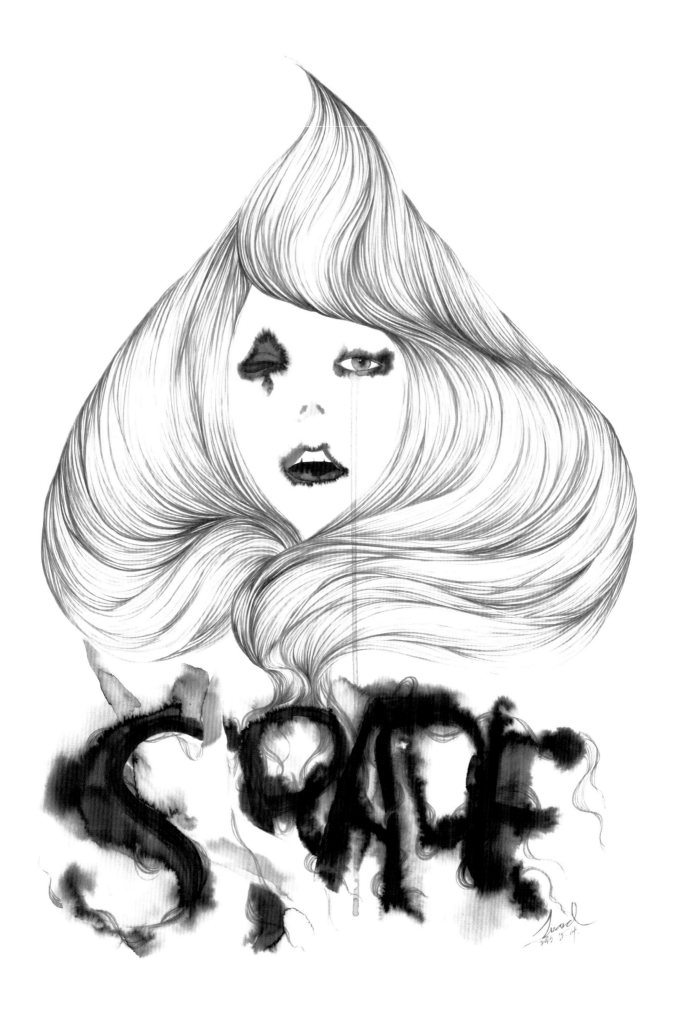

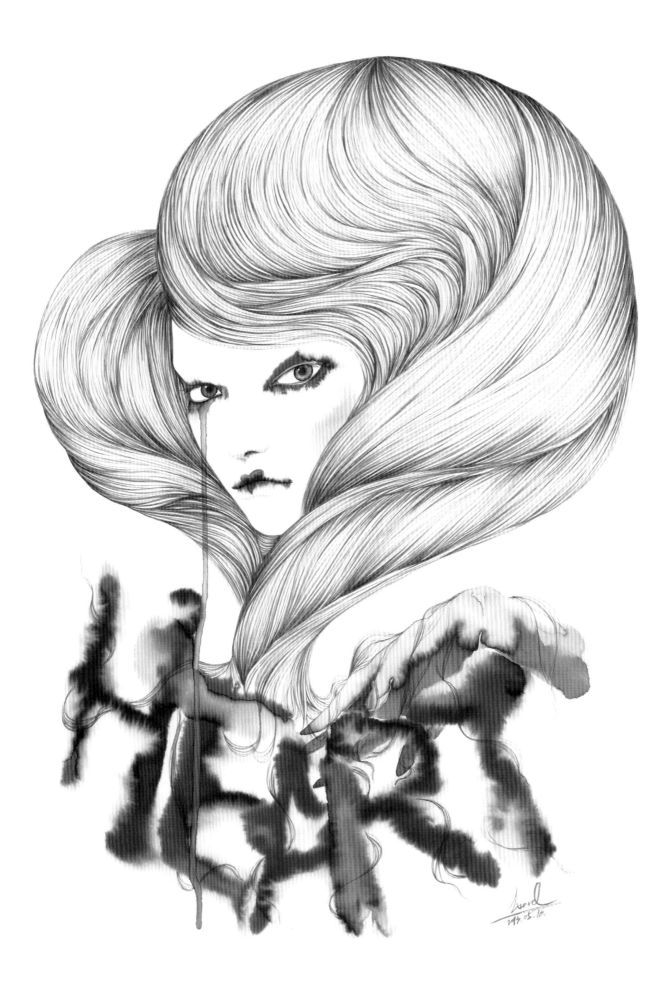

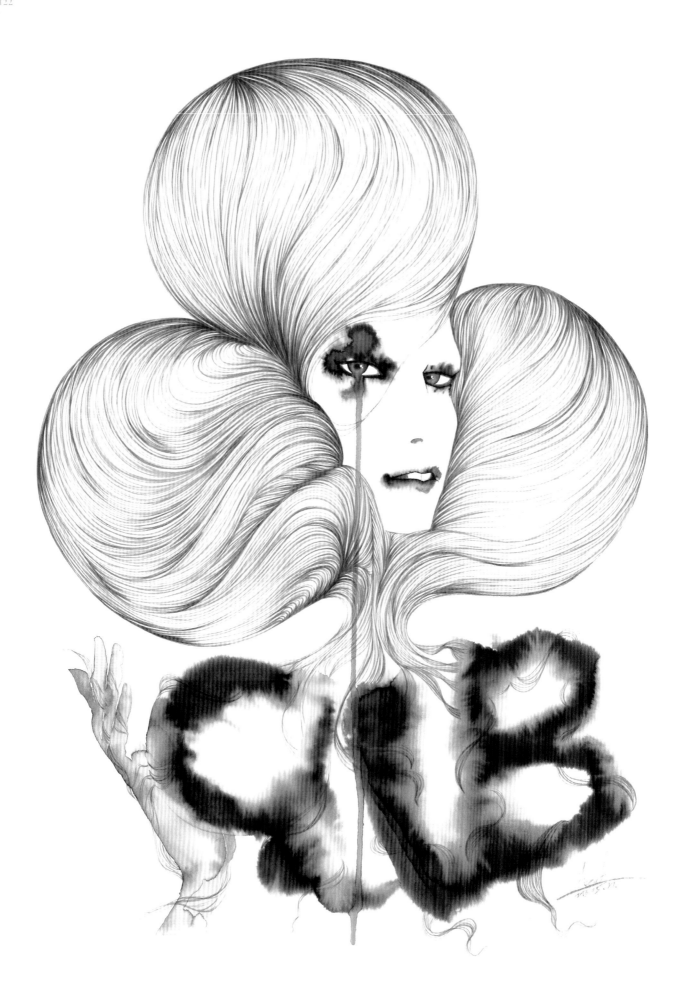

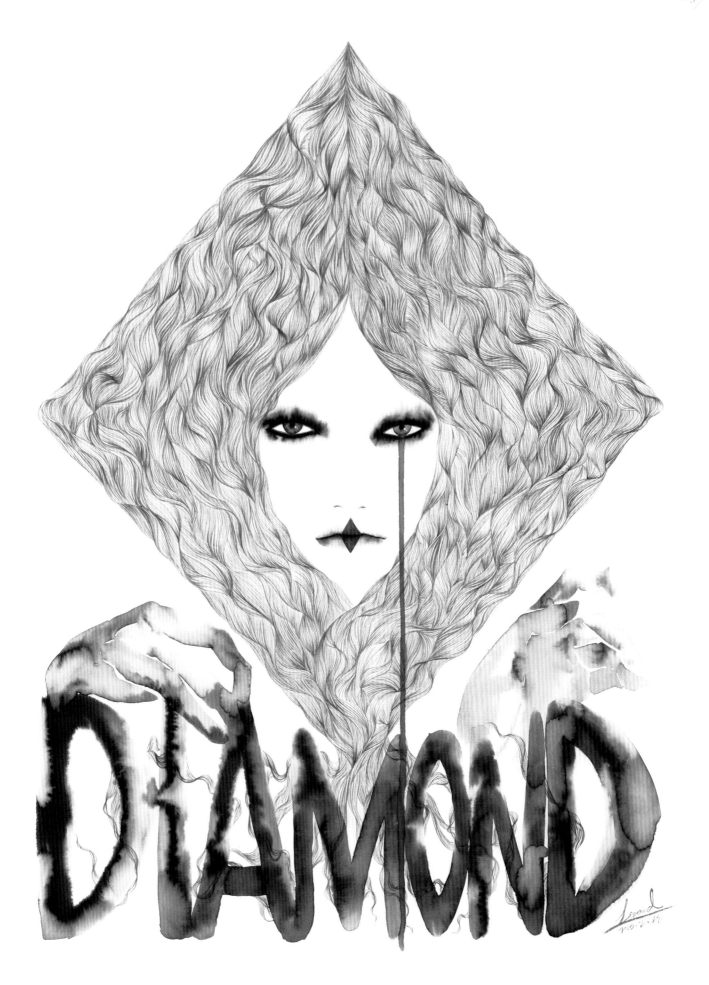

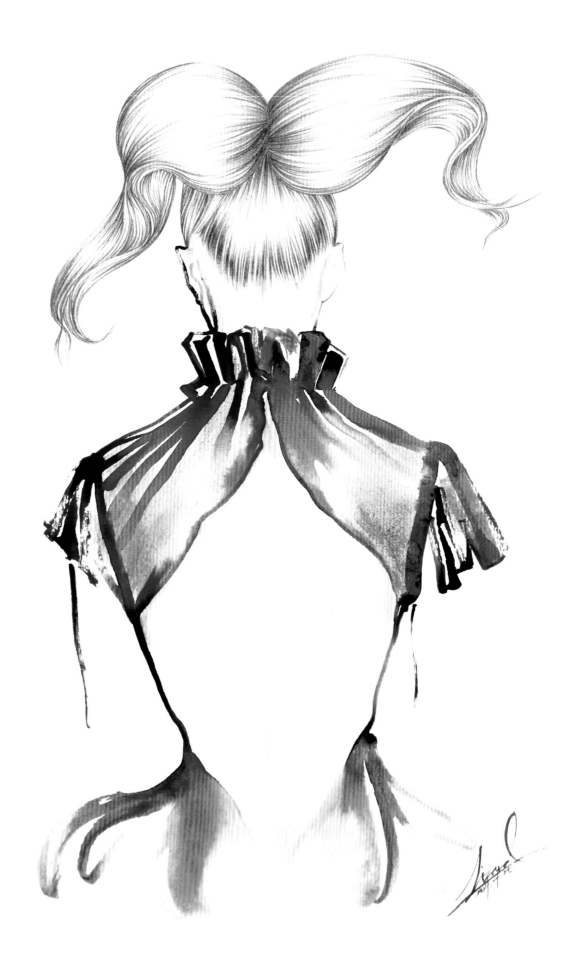

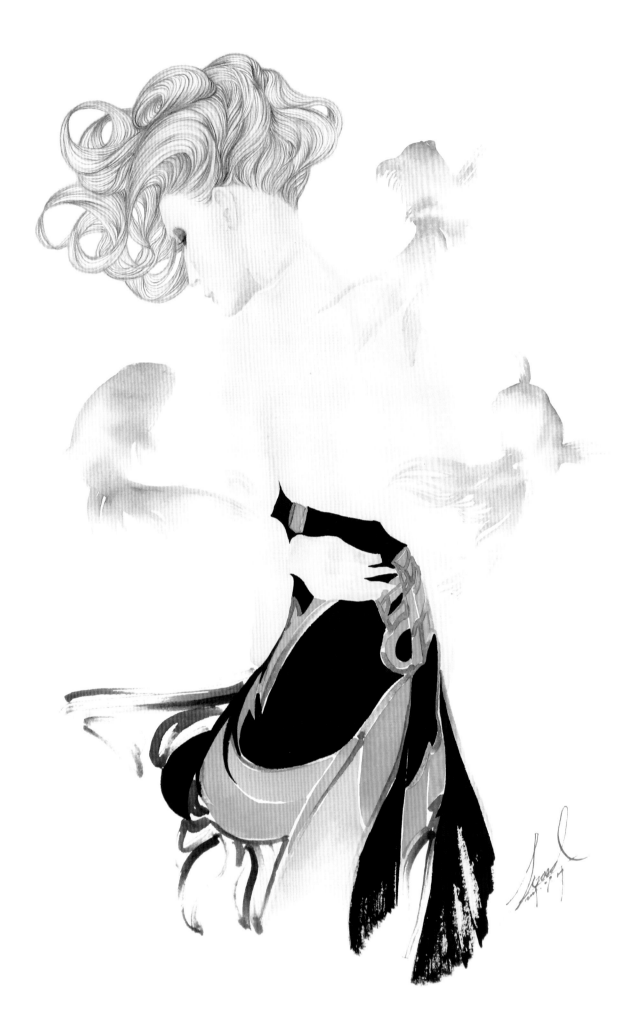

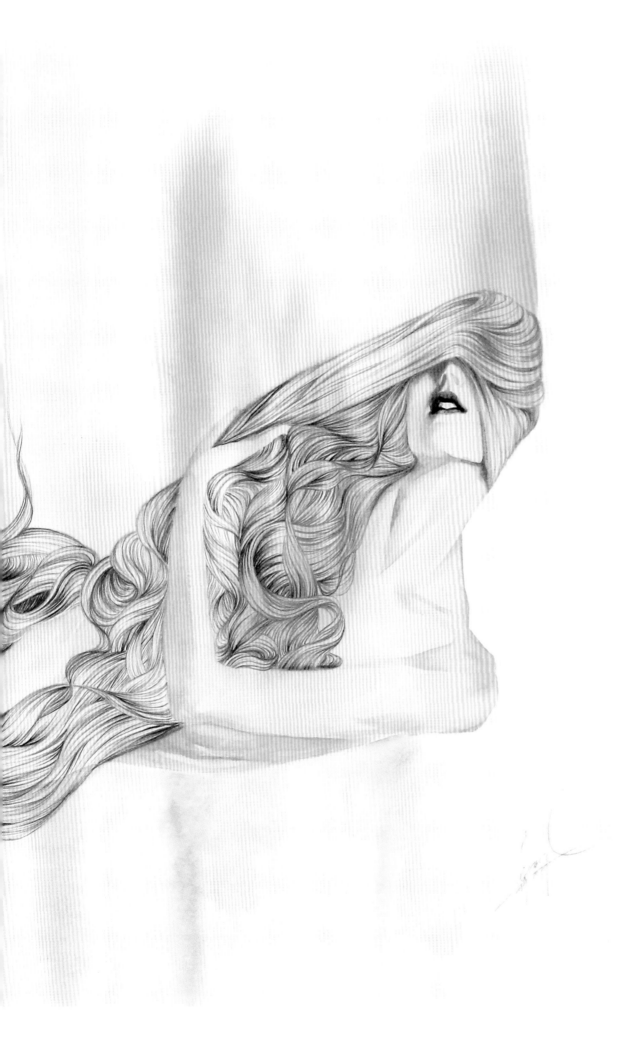

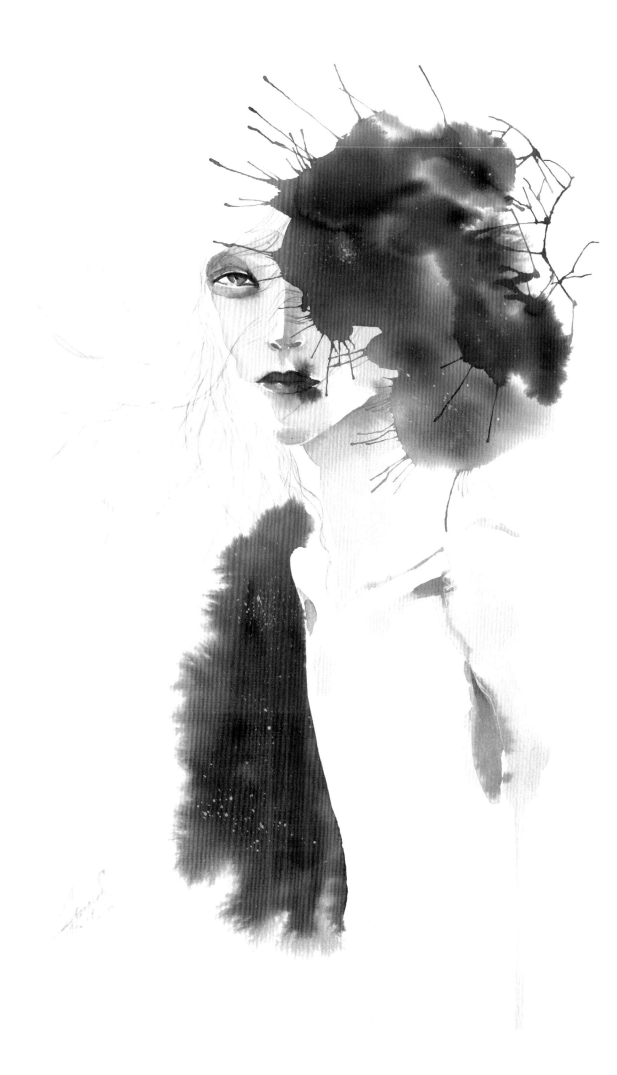

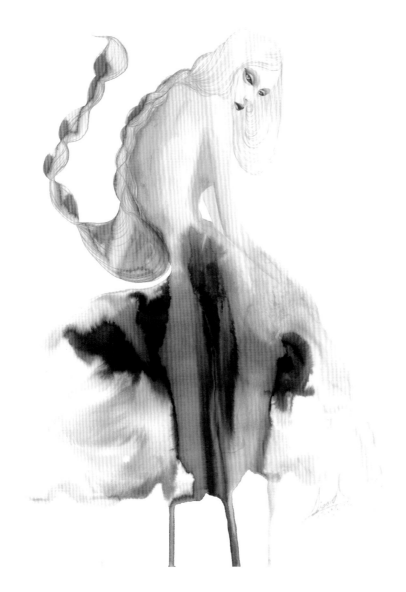

CLASSIC FASHION

I always adore "old fashion" which is so classic and uniquely alluring. In comparison to contemporary fashion, each has its own merits, although the Replica cannot exceed the Classics; the Classics can never create innovation. Although there are quite a few reforms of the Classic fashion, there is always main scheme in every era, such as the elegance of the body curve, bold and passionate mini-skirts, Op Art, avantgarde color blocks, Astronaut, Hippie culture, etc. "Broken Fashion" to me is mostly exaggerative and high profile of extension from the Classics, however, it could never be as classic. I don't mean to compare, it is simply out of personal taste and different generation. Seriously speaking, what I am good at drawing is not fashion, but I believe in fashion, the outfit has to be full of culture and connotation. If you want to be trendy and unique, you can't always follow the commercial, you have to spend time searching, this is the same as drawing.

我一向很鍾愛「老時尚」，它們是如此的典雅且獨具魅力，相較於當代時尚各有千秋，雖復刻無法超越經典；但經典也無法再度創新。經典時尚雖然有不少的變革，但在每個年代總會有個主軸，優雅重身材曲線、大膽激情的迷你裙、歐普藝術前衛大色塊或是太空人與嬉皮文化 ... 等等，現今眾多的「破格時尚」對我來說大多是誇張且高調的經典延伸，卻無法像經典那樣的經典，當然並非比較之意，純粹為個人喜好與時代區隔的不同。嚴格來說，我擅長的是繪畫並不是時尚，但相信時尚、穿搭是必須富有文化與內涵的，想要流行且獨特就不能完全聽信於商業，要自己花時間去尋、去找，這點與繪畫是相同的。

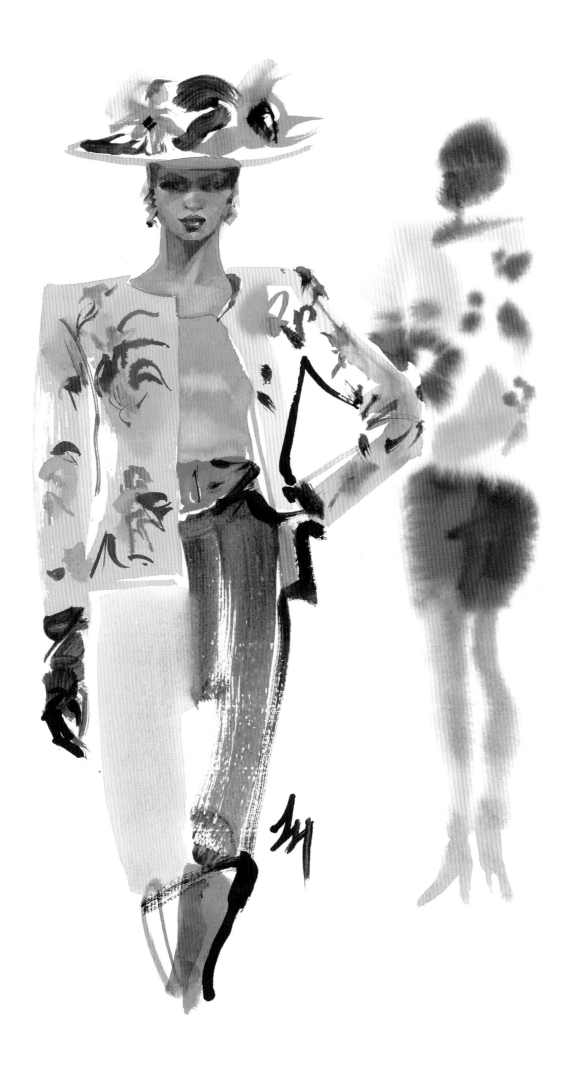

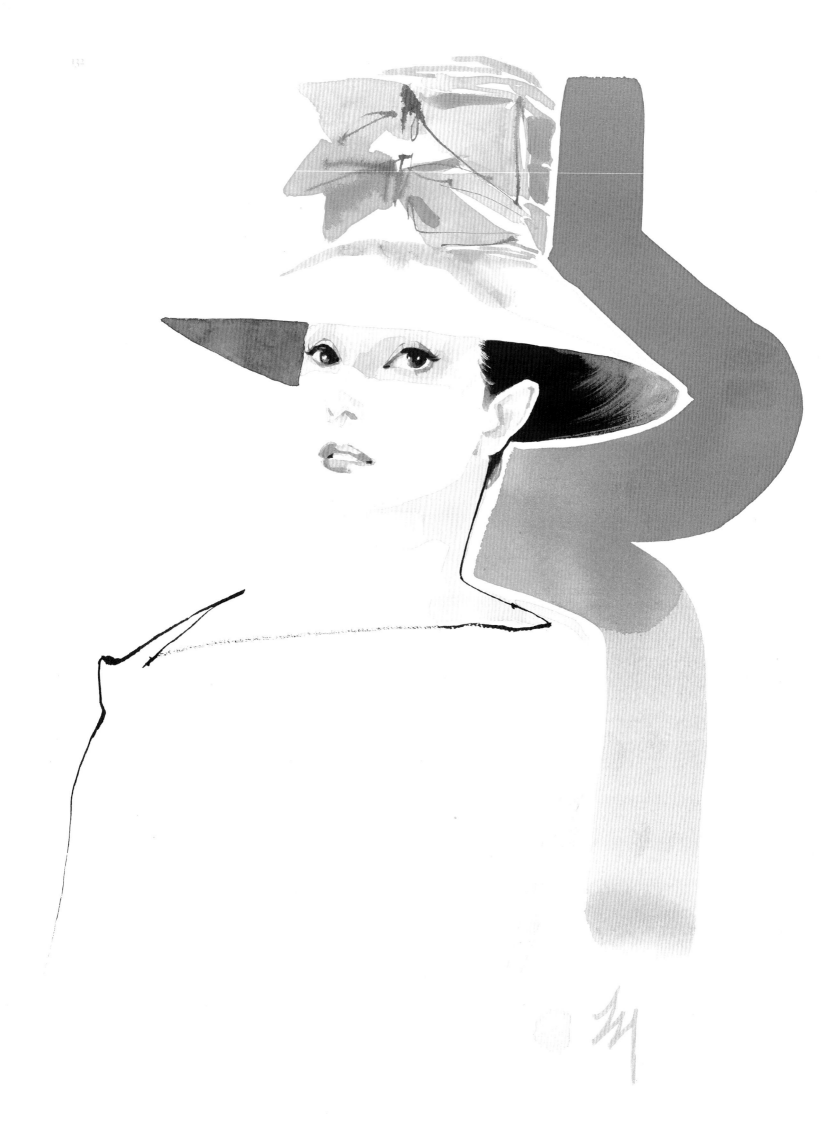

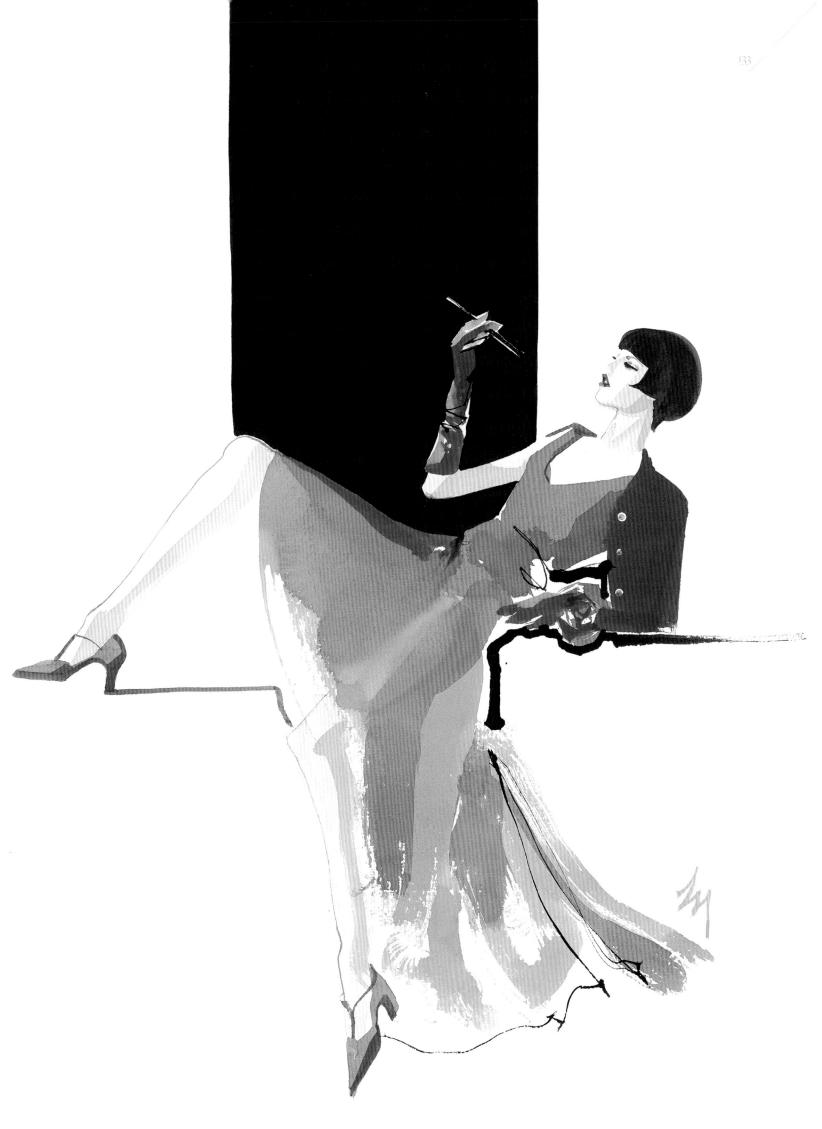

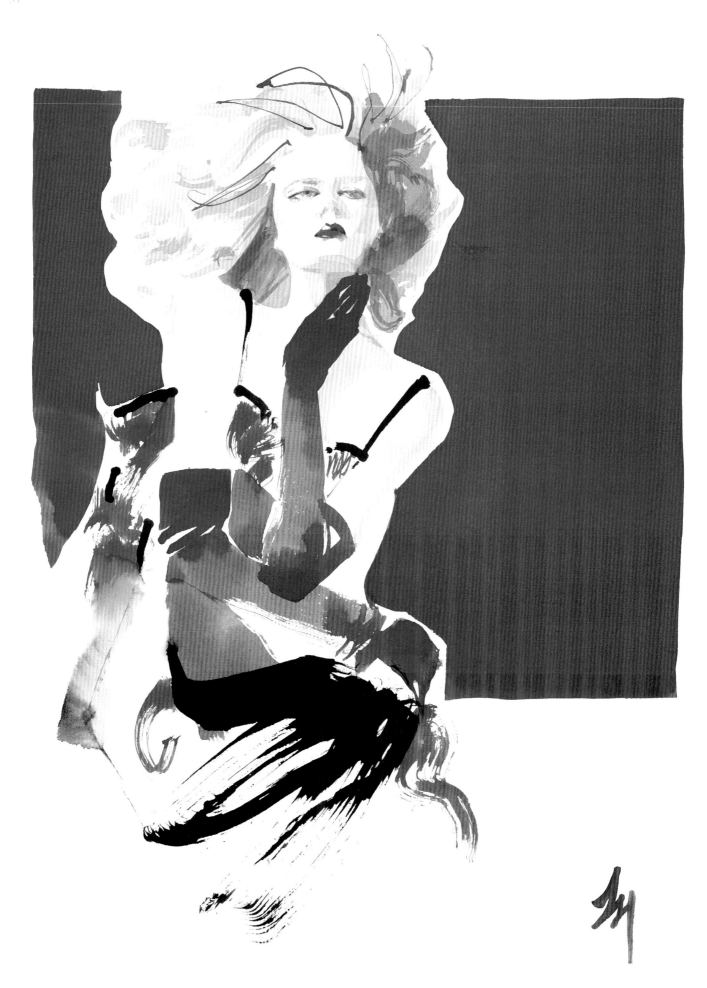

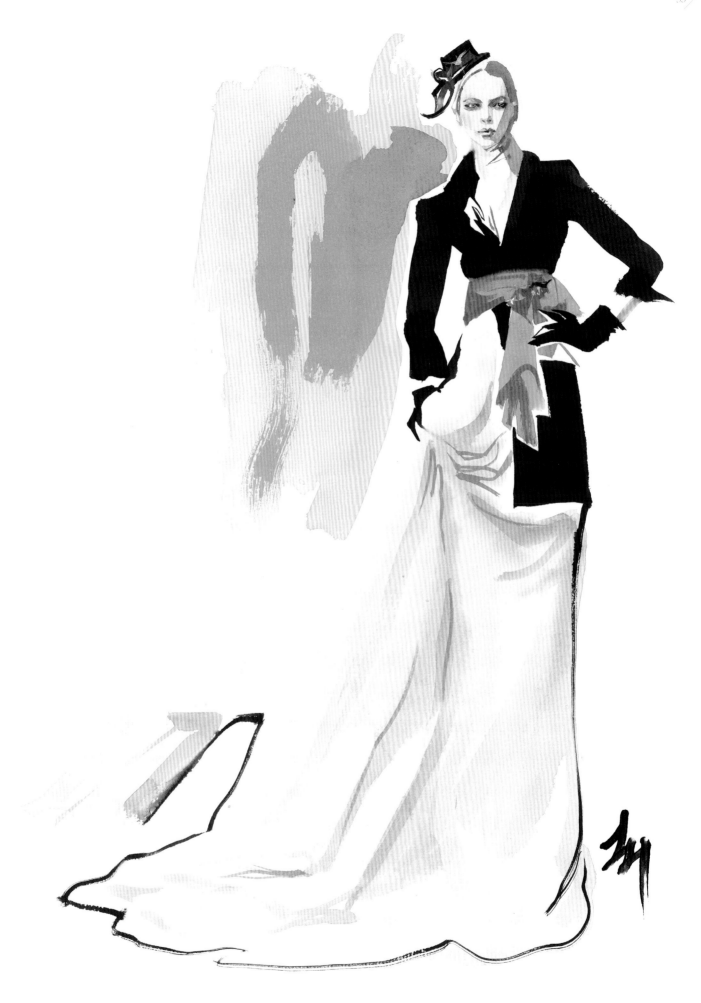

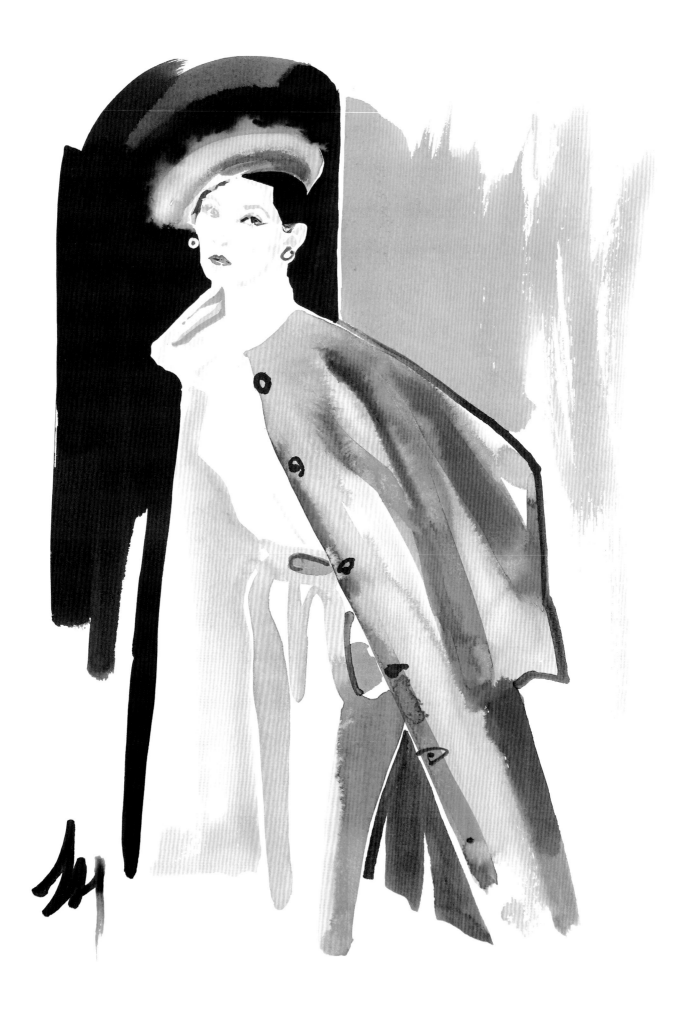

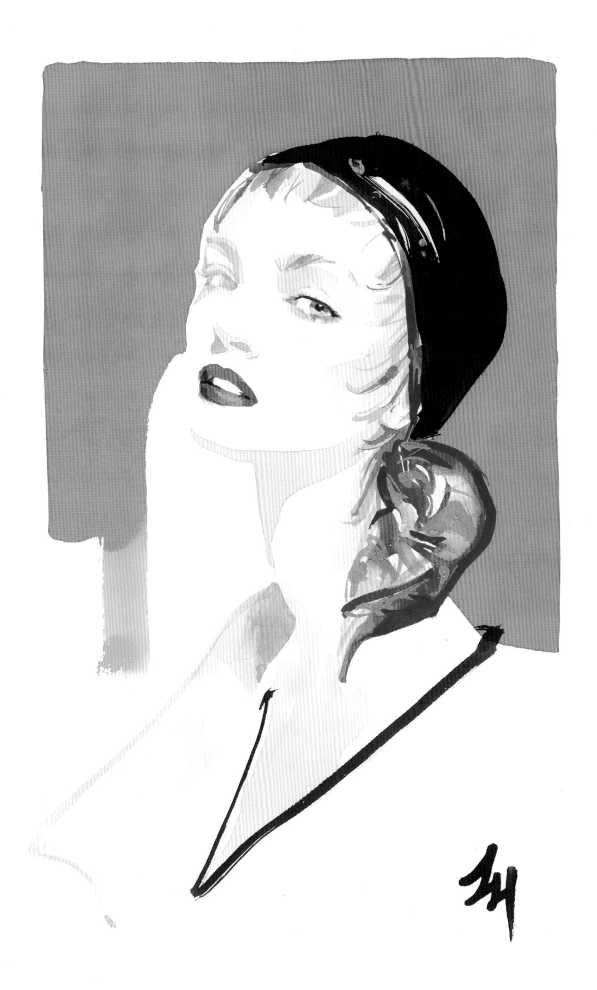

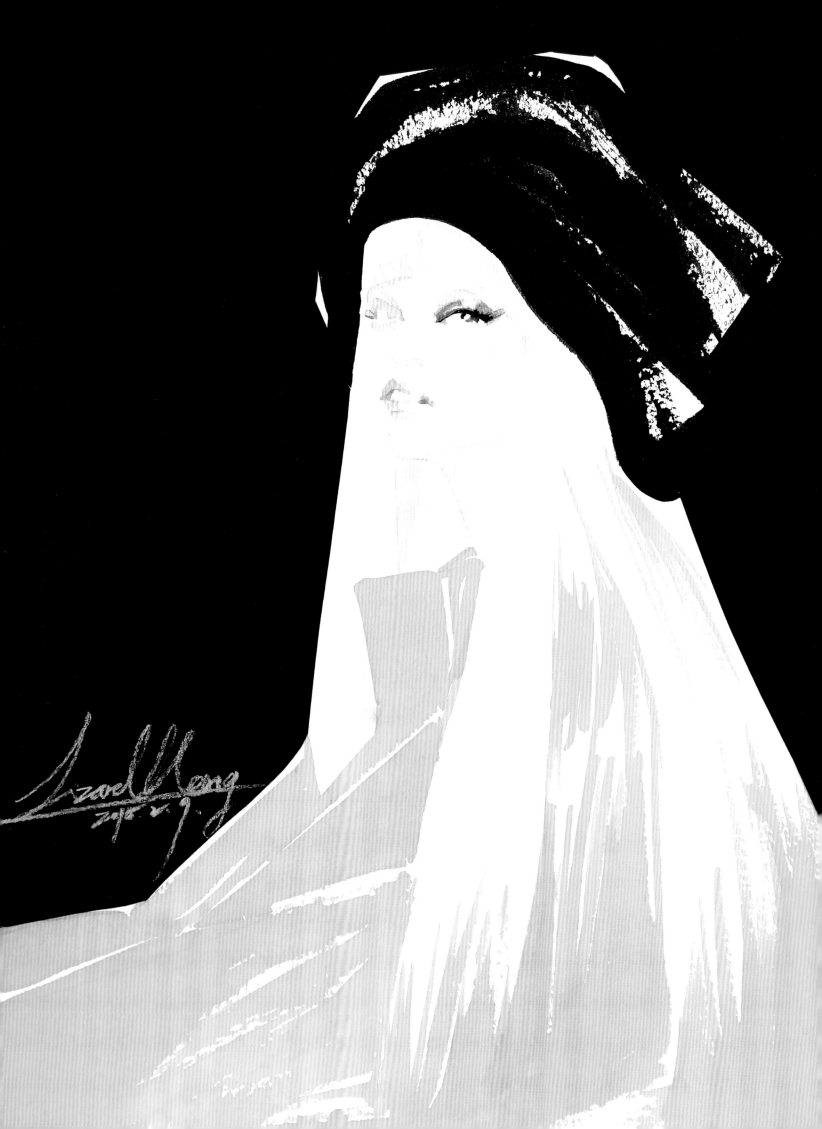

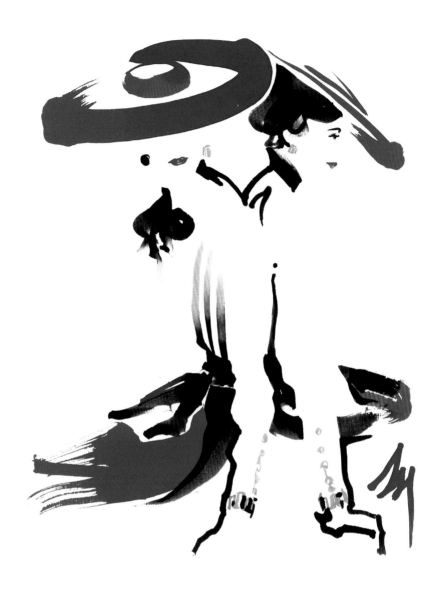

DESIGN
SKETCH

I usually practice basic sketching during breaks due to it does not require too much of thoughts for innovation. Coincidently, I watched a documentary on TV about Henry Matisse, reminding me of the artworks of this French artist. What's the most impression I have about his work is what he created by cutting out paper collages in his last 15 years of life, which gave me inspirations on extending my creation in ordinary sketching. In comparison to my watercolor artworks, this extended creation has become more extreme, grey and white realistic mixed with color paper teared by hand, and later on, I add watercolor, ink, black strokes that are darker than charcoals of the pencils, making it fiercely conflicting. I like very much this collision effect, which is like the dramatic scene that both sides are arguing who is the justice.

因為不太需要發想層面的創新，通常都是在休息時段來做這類的基礎素描練習。有一次偶然間在電視節目中看到了亨利‧馬諦斯的介紹特輯，使我再次憶起這位法國藝術家的生平創作，最令我印象深刻的是在他生命中最後的 15 年間所創作的剪紙拼貼畫，給我對於平時在做的素描練習有了延伸創作性的啟發。相較於我的水彩作品裡的虛實對比又更加的極端，灰與白的寫實搭配徒手撕碎的色紙，後來甚至開始加入水彩、墨水，比鉛筆更黑的黑和有色彩的筆觸，著實的讓畫面產生強烈的衝突感，我很喜歡這樣的碰撞效應，很像是正反兩派爭論著誰才是正義的戲劇畫面。

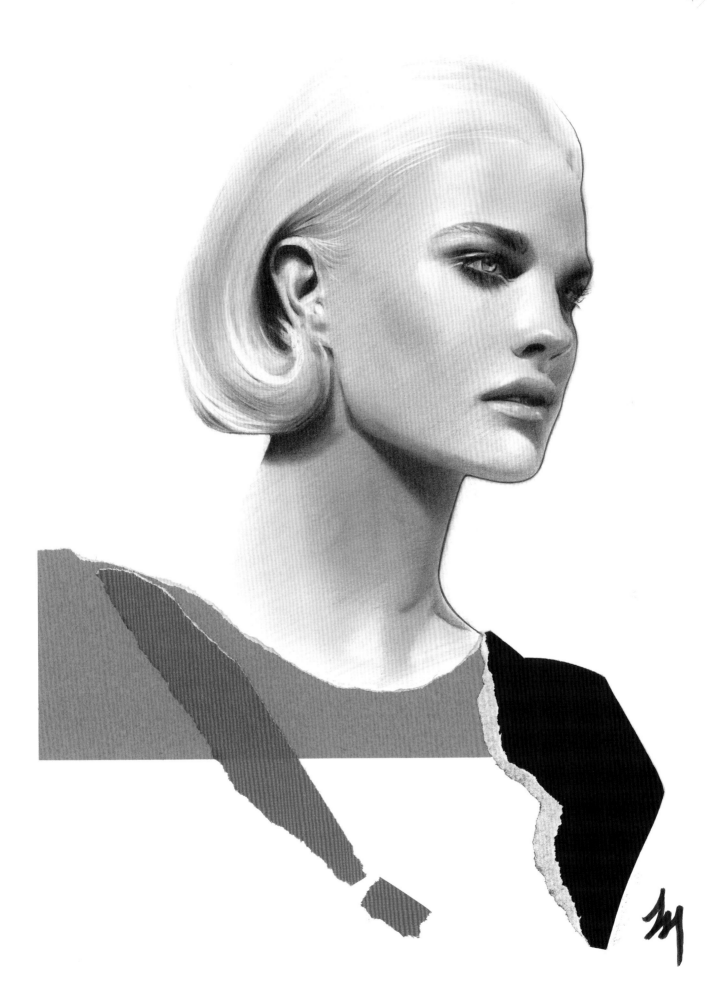

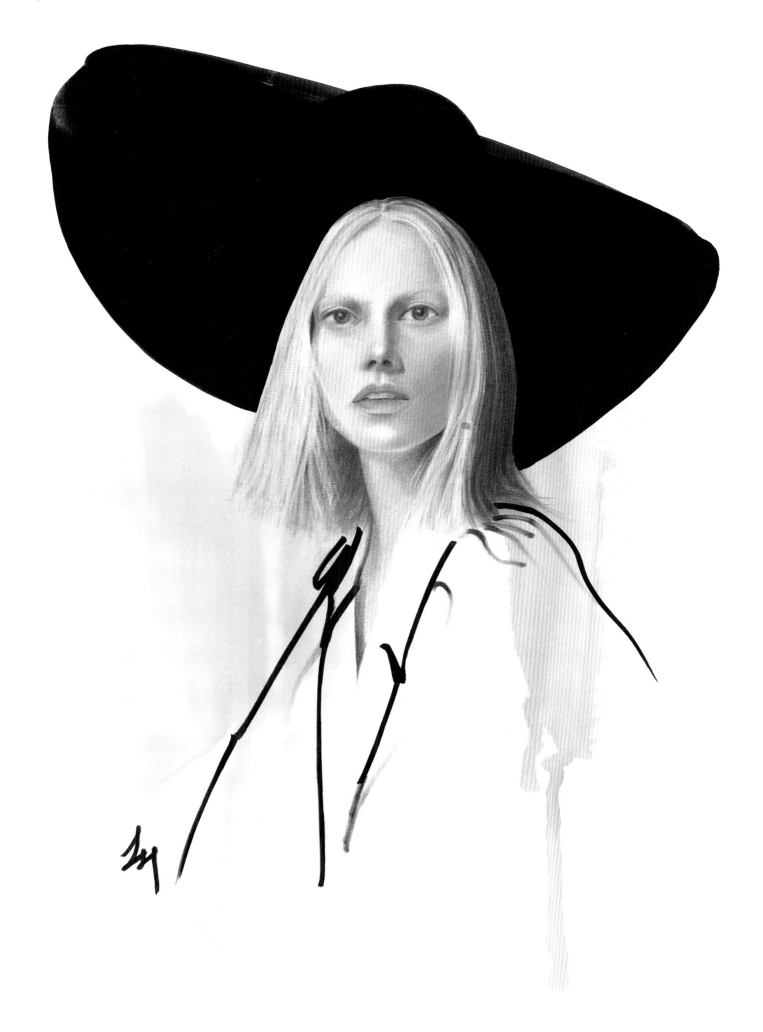

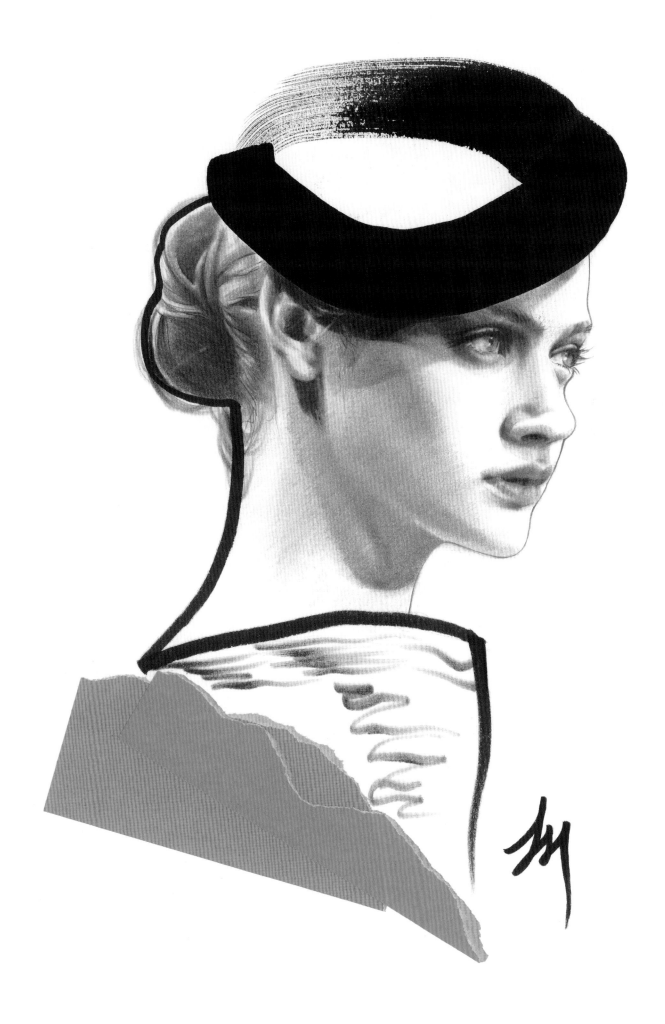

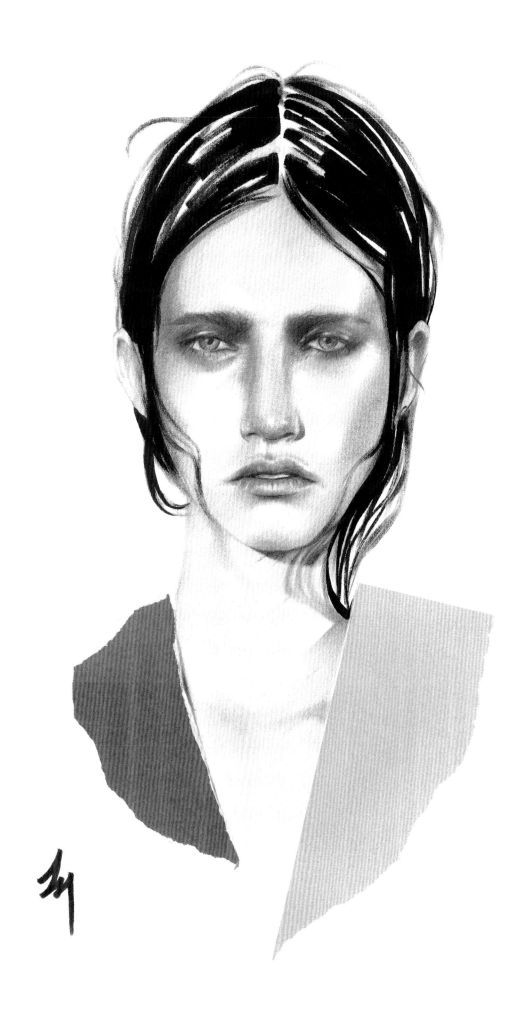

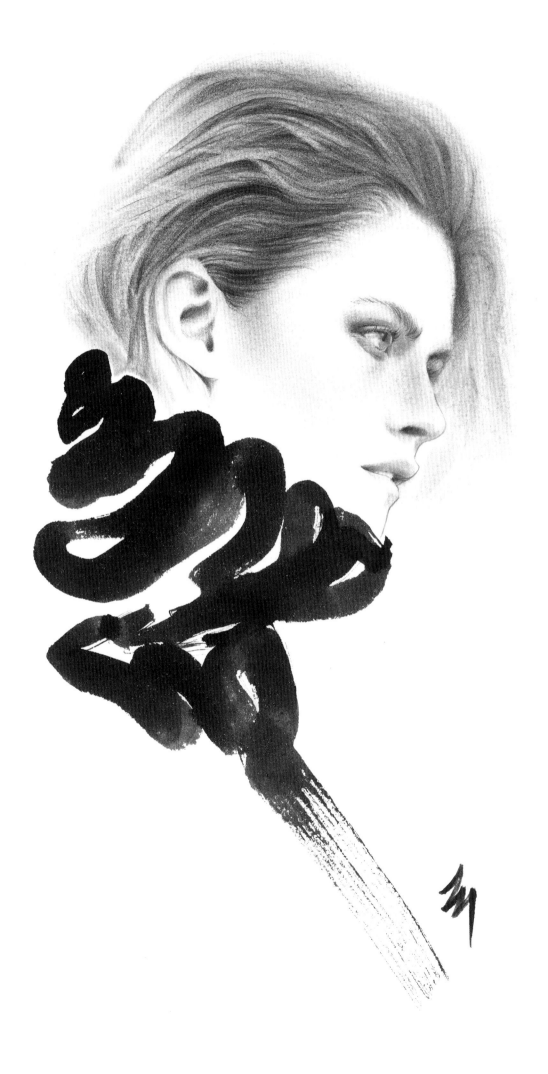

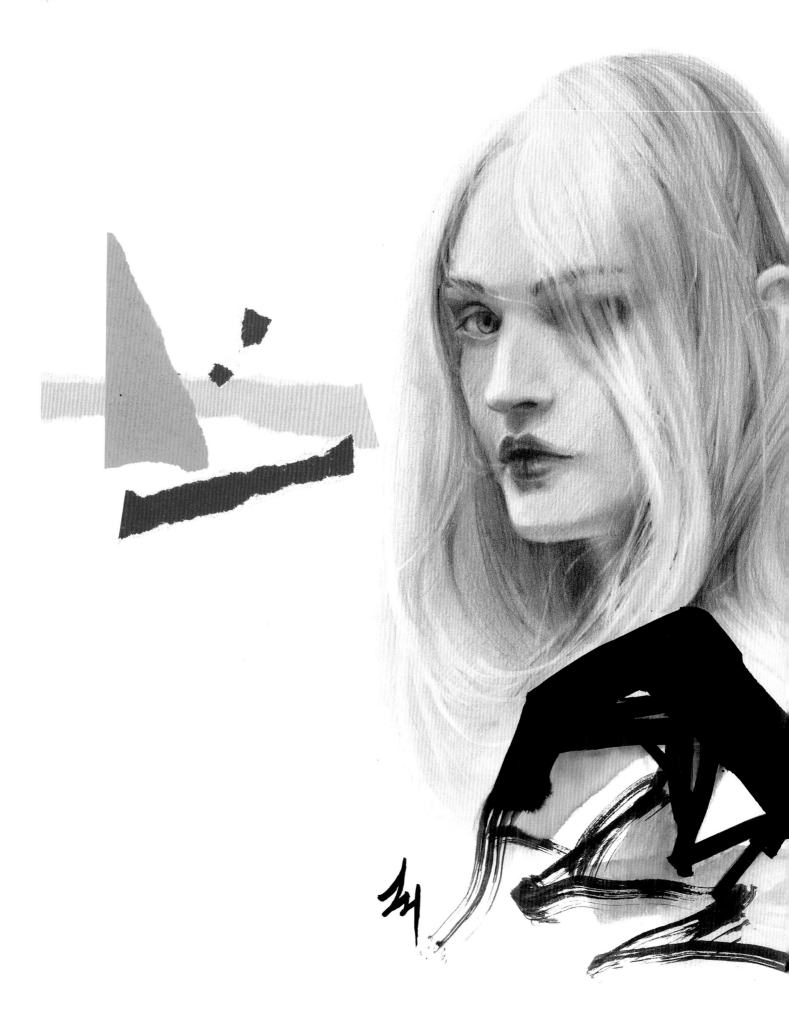

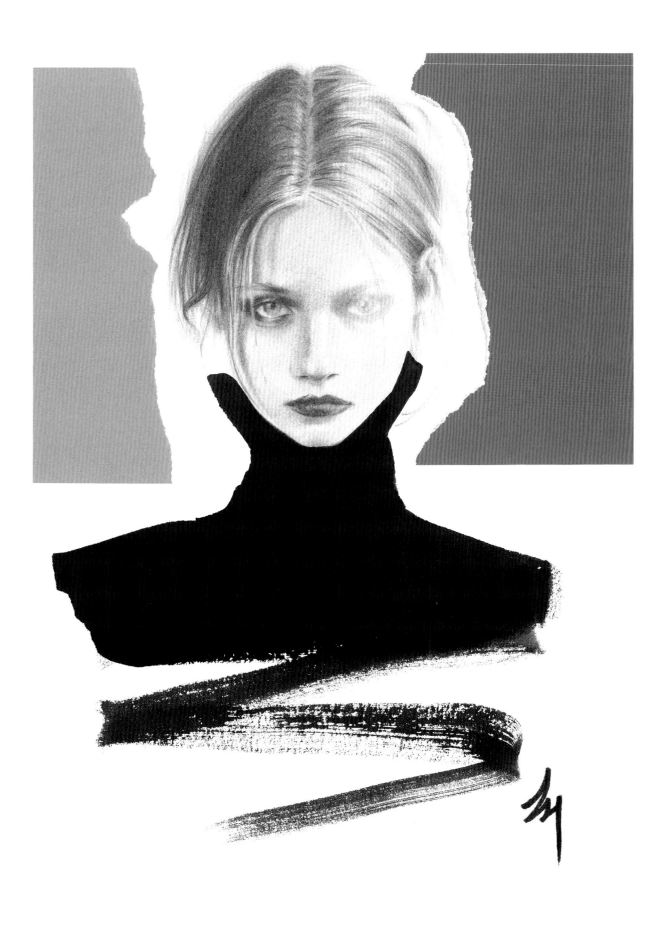

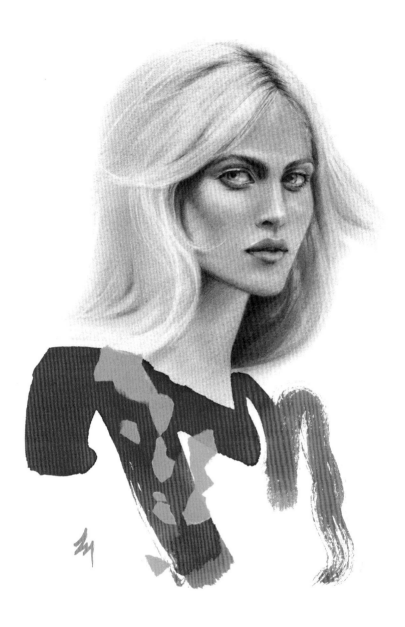

EXHIBITION

The exhibition is nothing more than a display of their own artistic creations, which conveys these unique energy to the public's communication mode by using colors, strokes and lines instead of words. I enjoy the sense of security in a space like my own creation in each exhibition, and lead everyone through each planet to tell their stories, and then listen to a variety of interesting feedback. The most special thing for me was the exhibition experience in London, England.

Being exhibited in "WORKS ON PAPER" together with other artists at the Brick Lane Gallery, London in 2016 was not only my first international exhibition, but also my first time to go to an European country. I have great fears due to unfamiliarity to the country and being questioned by customs about my itinerary and the purpose of my artworks sent from overseas. Due to my poor command of English, I was almost being rejected by the customs. However, I passed, and my excitement wasn't influenced too much by this episode. The moment I stepped in the street of London, I felt grounded and truthfully back to my original passion.

It is rather complicated about the international shipping of my artworks, not to mention the destination is England. It was a close call when my artworks arrived at the gallery, right before the opening of the exhibition, despite the fact that the original plan was meant to be delivered earlier. I brought a framed blank paper from Taiwan for the opening of the exhibition to do a Live show of drawing. Live drawing is not a challenge to me, just like what I am used to teach my students in class, and what's the best is that I did not have to talk while drawing.

It went quite smoothly from the start to the finish of the exhibition. What I gained the most about this exhibition is actually the "trip" itself. Visiting various big and small galleries, observing the architectures in big and small alleys, although my main object of drawing is usually human being, the source of my inspiration does not necessarily come from "people". Thoughts and experiences are also very essential elements.

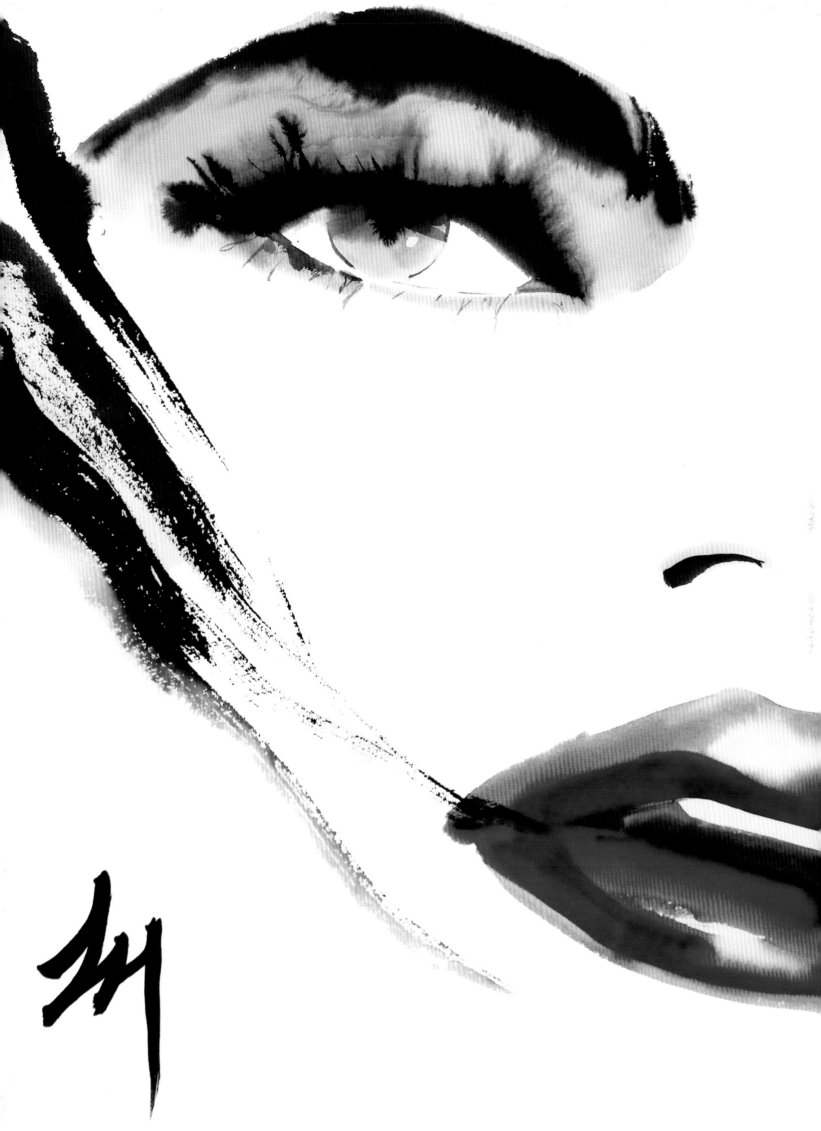

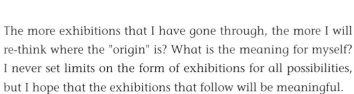

WORKS ON PAPER

The Brick Lane Gallery – LONDON

展覽不外乎是展示自己的藝術創作，將這些獨特的能量用色彩、筆觸、線條來代替語言傳遞給大眾的交流模式。我享受每次展覽時沈浸在一個像是自己親手打造出的宇宙空間當中的安全感，並帶領著大家走過每一顆行星述說著它們的故事，然後傾聽著各式各樣有趣的反饋。當中對我來說最特別的就是前往英國倫敦的展出經歷了。

The more exhibitions that I have gone through, the more I will re-think where the "origin" is? What is the meaning for myself? I never set limits on the form of exhibitions for all possibilities, but I hope that the exhibitions that follow will be meaningful.

WORKS ON PAPER 24th November – 4th December 2016
The Brick Lane Gallery, 216 Brick Lane | London | E1 6SA

展覽不外乎是展示自己的藝術創作，將這些獨特的能量用色彩、筆觸、線條來代替語言傳遞給大眾的交流模式。我享受每次展覽時沈浸在一個像是自己親手打造出的宇宙空間當中的安全感，並帶領著大家走過每一顆行星述說著它們的故事，然後傾聽著各式各樣有趣的反饋。當中對我來說最特別的就是前往英國倫敦的展出經歷了。

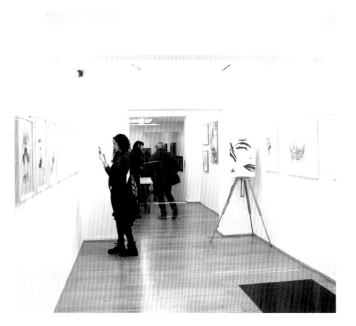

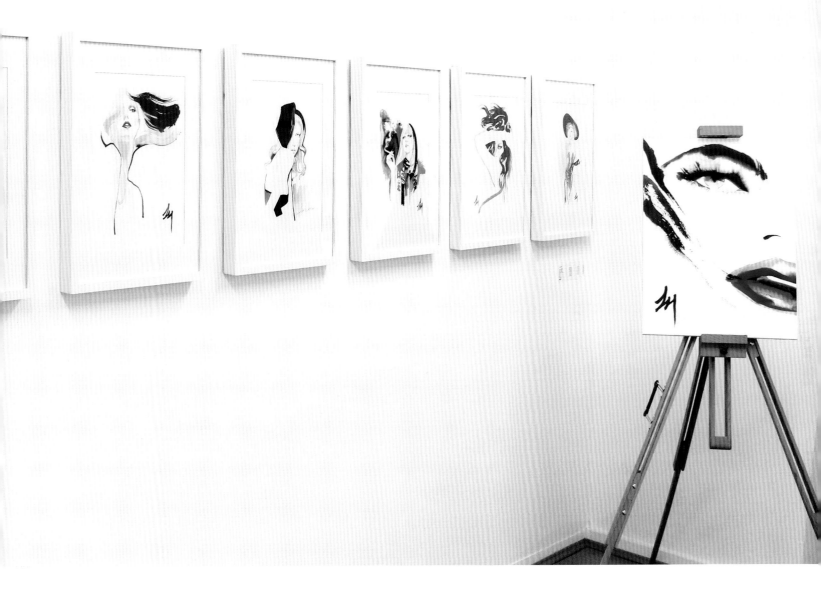

2016 於英國倫敦 The Brick Lane Gallery 名為 WORKS ON PAPER 的藝術家聯展，不僅是我的首次國際性展覽，也是第一次去歐洲國家，人生地不熟的確有所恐懼感纏身，剛抵達倫敦時機場時海關的盤查行程規劃與即將寄送來的藝術品目的性，因為語言關係差點無法順利入關，不過興奮的心情並沒有被這小插曲所影響太久，踏入倫敦街頭的霧那間馬上就調整回原來的心情，感受到自己已在此地的真實感。

國際運送作品過程相當繁瑣更何況目的地又是英國，雖然在最後一刻安全送進畫廊內佈展，但已經是千鈞一髮的最後時間了，當然一開始所規劃的抵達時間是有預計提早的。為了展覽的開幕式特地從台灣攜帶了自己事先水裱好的畫紙板到現場進行創作，現場作畫對我而言並不陌生，就像是平常在替學生上課那樣的習慣，而且不用「邊話邊畫」當然是又更得心應手了。

展覽過程開始到結束都算是順利，回想起這次的展覽對於自己更

大的收穫其實是「旅行」，參觀大大小小的美術館、大街小巷中的建築物，雖然說畫的是人，但有時候創作的泉源卻不盡然非得由「人」那邊來取得，思緒和見識也是相當重要的因素。

歷經愈多場展覽愈是會重新想起「原點」在哪裡？對於自己的意義是什麼？我從來不會設限對於所有的可能性的展覽形式，但期望往後的展覽之於自己都能夠是意義非凡的。

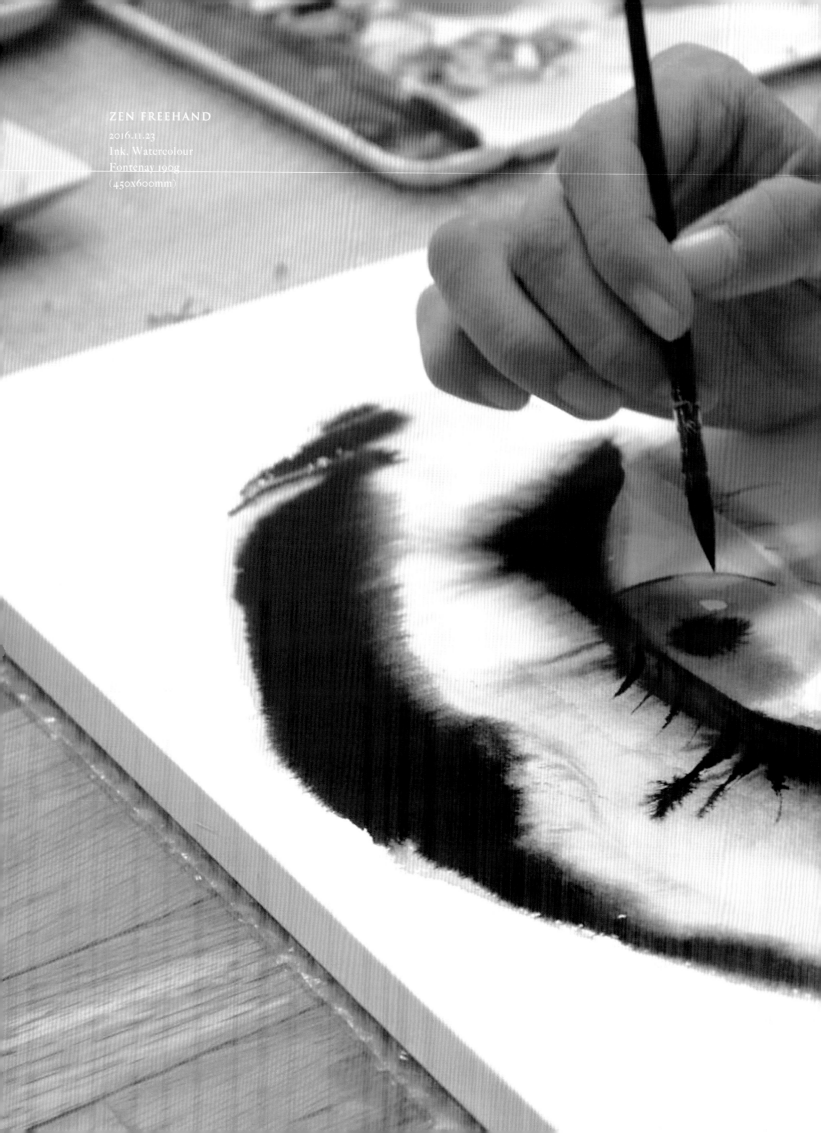

ZEN FREEHAND
2016.11.23
Ink, Watercolour
Fontenay 190g
(450x600mm)

Interview

Synonymous with fashion style,
a new interpretation of timeless classics.
-Dpi Magazine

Q：你的創作結合了水彩與水墨等媒材。可以分享一下是在怎樣的機緣下開始嘗試混合使用水彩與水墨？融合上有無扞格？

A：印象中有開始畫畫的記憶約莫是在唸小學五年級的時期。進入復興美工前甚至只畫過兩三次的水彩，直到台灣藝術大學畢業應該說是退伍後，可能沒了學校的課業和專題壓力後，反而讓我覺得有些力不從心，開始每天享受沐浴在創作中的感覺。在美術社無意間認識了彩色墨水，沒有學術上對與錯之下我隨心所欲地揮灑，彩色墨水高彩度的豔麗感深深地令我著迷，肆無忌憚地畫了約莫一年，體悟到了一幅畫是不能只有彩度這回事，於是將塵封已久的水彩實驗性質的與墨水做了結合，當然失敗的挫折感並不是短期內能夠結束的，每一種水彩紙、筆毛或顏料的乾濕度、時間計算觀察，成功都是由失敗的經驗累計而來的。

Q：請問你最喜歡的時尚品牌？

A：這樣說好了，我本來就不是會只喜歡一種風格或想一直做一樣事情的人，他們並不像是選擇數字 1、2、3、4 那樣的條件對等，大多數的時尚品牌也都有屬於自我風格的獨特品味，若真的非得挑選的話，我非常崇敬聖羅蘭時期的 YSL（Yves Saint Laurent），聖羅蘭不僅是第一位將時尚設計融合藝術的服裝設計師，也讓高級訂製服提升至藝術境界。最著名的就是加入畢卡索、馬諦斯等藝術大師的畫中元素所設計出的作品。他不斷的突破並打破傳統，總是能在他的設計中看見與眾不同的精緻細節，這些都是使我深深著迷的原因，就如同我創作理念一樣，必須構思如何呈現重點，但細節又更是重要，我認為那是一件好作品的內涵表現，並且能夠引人入勝。

Q：是否曾嘗試服裝設計？是否也曾做過彩妝造型呢？

A：其實兩者我都很有興趣，但並沒有實際深入研究過，因為幾乎已經將時間都花費在繪畫上都不太夠用了。但很想嘗試和時尚造型師共同創作主題式展覽或其他的跨界合作。雖然我不懂如何操作服裝設計與彩妝造型的專業領域，但我深入研究服裝的材質、剪裁、配色；彩妝的眼、唇、眉、睫等外在上的感官細節變化，這樣才能毫不心虛的將他們一一畫出，我喜歡對有感覺的東西瞭若指掌後再進行創作。

Q：可以分享一下年的教學歷程？什麼機緣下開始插畫教學的呢？

A：一開始是為了能夠在台灣推廣時尚插畫，並且多一份生活收入來支持自己的創作理想，到後來持續教學對我來說更重要的反而卻是教學相長這件事。替初學者上課時，每個月份都必須在上課前將所有基礎重新來過，有了完美的狀態才能回應學員們的各式問題，使我在創作路上一樣穩固基石不會只顧著畫新的東西，並且經常看到了以前的自己與初衷，所以對我來說教學也是藝術旅程中非常重要的一站。

Q：請問你認為繪製時尚插畫與一般插畫最大的不同是？

A：時尚插畫對我來說只是一個名詞，一個讓沒接觸過的人知道是什麼的詞。我認為時尚插畫的範疇很廣泛，嚴格來說並不是非得要拿時尚來作為創作的主題才算是時尚插畫，當然也不侷限什麼工具媒材。「時尚插畫」是一種畫風，將自己所看到的重新詮釋，不必要的瑣碎拿掉；須要的元素更加強，間單的說就是去蕪存菁，畫愈簡單實則愈難畫，最後則是較為意象的「留白境界」。然而和一般插畫最為不同的我認為是它含括了「設計」層面，也就是點、線、面的元素構成。

Q：時尚品牌合作現場肖像速寫活動的經驗：

A：現場作畫對我來說再熟悉不過了，像是在教學時的現場示範一樣，而且不用邊講、邊畫、邊教更是容易許多。因為每個品牌的每項活動皆有不同主題或時間限制，所以常常能在此類型的工作中找到一些創作上的靈感

或新的成長，必須在十分鐘左右抓住素昧生平的貴賓們神韻，並完成到達自我要求的構圖與上色，對於藝術家最需要的洞察力也因此能不斷的提升。

Q：2016 年作品受邀在英國倫敦藝廊展覽的經歷 :

\：很感謝英國倫敦藝廊 THE BRICK LANE GALLERY 的展覽邀約，展覽主題名為【WORKS ON PAPER】，雖然當時收到邀請函時有一度覺得是詐騙集團，在求證沒問題後隨之而來的反而是心境的變化，時間急迫必須在一個禮拜之內回應是否展出的決定，不到一個月的時間要在幾百張的作品海中挑選合適展出的得意之作，還要搞定裱框、國際運輸、佈展的聯繫這些問題，最後一切就緒後心裡總算有了如願讓原作掛上了國際舞台的悸動，並在開幕當天進行了全開的現場創作，有種無法言喻的喜悅感。

Q：分享你對未來的計劃與目標？

\：展覽、個人畫冊與品牌的跨界合作是我一直以來的計畫與目標，也一直都是進行式的狀態。唯獨畫冊其實早在（2016）就計畫完成出版，因為期間不間斷的有新作品產出，對於作品的滿意度一直未達自己的完美主義門檻，才遲遲沒有集結成冊，但最後也終於在今年完成了自己的第一本畫冊。未來希望持續在自我內心的成長上發掘，能藉由自己的作品讓大眾能意識到藝術與生活的聯繫，進而豐富社會對於生活美學的發展，因為藝術本該是始於生活的。雖然計畫永遠趕不上變化，但或許我就適合這樣的模式吧。

Q : Your creation combines materials such as watercolor and ink. Can you share what kind of opportunity you started experimenting with the use of watercolor and ink? Is there any ambiguity in the fusion?

\ : The memory of the beginning of my painting is about the fifth grade of elementary school. I only painted two or three watercolors before entering Fu-Hsin Trade & Arts School, it is not until after the graduation of the Taiwan University of the Arts or after finishing the compulsory military service did I begin to enjoy bathing myself in art creation every day due to getting rid of school's coursework and the pressure from special projects. I have inadvertently encountered the color ink in the art society. I didn't have the academic mindset of right and wrong. I swayed as I liked it. The glamour of the color ink was so fascinating to me. I painted it for a year without hesitation, and realized that a painting was not only to do with chroma, but also the long-standing watercolor experimental nature is combined with ink. Of course, the frustration of failure did not come to an end in short-term, the dryness and humidity of each watercolor paper, pen or pigment all require time calculation and observation, every success is accumulated from the experience of failure.

Q : What is your favorite fashion brand?

\ : Well, I am not a person who wants to do the same thing or same style all the time. They are not like the choice of the numbers 1, 2, 3, 4, etc. Most fashion brands have their unique tastes that belong to the style of itself. If I really have to choose, I highly respect YSL (Yves Saint Laurent). He was not only the first fashion designer who integrated fashion design into art but upgraded High Fashion Clothing into the realm of art. His most famous work was created by the elements of the paintings of artists such as Picasso and Matisse. He constantly broke the tradition, always seeing the exquisite details in his design. These are the reasons that make me deeply fascinated. Just like my creative concept, I must conceive how to present the key points, but the details are even more essential. I think that is the connotation of a good work and can be fascinating.

Q : Have you tried fashion design? Have you ever done makeup?

\ : Actually, I am very interested in both, but I have not actually studied it in depth, because it is not enough to spend almost all of my time on painting. But I would like to try to create a themed exhibition or other cross-border cooperation with fashion stylists. Although I don't know how to operate the professional field of fashion design and make-up modeling, I have studied the material, tailoring and color matching of the clothing; the sensory details of the eyes, lips, eyebrows, eyelashes and other external changes of the makeup, so that I can vividly draw them one by one, and I like to create something that I have feeling when I master it.

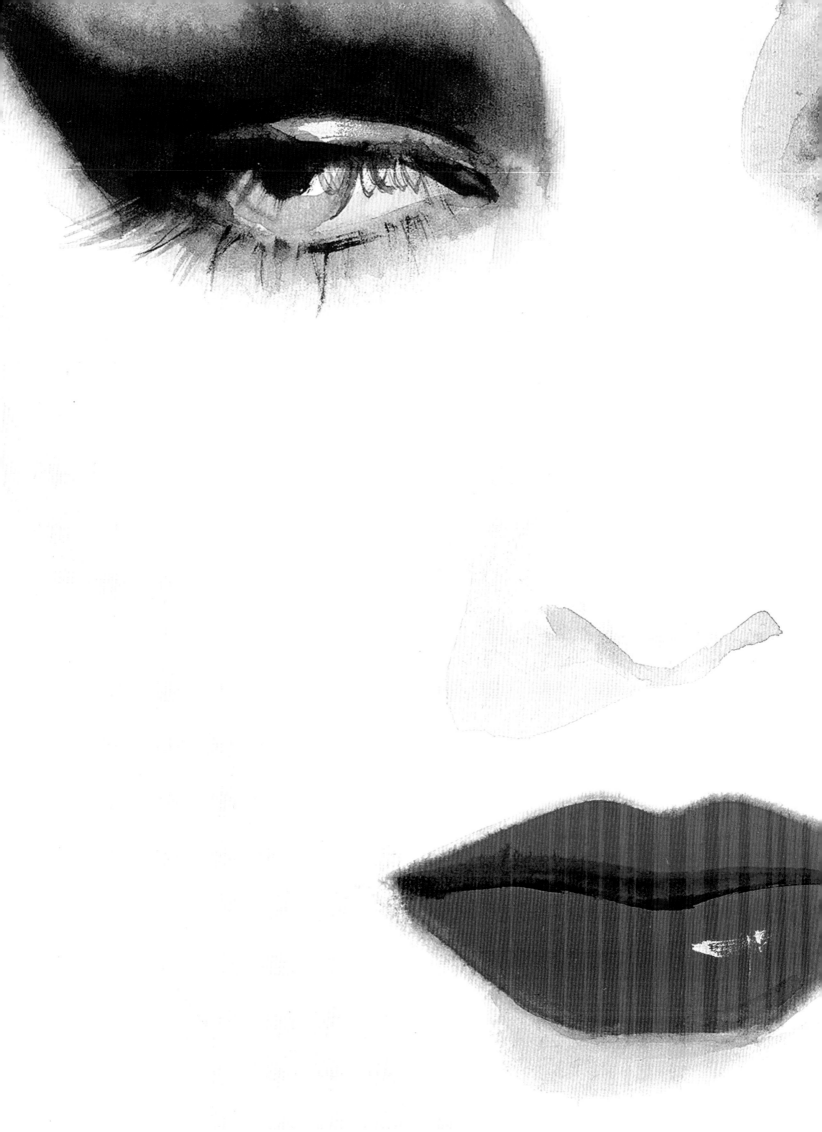

Q : Can you share your teaching history? How did you start teaching the illustration?

\ : At the beginning, I was able to promote fashion illustrations in Taiwan, and I had more income from my life to support my creative ideals. Later, continuing teaching is more important learning to me than it is teaching. When starting a class for beginners, every month I must return to all the foundations before class. Only wiith perfect status can I respond to the various questions from the students, so that I can not only focus on painting new things on the road of creation but to stabilize my foundations during which I often observe myself with original intention, so for me, teaching is also a very important station in my art journey.

Q : What do you think is the biggest difference between drawing a fashion illustration and a general illustration?

\ : Fashion illustrator is just a noun for me, a word that lets people know what it is before being exposed to it. I think that the scope of fashion illustrations is very broad. Strictly speaking, it is not necessary to use fashion as the theme of creation to be a fashion illustration. Of course, there is no limit to any tool as medium. "Fashion Illustrator" is a style of painting that removes the unnecessary triviality with reinterpretation of what you see; the necessary elements are strengthened, and the single statement is to save the quintessence. The simpler the painting, the harder it is to draw. Finally, It is a more vivid image of "white space". However, the most different from the general illustration, I think it includes the "design" level, that is, the elements of points, lines and planes.

Q : What is your experience of fashion brand cooperation with live portrait sketching activities?

\ : The painting on the spot is familiar to me, like the on-site demonstration during teaching, and it is much easier without the necessity to talk while teaching. Because each activity of each brand has different themes or time constraints, it is often possible to find some creative inspiration or new growth in this type of work. It is necessary to grasp the charm of the guests in about ten minutes. And to complete the composition and coloring, the insight that the artist needs most can be continuously improved.

Q : The 2016 work was invited to exhibit at the London Gallery of Art in the UK:

\ : I am very grateful to the exhibition of THE BRICK LANE GALLERY in London, England. The theme of the exhibition is [WORKS ON PAPER]. Although I received the invitation at the time, I felt that it was a fraud group, and it came after the verification. Instead, it is a change in my mood. Time is urgent to respond to the decision whether or not to exhibit in a week. In less than a month, it is necessary to select the appropriate exhibits out of the hundreds of my works, and to complete the frame. After all the problems of international transportation and exhibitions were completed, I finally had the wish to let the original work hang on the international stage, and on the opening day, I had a full-open live creation, and there was an unspeakable sense of joy.

Q : Please share your plans and goals for the future?

\ : The cross-border cooperation between exhibitions, personal albums and with other brands is my long-standing plan and goal, and it has always been a state of progress. In fact, this album was actually planned to publish as early as in 2016 because there were new works produced during the period, but the satisfaction of the works has not reached my perfectionism threshold, it has not been assembled yet. I finally finished my first album this year. In the future, I hope to continue to explore the growth of my own heart. Through my own works, the public can realize the connection between art and life, and enrich the society's development of life aesthetics, because art should start with life. Although the plan will never catch up with the changes, maybe I will be suitable for this model.

INDEX
Page numbers refer to illustration

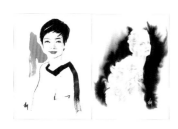
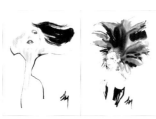
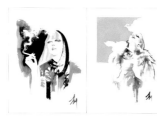
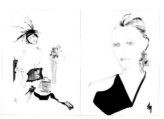
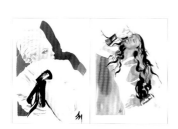
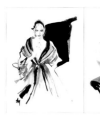
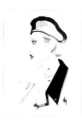
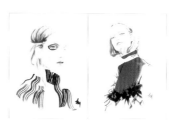
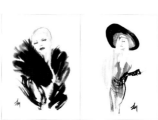

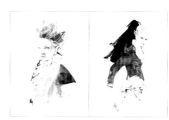
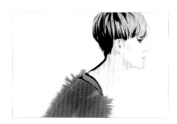

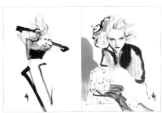
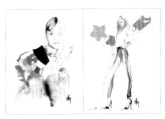
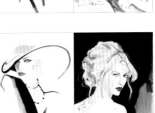
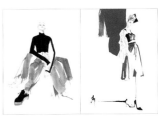
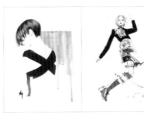
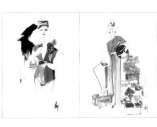
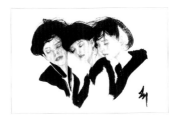
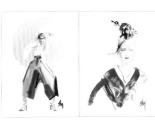
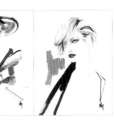
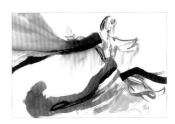
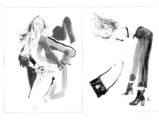
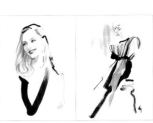
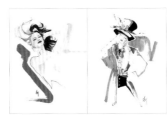
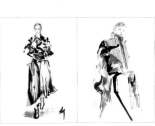
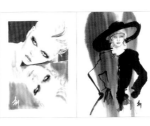
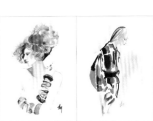

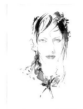 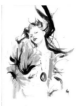
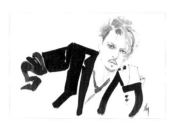
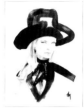 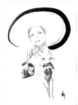
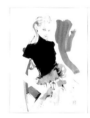 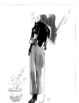
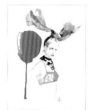 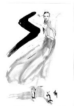
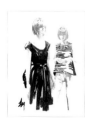 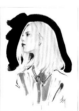
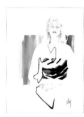 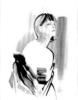
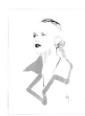 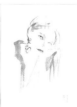
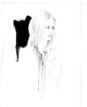
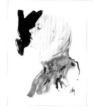
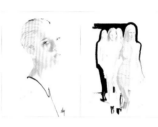
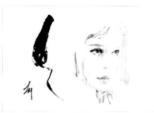
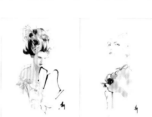
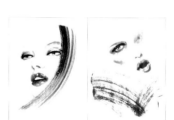
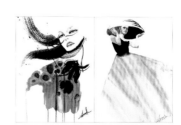
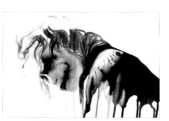

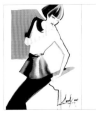 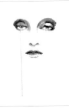
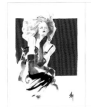 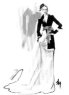
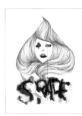 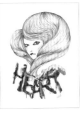
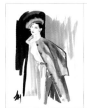 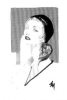
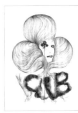
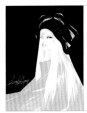
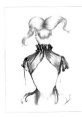
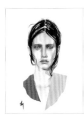 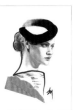

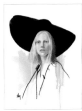
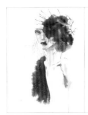
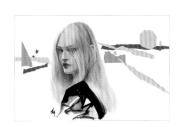
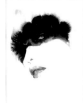 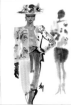
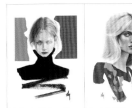
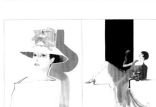
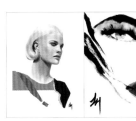

Creative
Experience

COOPERATION

CHANEL, Cartier, Guerlain, Calvin Klein, PIAGET, Jaeger-LeCoultre, Girard-Perregaux, Sybilla, SAMSUNG, SHISEIDO, ELLE, L'Oréal Paris, ECCO, eslite, Laura mercier.

EXHIBITION

2013.3.16-4.16 THE WALL SOLO EXHIBITION BY LIZARD – Arthere Café, TAIPEI

2013.6.24-7.24 IMMENSE x LIZARD – IMMENSE, TAIPEI

2013.7.6-7.28 Action III Hopping Consciousness – Art Creator Trade Union, TAIPEI

2013.8.1-9.1 FASHION ILLUSTRATION JOINT EXHIBITION – SOUL ART GALLERY, TAIPEI

2013.9.1-10.13 ERROR DESIGN TAIWAN JOINT EXHIBITION – EXPO PARK, TAIPEI

2013.10.23-11.13 BETOND the GALAXY – 435 ART ZONE, NEW TAIPEI CITY

2014.6.20-6.25 FASHION ILLUSTRATION ART JOINT EXHIBITION – No.16 Chingtian, TAIPEI

2014.11.2-11.13 THOUGHTS – A8 Café & Gallery, TAIPEI

2015.03.12-04.06 DAILY TASTES OF LIFE EXHIBITION – ESLITE SPECTRUM SONGYAN STORE, TAIPEI

2015.08.01-08.31 FASHION ART EXHIBITION – FUJIN by Plain-me, TAIPEI

2015.10.23-10.25 ART easy 2015 – Huashan1914-Creative Park, TAIPEI

2016.11.24-12.04 "WORKS ON PAPER" – The Brick Lane Gallery, London

EDUCATION

Fu-Hsin Trade and Arts School, Advertisement Design

National Taiwan University of Arts, Visual Communication Design

品牌經歷：

法國時尚品牌香奈、法國時尚品牌卡地亞、法國時尚品牌嬌蘭、美國凱文克萊 C.K、瑞士伯爵珠寶、瑞士積家錶、瑞士芝柏錶、西班牙 Sybilla、韓國三星、日本資生堂、台灣 ELLE 雜誌、日本 G U、巴黎萊雅、丹麥愛步、誠品生活松菸、蘿拉蜜思。

展覽經歷：

2013.3.16-4.16 THE WALL SOLO EXHIBITION BY LIZARD 施易亨創作個展 - 台北上樓看看咖啡
2013.6.24-7.24 IMMENSE x LIZARD 創作個展 - 台北 IMMENSE
2013.7.6-7.28 臺北市藝術創作者職業工會聯展「2013 年度匯演：Action III 意識跳格」- 台北信義區
2013.8.1-9.1 時尚插畫聯展 － 台北美人愚藝廊
2013.9.1-10.13 ERROR DESIGN TAIWAN 設計師聯展 － 台北花博公園
2013.10.23-11.13 《天河之上》- 創作個展 板橋 435 藝文中心
2014.6.20-6.25 《時尚 · 藝術》繪畫展 － 青田十六 - 師大當代人文藝術空間
2014.11.2-11.13 《絲緒》A8 Café & Gallery － 台北 A8 咖啡
2015.03.12-04.06 『日嚐生活』插畫展 - 台北誠品生活松菸店
2015.08.01-08.31 施易亨 時尚繪畫原畫展 - 台北附近 FUJIN
2015.10.23-10.25 第一屆台灣輕鬆藝術博覽會 - 台北華山 1914 文創產業園區
2016.11.24-12.04 【WORKS ON PAPER】- 英國倫敦

學習經歷：

私立復興商工 廣告設計科
國立台灣藝術大學　視覺傳達設計學系

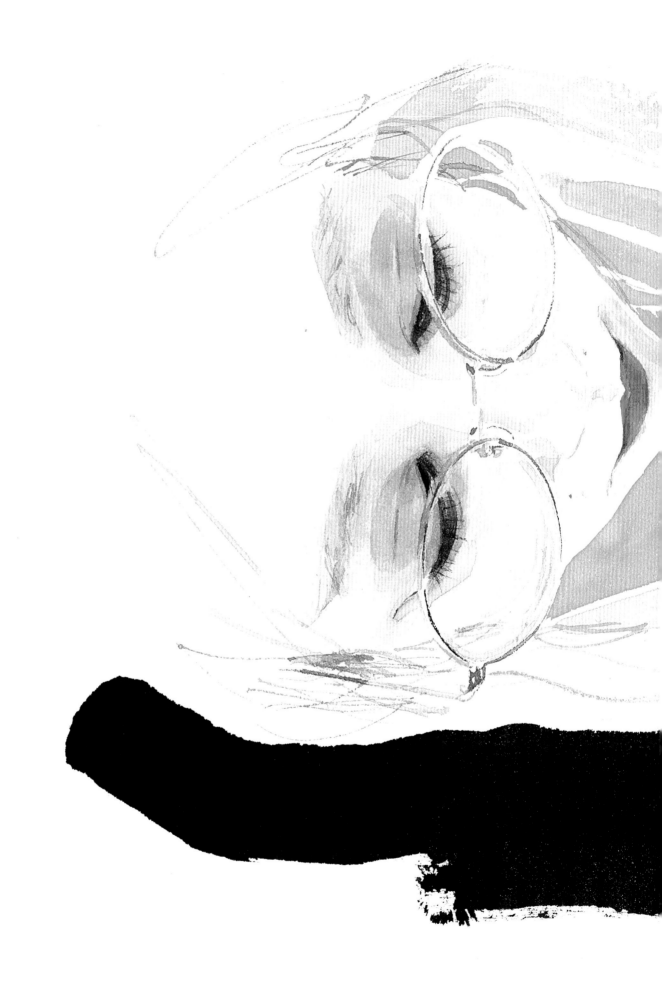

SAKANA
2018.04.12
Ink. Watercolour
Vergé ARCHES 300g
(188x260mm)

ART OF LIZARD

Fashion Sharpens Your Style.

施 易 亨 ｜ 藝 術 ‧ 時 尚

THEWALL-LIZARD.COM
FACEBOOK | facebook.com/lizardheng
INSTAGRAM | instagram.com/lizardheng
EMAIL | lizardheng@gmail.com

藝術家／施易亨

藝術總監／施易亨

美術設計／施易亨

本文撰寫／施易亨

翻譯顧問／洪翎玲

行銷企畫／張容瑩、蔡欣儒、
廖可筠、張莉滎、蕭羽猜

總 編 輯／賈俊國

副總編輯／蘇士尹

編　　輯／高懿萩

發 行 人／何飛鵬

印刷製版／艾瑪印刷美學工作室
Email：ruani0517@gmail.com
電話：+886975-632-257

初　　版／2019 年 1 月

售　　價／1680 元

I S B N ／978-957-9699-52-5

Artist / Yi Heng Shi (Lizard)

Art Director / Yi Heng Shi (Lizard)

Art Design / Yi Heng Shi (Lizard)

Content Written / Yi Heng Shi (Lizard)

Translation Consultant / Lynn Lynn Hung

Marketing Planning / Jung Ying Chang,
Hsin Ju Tsai, Ke Yun Liao, Li Ying Zhang, Yu Cai Siao

Chief Editor / Jun Guo Jia

Deputy Editor-in-Chief / Shi Yin Su

Editor-in-Chief / Yi Ciou Gao

Publisher / Feipeng He

Printing / Emma printing aesthetic studio

First edition / January 2019

Retail Price / 1680 TWD

出　　版／布克文化出版事業部
台北市中山區民生東路二段 141 號 8 樓
電話：(02)2500-7008
傳真：(02)2502-7676
Email：sbooker.service@cite.com.tw

香港發行所／城邦（香港）出版集團有限公司
香港灣仔駱克道 193 號東超商業中心 1 樓
電話：+852-2508-6231
傳真：+852-2578-9337
Email：hkcite@biznetvigator.com

發　行／英屬蓋曼群島商家庭傳媒股份有限公司城邦分公司
台北市中山區民生東路二段 141 號 2 樓
書虫客服服務專線：(02)2500-7718；2500-7719
24 小時傳真專線：(02)2500-1990；2500-1991
劃撥帳號：19863813；戶名：書虫股份有限公司
讀者服務信箱：service@readingclub.com.tw

馬新發行所／城邦（馬新）出版集團 Citeé (M) Sdn. Bhd.
41, Jalan Radin Anum, Bandar Baru Sri Petaling,
57000 Kuala Lumpur, Malaysia
電話：+603- 9057-8822
傳真：+603- 9057-6622
Email：cite@cite.com.my